Van Gogh's Van Goghs: Masterpieces from the Van Gogh Museum, Amsterdam

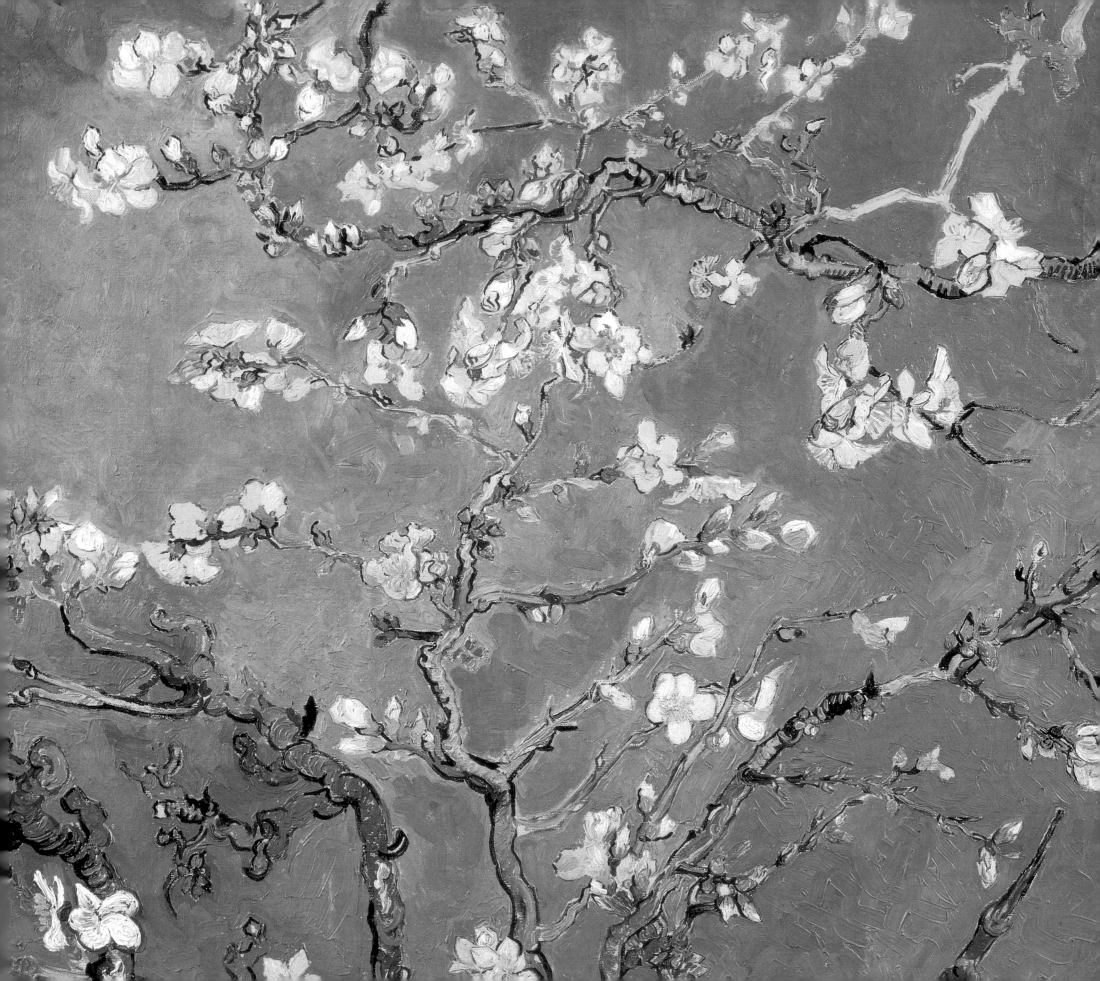

VAN GOGH'S

Van Goghs

Masterpieces from the Van Gogh Museum Amsterdam

Richard Kendall

with contributions by
John Leighton and
Sjraar van Heugten

National Gallery of Art, Washington

Distributed by
Harry N. Abrams, Inc., Publishers

Andersen Consulting is proud to sponsor *Van Gogh's Van Goghs* in Washington

The exhibition is organized by the National Gallery of Art, Washington, and the Van Gogh Museum, Amsterdam, in collaboration with the Los Angeles County Museum of Art.

The exhibition is supported by an indemnity from the Federal Council on the Arts and the Humanities.

Exhibition Dates
National Gallery of Art
4 October 1998–3 January 1999

Los Angeles County Museum of Art
17 January–4 April 1999

The book was produced by the Editors Office, National Gallery of Art
Editor-in-chief, Frances P. Smyth
Editor, Susan Higman
Designer, Chris Vogel

Typeset by Duke & Company,
Devon, Pennsylvania
Separations by Nederlof Repro, Heemstede,
The Netherlands
Printed on Lumisilk matte by Arnoldo Mondadori
Editore, Verona, Italy

The clothbound edition is distributed by
Harry N. Abrams, Incorporated, New York

Library of Congress Cataloging-in-Publication Data

Kendall, Richard.
 Van Gogh's van Goghs: masterpieces from the Van Gogh Museum, Amsterdam / Richard Kendall with contributions by John Leighton and Sjraar van Heugten.
 p. cm.
 Catalog of an exhibition to be held at the National Gallery of Art, Oct. 4, 1998–Jan. 3, 1999 and at the Los Angeles County Museum of Art, Jan. 17–Apr. 4, 1999.
 Includes bibliographical references.
 ISBN 0-89468-237-7
 ISBN 0-8109-6366-3 (Abrams hardcover)
 ISBN 0-8109-6374-4 (BOMC paperback)
 1. Gogh, Vincent van, 1853–1890—Exhibitions. 2. Painting—Netherlands—Amsterdam—Exhibitions. 3. Van Gogh Museum, Amsterdam—Exhibitions. I. Gogh, Vincent van, 1853–1890. II. Leighton, John. III. Van Gogh Museum, Amsterdam. IV. National Gallery of Art (U.S.) V. Los Angeles County Museum of Art. VI. Title.
ND653.G7A4 1998
759.9492—dc21 98-21871

Contents

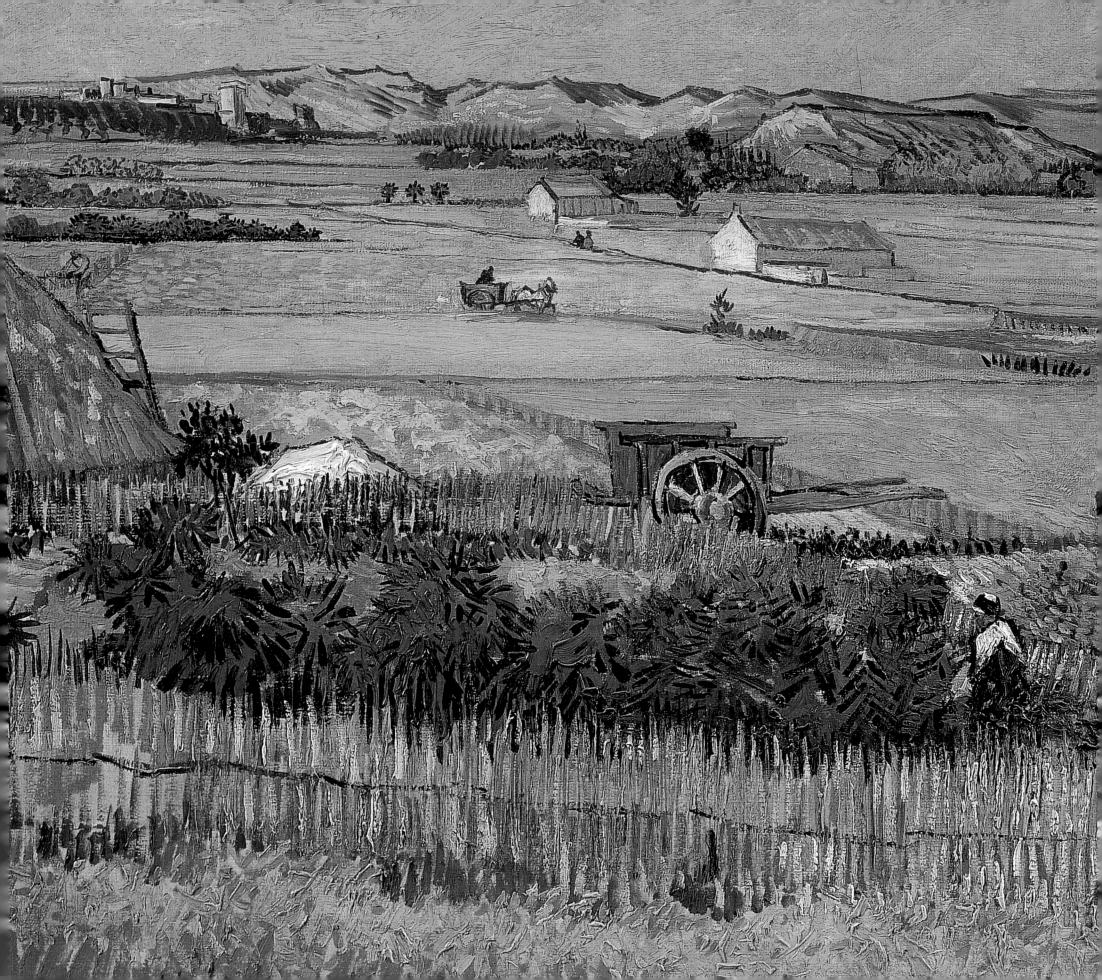

Directors' Foreword

Van Gogh's Van Goghs presents a unique opportunity for visitors to our museums, one on the East Coast and one on the West Coast, to see seventy of this great postimpressionist painter's works, from his earliest paintings done in his native Holland to the last works made just before his tragic end in Auvers-sur-Oise. Their provenance is impeccable and special, for they all passed directly from Vincent to his brother Theo, and in turn were inherited by Theo's widow Johanna van Gogh-Bonger; from her they were inherited by her son Vincent Willem van Gogh, known as "The Engineer," who eventually established the Vincent van Gogh Foundation and the Van Gogh Museum in Amsterdam, which houses them today.

It is thanks to the generous suggestion of the former director of the Van Gogh Museum, Ronald de Leeuw (now director of the Rijksmuseum, Amsterdam), that the present exhibition was proposed in 1996 to the National Gallery of Art. It is made possible by the temporary closing of the Van Gogh Museum for renovation and expansion for a few months in late 1998 and early 1999. The Los Angeles County Museum of Art eagerly joined the project as the West Coast partner. John Leighton, the present director of the Van Gogh Museum, has been unhesitatingly supportive of this collaborative project, and generous with the masterpieces he has sent across the Atlantic. We express our profound gratitude to him and his staff, and the Van Gogh family and Foundation. The Van Gogh Museum is the most popular tourist destination in Holland, which can only underline the significance and generosity of this loan. A handful of important works from the collection will remain on display at the Rijksmuseum, so that Van Gogh will not be entirely absent from Amsterdam during this period.

The selection of works, made by Mr. Leighton in consultation with Van Gogh Museum curator Louis van Tilborgh and with Philip Conisbee, senior curator of European paintings at the National Gallery of Art, presents a balanced survey of Van Gogh's career as a painter, and includes many of his greatest and most iconic works, as well as paintings that will be less familiar to those who have not made the pilgrimage to Amsterdam. We would like to thank Richard Kendall for providing a fresh and lively account of Van Gogh's art for this catalogue.

The exhibition in Washington is made possible by generous support from Andersen Consulting. The exhibition is supported by an indemnity from the Federal Council on the Arts and the Humanities.

Earl A. Powell III
Director
National Gallery of Art

Graham W. J. Beal
Director and Executive Vice President
Los Angeles County Museum of Art

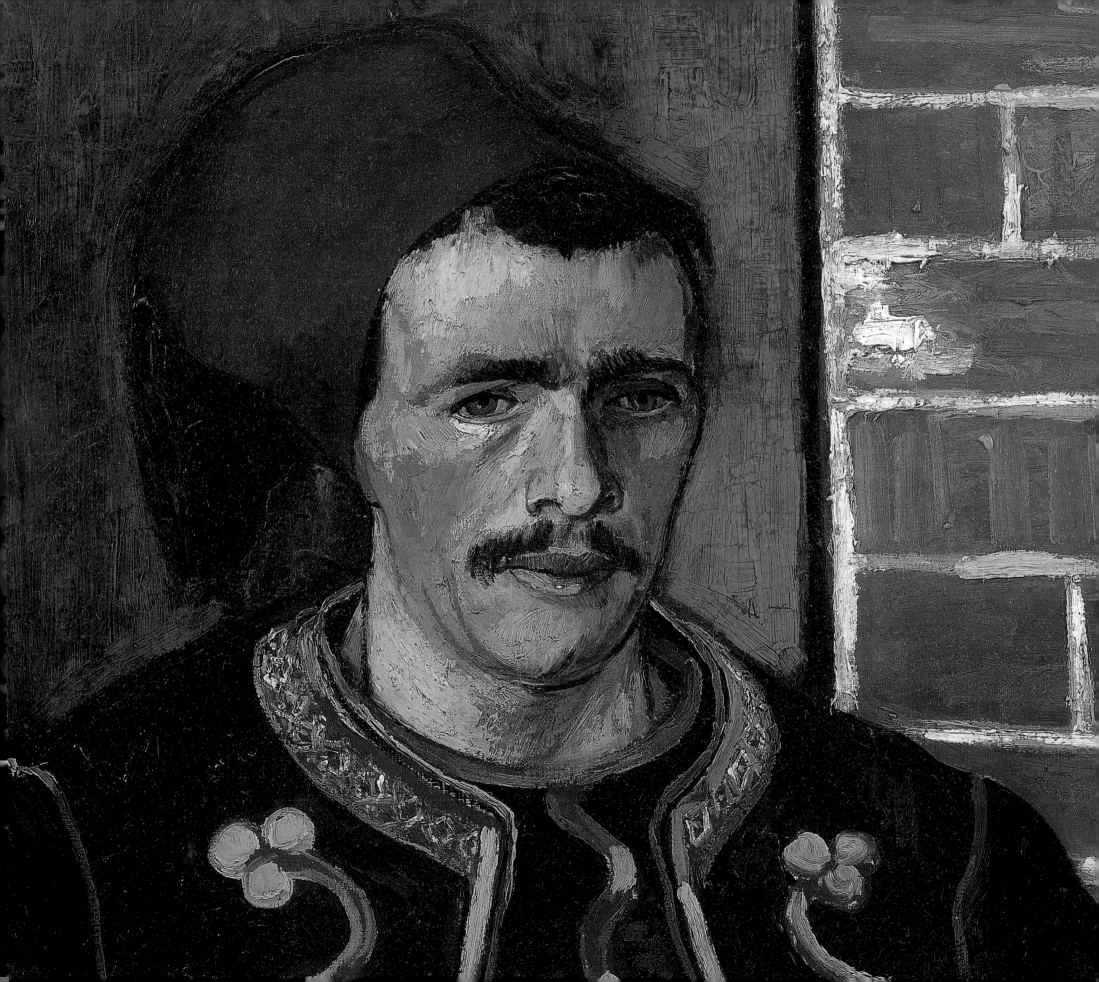

Acknowledgments

We are most grateful to the staff of the Van Gogh Museum, Amsterdam, for their collaboration in this endeavor, in particular John Leighton, director; Ton Boxma, deputy director; Louis van Tilborgh, chief curator; Andreas Blühm, exhibition coordinator; Aly Noordermeer, registrar; Andries Mulder, head of internal affairs; and Cor Krelekamp, head of commercial affairs.

Many individuals on the National Gallery staff have contributed to this exhibition, and we thank especially Philip Conisbee, senior curator of European paintings, Florence E. Coman, assistant curator, French paintings, Kate Haw, former departmental assistant, and Ana Maria Zavala, departmental assistant; D. Dodge Thompson, chief of exhibitions, Ann B. Robertson, exhibition officer, and Jennifer Bumba-Kongo and Jonathan Walz, assistants for exhibition administration; Frances P. Smyth, editor-in-chief, Susan Higman, editor, and Chris Vogel, production manager; Mark Leithauser, chief of design, Donna Kwederis, design coordinator, John Olson, production coordinator, and Deborah Clark-Kirkpatrick, production assistant; Sara Sanders-Buell, museum specialist in imaging and visual services; Susan Arensberg, head of exhibition programs, and Isabelle Dervaux, associate curator of exhibition programs; Sally Freitag, chief registrar, and Michelle Fondas, registrar of exhibitions; David Bull, chairman, painting conservation, and Ann Hoenigswald, conservator; Sandy Masur, chief corporate relations officer, and Chris Myers, deputy corporate relations officer; Deborah Ziska, press and public information officer, and Patricia O'Connell, publicist; Ysabel Lightner, assistant chief and merchandising manager, gallery shops; Marilyn Tebor Shaw, associate general council, and Montrue O'Connor, secretary; and Ann Leven, treasurer, and Nancy Hoffman, assistant to the treasurer for risk management and special projects.

At the Los Angeles County Museum of Art we wish to thank Andrea Rich, president and chief executive officer; Graham W. J. Beal, director and executive vice president; Melody Kanschat, vice president of external affairs; Tom Jacobson, acting director, membership and development; Irene Martin, assistant director, exhibition programs, Leslie Greene Bowman, former assistant director, exhibition programs, Christine Weider Lazzaretto and Beverly C. Sabo, exhibition programs coordinators, and Nancy L. Carcione, former exhibition programs coordinator; J. Patrice Marandel, curator of European painting and sculpture; Renee Montgomery, assistant director, collections management; Chandra King, registrar; Joseph Fronek, senior paintings conservator; Jane Burrell, chief, art museum education; Keith McKeown, assistant vice president, communications and marketing; Cim Castellon, general merchandise manager, museum shop; Deborah Kanter, general counsel; Donald Battjes, chief, operations and facility planning; Art Owens, assistant director, exhibition operations; Jim Drobka, head graphic designer, and Amy McFarland, senior designer; Thomas Frick, associate editor; and Bernard Kester, exhibition designer.

Richard Kendall would like to thank the curators, conservators, researchers, and librarians at the Van Gogh Museum, Amsterdam, who so generously assisted in his study of the collection and answered numerous inquiries; the curatorial and editorial departments of the National Gallery of Art, for their invitation to participate in this project; Bruce Bernard, for sharing his greatly superior knowledge of the artist over many years; and his daughter Ruth, for her patient work in the library.

cat. 49 Detail

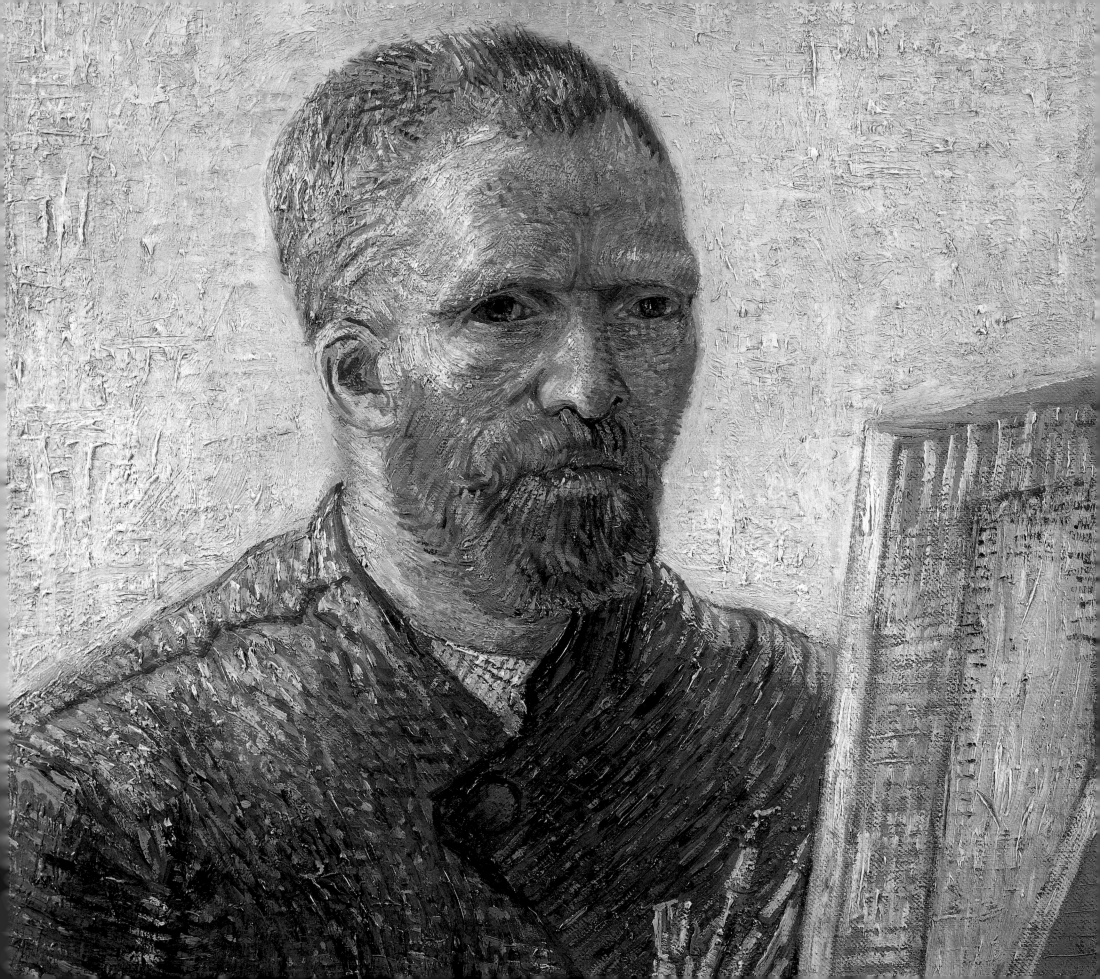

The Van Gogh Museum: A History of the Collection

John Leighton

In the relatively short period since it opened, in 1973, the Van Gogh Museum has become a hugely popular institution. Over the past twenty-five years, millions of people from all over the world have passed through the doors of the compact building that Gerrit Rietveld designed to house the world's largest and most representative collection of works by Vincent van Gogh. A visit to the museum affords the viewer the opportunity to follow almost every turn in Van Gogh's brief career. With more than two hundred paintings, five hundred drawings, and a substantial archive that includes some seven hundred of the artist's letters, the museum is not only a place of pilgrimage for the enthusiast but a seemingly limitless resource for the detailed study of the artist and his era.

The museum may be young but its collection of works by Van Gogh has a much longer history, stretching back to the painter himself and to his brother Theo van Gogh (1857–1891). The story of how this collection first came into being and then survived in its present form is a remarkable one. As one of Theo's grandsons wrote, "its very existence is cause for wonder, for it was utterly worthless when it was created, and in later years there was the ever-present threat that it would be totally dispersed."[1] It is not hard to imagine that the works produced by a virtually unknown and unrecognized painter could easily have been disposed of by those who inherited it. Thanks to the dedication and foresight of Theo and his descen-

dants, the body of work that Vincent left with his family not only became a crucial instrument in the establishment of the artist's posthumous reputation but was kept together in sufficient bulk to provide a permanent survey of his achievements.

VINCENT AND THEO

The origins of the collection lie in Van Gogh's working practices and, in particular, in his dependence on the financial and moral support of his brother Theo (fig. 1). Vincent relied on the money that Theo was able to provide out of his modest income as an employee of the art dealers Boussod et Valadon in Paris. In return, Vincent sent his brother most of his canvases. The painter saw this as a simple business arrangement. He encouraged Theo to put his "best things" to one side and to "consider these pictures as a payment to be deducted from what I owe you. . . ."[2] Vincent's gratitude to his brother is reflected in the way that he regarded his oeuvre as the result of a partnership, while, for his part, Theo was convinced of his older brother's talent. Gradually Theo accumulated large numbers of the canvases so that by the time he married Johanna Bonger in 1889, Vincent's pictures dominated their small Paris apartment. Johanna remembered how these paintings covered the walls and how "huge piles of unframed canvases" occupied every space, "under the bed, under the sofa, under the cupboards. . . ."[3]

Vincent's reluctance to show his work in public may have encouraged this tendency to hoard. Although his pictures could be seen, for example, by visitors to Theo's apartment or, by those in the know, with the dealer Père Tanguy, his work was shown to the wider public on only rare occasions during his lifetime. In Arles he had evolved ambitious plans for a major exhibition, but this optimism and confidence was dispelled by the first outbreak of his illness at the end of 1888, and the scheme was never realized. It is well known that Van Gogh sold only a handful of pictures but ultimately he had become suspicious of any signs of success. He managed to discourage, for example, those few writers who began to show

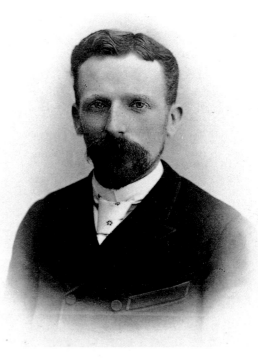

cat. **39** Detail

fig. 1 Theo van Gogh, age thirty-two. Van Gogh Museum archive, b4780 v/1962

a serious interest in his efforts, and he worried about the corrupting influence of early recognition.

During the artist's lifetime, therefore, his work was not widely dispersed, and after Vincent's suicide in July 1890, Theo came into possession of a large and unwieldy collection. A few months later Theo reported despairingly to his mother, "We are still in a terrible mess and don't know where we are going to put all these things."[4] Vincent's death had thrown Theo's life into disarray but amid all the grief and confused emotions one very clear aim emerged. Theo resolved to use his collection to establish his brother's reputation; "people must know that he was a great artist," he declared in a letter to his sister Lies in August 1890.[5] Theo had done relatively little to promote Vincent's work when he was alive. Now, however, he evolved plans for an exhibition with the dealer Durand-Ruel, and he contacted the critic Albert Aurier and Vincent's friend in Auvers-sur-Oise, Dr. Paul Gachet, about writing biographies of the painter. Expressing his hopes for the exhibition Theo told Gachet that "by permitting these masterpieces to go ignored I would hold myself to blame, nor could I ever forgive myself if I did not do everything in my power to try to bring this about,"[6]

The plans for an exhibition with Durand-Ruel did not materialize. Instead Theo invited the artist Emile Bernard to arrange the collection in the apartment to make a more coherent display. Bernard later recalled how he had laid out the pictures:

> When it was finished, the rooms gave the impression of a series of galleries in a museum, because I'd not left a single empty space on the walls. I had taken great care to follow an idea that Vincent had often mentioned in his letters: to make one painting sing by placing it next to another; to place a color scale of yellow next to a scale of blue, a scale of green next to a red, etc. . . .[7]

It had been Theo's wish to present a "good survey" of Vincent's work.[8] Unfortunately, there is scant evidence as to the reactions of those who came to see what was in effect Van Gogh's first retrospective. Bernard recalled that the friends and artists who visited were impressed by the painter's originality and by his merits as a colorist. The Dutch critic Johan de Meester offered a more forlorn account:

> During these cold, short Christmas days, while the crowds took pleasure in crowding around the motley displays of the stalls on the boulevard, there were some Dutchmen assembled in the somber little rooms of a temporarily uninhabited apartment in Montmartre, and there they admired a few hundred paintings. Sad emotions interfered with their enthusiasm; the art treasures which lay and stood together here in the cheerless, cold room were the legacy of an artist, dead too early, . . .[9]

As de Meester went on to report, Theo van Gogh was now seriously ill. His physical and mental health, always fragile, had collapsed. He had a breakdown in September 1890 and the following month he was taken into the hospital. He was brought back to Holland but he died shortly afterward in January 1891, a mere six months after his brother's suicide.

JOHANNA VAN GOGH-BONGER

Responsibility for the stewardship of the collection now passed to Theo's young widow, Johanna. Other members of Vincent's family showed no interest in claiming any of his works. His sisters had already made it clear that they were happy for Theo to take over their share of their brother's estate. After Theo's death this arrangement was formalized when the family signed a legal document ceding their interest in Vincent's pictures to Theo and Johanna's infant son, Vincent Willem (fig. 2). A valuation drawn up in 1891 indicates the scale of the collection but also confirms that it was considered to be almost worthless; two hundred paintings by Van Gogh were given the nominal value of two thousand Dutch guilders.[10]

It has always seemed remarkable that a young woman who had met her brother-in-law on only three occasions should have dedicated the rest of her life to nurturing his reputation. Johanna took over Theo's ambitions

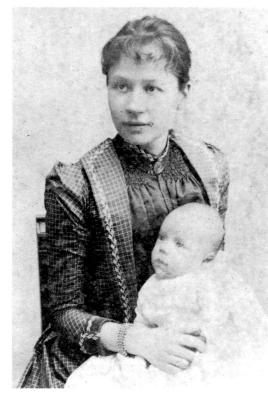

for the collection. With her infant son she moved back to Holland, setting up a small boarding house in Bussum near Amsterdam where Vincent's pictures served as decoration. "It is a beautiful house," she wrote to Bernard back in Paris, "and we will have a roomier place, the baby, the paintings, and myself, than in our apartment in the Cité. . . . Therefore you don't have to fear that the paintings will be put in an attic or a cupboard; the whole house will be decorated with them."[11]

Johanna quickly set about organizing displays of Vincent's work. A series of small touring shows in Holland culminated in an exhibition of 112 works at the Kunstzaal Panorama in Amsterdam in 1892. Other shows were put together in France beginning with a presentation of sixteen works organized by Bernard at Le Barc de Boutteville's gallery in April 1892. Not all of Vincent's former friends rallied to the cause. Gauguin's opposition to the idea of showing Van Gogh's work is now famous. Worried that the public would associate his own art with Vincent's apparent "madness," Gauguin had written to discourage Bernard, describing the idea of showing Vincent's art as "idiotic."[12]

Alongside the effort to show Van Gogh's work in public, Johanna also helped to encourage interest in his correspondence. Initially she seems to have turned to the letters as a form of comfort in her grief for her late husband. Writing to a friend she later recalled, "The first evening that I spent again in our home, I turned to the bundle of letters because I knew that I would meet him in them, and night after night I found solace there for my great misery. . . ."[13] However, as more excerpts from the letters began to be published during the 1890s, their significance became more apparent. As a tool for interpreting Vincent's art, as an expression of the richness of his thought and, of course, as a moving account of his daily struggles, the letters played a crucial role in stimulating interest in his work. Johanna took on the enormous task of sorting the voluminous correspondence into some form of chronological order and eventually, in 1914, she published what might be described as her life's work, a three-volume edition of the artist's letters with, as a preface, a substantial memoir of the artist.

From the time that Vincent's paintings were shown after his death, draped in the black crepe of mourning, and from the moment when commentators began to dwell on the tragedy of his early death, there seemed little chance that the appreciation of Vincent's art could be separated from a fascination with the tragic details of his life. In her memoir of Vincent Johanna carefully projected a degree of objectivity, observing that it would have been unfair to the dead artist "to create interest in his personality before the work, to which he had devoted his life, was recognized and appreciated as it deserved. . . ."[14] Nevertheless, it seems clear that Johanna's attitude to Vincent's art, steeped in grief for her husband and by association his brother, did much to propagate a sentimental approach to Vincent's art. As early as 1892 there was resistance from the artist's admirers with complaints that his art had become "the illustration of his sorrowful life-drama."[15] These were the words of the Dutch symbolist artist Richard Roland-Holst who had helped Johanna to organize the Van Gogh show in Amsterdam in 1892. In the same year he made the following rather disparaging comments about the young widow in a letter to Jan Toorop: "Mrs. Van Gogh is a charming little woman, but it irritates me when someone gushes fanatically on a subject she under-

stands nothing about, and although blinded by sentimentality still thinks she is adopting a strictly critical attitude. It is schoolgirlish twaddle, nothing more."[16]

If Johanna was naive or sentimental in her approach to Vincent's art she displayed considerable determination and some acumen in her business dealings with the art trade. It was Theo who as an art dealer had realized the importance of selling works from the collection in order to promote the artist's reputation. When he told his sister Wil that some pictures had been sold he commented, "We thought it would be a good thing that there were some of them in circulation and so make people talk about him."[17] Johanna continued this sensible policy, and over the years she negotiated sales with various dealers, a process that became simpler as the market for Van Gogh's work developed. It is difficult for anyone now involved with the Van Gogh Museum to ponder these sales without a certain wistful sense of what might have been had the collection remained fully intact. Yet it was obviously of far greater benefit for the artist's reputation that his oeuvre should have been allowed to become widely dispersed and that his works should have found their way into some of the world's most prestigious collections.

From the large archive that covers the early history of the collection it is not easy to get a sense of the factors that determined its present form. It is difficult, for example, to give a clear view of the extent to which it was defined through chance or the whims of the art market and the extent to which it represents a predetermined idea of what should be retained in order to provide a good account of Vincent's achievement. Many of what the artist himself regarded as his most significant works were sold yet there were other works that Johanna steadfastly refused to part with. Among the works that were to be "retained if possible for Holland" were *The Potato Eaters*, *The Harvest*, and the little copies after Millet.[18] When in 1923 the director of the Tate Gallery in London was trying to buy a famous version of *Sunflowers* Johanna replied, "The Sunflowers are not for sale, never; they belong in our family, like Vincent's bedroom and his house at Arles." In the face of persistent appeals Johanna finally relented, albeit reluctantly: "I felt as if I could not bear to separate from the picture I had looked on every day for more than thirty years. . . . it is a sacrifice for the sake of Vincent's glory."[19]

By the time of her death in 1925 sales from the collection had slowed to a trickle. What remained contains both wheat and chaff, or perhaps more accurately, pictures that Vincent himself treasured, such as *The Harvest*, alongside more experimental compositions and studies. Yet it seems very likely that Johanna had a firm idea of what to keep in the family's possession and that this core collection reflected more than just a general wish to retain a souvenir of her first husband. Johanna presumably remembered Theo's ideas about Vincent's art and which works he would have regarded as essential milestones. It seems reasonable to suggest that with its fine ensembles of work from all periods, punctuated by major masterpieces, the collection that Johanna passed on to her son represents in some way her idea of what Theo himself would have regarded as a "good survey" of Van Gogh's art.[20]

VINCENT WILLEM VAN GOGH: "THE ENGINEER"

In 1921 Johanna wrote in a letter to Paul Gachet junior that her son Vincent Willem shared her interest in what she described as the "culte du souvenir" of Theo and Vincent.[21] Yet when Vincent Willem took over the collection after his mother's death in 1925 he seems to have been somewhat diffident about his new curatorial responsibilities. By now Van Gogh was known as a famous artist, and his status as one of the key painters of the last century was secure. His young nephew was eager to forge his own identity without living off his famous uncle's name. He was suspicious both of his mother's indiscriminate veneration of the painter and her vague aestheticism. Much later he recalled: "At home it was rapture, rapture all the time, with no attempt to justify oneself. I was never taught how to understand art. . . . I respected it, but regarded it as a sort of sorcery that was not for me."[22]

Vincent Willem had already resolved to occupy himself with "more concrete matters

and work in society." After training as a mechanical engineer he spent some years in France, the United States, and Japan before returning in 1920 to Holland, where he established a career as a consulting engineer. When they were requested pictures were lent to exhibitions, but apart from a small number of works that decorated his home, the Van Gogh paintings were kept out of sight in an improvised store. Eventually the problem of allowing public access to the pictures was solved when after a successful exhibition of Van Gogh at the Stedelijk Museum in Amsterdam in 1930 Vincent Willem agreed to place the collection on loan at that institution. Since then the collection of paintings has remained more or less continuously on view for the public.

In the period after the Second World War, "the Engineer," as he became popularly known, became much more actively involved with the collection. Numerous exhibitions drawn from the collection were organized around the world, and frequent lectures were given by Vincent Willem in which he expounded on his ideas of the significance of art for the general public. He remained wary of his own sentimental attachment to Vincent's art, warning an audience in Washington, D.C., in 1964, that on its own, emotion "leads us nowhere."[23] Ultimately, however, he seems to have come round to his mother's notion of the "culte du souvenir," seeing himself as the upholder of a tradition established by his parents.

The idea of founding a museum to house the collection emerged in the 1950s. Various locations were considered, including the Kröller-Müller Museum at Otterlo and the artist's hometown of Zundert in North Brabant. However, this issue was not resolved until the Engineer's later years. In 1962 the collection was purchased by the newly formed Vincent van Gogh Foundation with funds provided by the Dutch state. Construction of a new museum beside the Stedelijk Museum in Amsterdam began in 1969 and the Rijksmuseum Vincent van Gogh opened officially on 2 June 1973 (fig. 3). As a permanent loan from the Vincent van Gogh Foundation to the Van Gogh Museum, the collection had found its home.

THE VAN GOGH MUSEUM

The original commission to design the new museum was awarded to Gerrit Rietveld, a leading exponent of the De Stijl movement. Rietveld died shortly afterward, having made only a few sketches, and the execution of the definitive designs fell to his successors, J. van Dillen and J. van Tricht. The resulting building, clad in gray, concrete blocks, is somewhat forbidding from the outside (fig. 4). The interior, however, is spacious and radiates with as much natural light as today's norms for museum presentation will allow. The Engineer, who played a key role in the development of the plans, was an admirer of Frank Lloyd Wright's Guggenheim Museum in New York. While the comparison might seem pretentious, the interior of the Van Gogh Museum evokes something of the Guggenheim's spectacular atrium in the open-plan arrangement of the floors around a central, light-filled void.

The Engineer's original idea was to match the collection to the architecture with Van Gogh's darker, Dutch period works on the ground floor and the more colorful canvases on the upper floors nearer the skylights. Now, however, a selection of Van Gogh's works is arranged in chronological order on the first floor in a presentation that allows a very clear view of the main phases of the artist's career. To the occasional surprise of some visitors Van Gogh is not shown in isolation but alongside works by his predecessors and contemporaries. Many of these works were collected by Vincent

and Theo and many of them were acquired through exchange with their artist friends. Famous names such as Gauguin and Toulouse-Lautrec appear with lesser talents such as Charles Laval or Bernard, all of whom formed part of the Van Gogh brothers' circle of contacts.

In recent years the collection has been further expanded through loans and acquisitions, and today the museum aspires to be a gallery of nineteenth-century art for the Netherlands. The core collection of Van Gogh is supplemented by displays of realist art and impressionism. Displays of Salon art and symbolist artists provide part of this rich overview, which is now complemented by a small but growing collection of sculpture. Temporary exhibitions play a prominent role in this program. Numerous shows devoted to Vincent and his context have been mounted, but there have also been exhibitions covering a wide range of subjects in nineteenth-century art. The museum has also expanded its role as a center for study and research. The archive is a primary resource for research on Van Gogh and the museum has developed a reputation for high-quality scholarly publications.

The Van Gogh Museum was built to accommodate an average of eighty thousand visitors a year. Twenty-five years ago it must have been difficult to envision just how popular the museum would become; last year alone attendance exceeded one million visitors. In order to better serve this level of demand, a new wing is now being built next to the exist-

ing building. Designed by the Japanese architect Kisho Kurokawa, this elegant new pavilion consists of three floors that will be used to house temporary exhibitions (fig. 5). The existing building closed this year for a complete renovation. Structural improvements will be carried out, the technical installations will be replaced, and a whole range of facilities will be renewed or upgraded. Both the refurbished Rietveld building and the new wing will open in May 1999 to offer what in effect will be a new museum.

The first exhibition in the new wing will be devoted to Theo van Gogh. The show will present the story of Theo's activities as a dealer, a collector, and, of course, as a supporter of Vincent. The Van Gogh Museum is set to enter a new phase in its history but it seems appropriate that we should launch our new program with a tribute to the very first custodian of this world-famous collection.

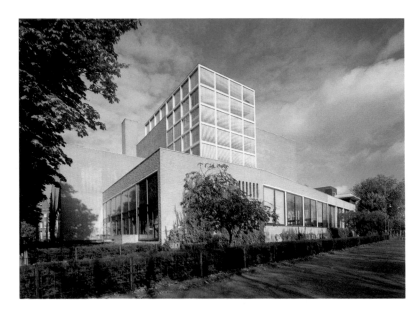

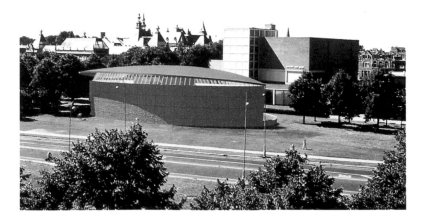

fig. 4 The Van Gogh Museum, Amsterdam, as seen from the Museumplein (photo Luuk Kramer)

fig. 5 Computer-generated image of Kisho Kurokawa's design for the new exhibition wing of the Van Gogh Museum

Notes

1. Johan van Gogh, "The History of the Collection," in *The Rijksmuseum Vincent van Gogh*, ed. Evert van Uitert (Amsterdam, 1987), 1. For further details about the history of the Van Gogh Museum see also Ronald de Leeuw, "Introduction: The Van Gogh Museum as a National Museum 1973–1994," *Van Gogh Museum Journal* (1995), 9–23.

2. *The Complete Letters of Vincent van Gogh*, introduction by Vincent Willem van Gogh; preface and memoir by Johanna van Gogh-Bonger, 3 vols. (London and New York, 1958), letter 485, Vincent to Theo, 10 May 1888.

3. Johanna van Gogh-Bonger in *Letters*, LI.

4. Letter from Theo to his mother, 16 September 1890, Van Gogh Museum archive, b938 v/1962; see also Jan Hulsker, *Vincent and Theo van Gogh: A Dual Biography* (Ann Arbor, 1990), 450.

5. Theo to Lies, 5 August 1890, present whereabouts of letter unknown, cited in E. H. du Quesne-van Gogh, *Vincent van Gogh: Persoonlijke herinneringen aangaande een kunstenaar* (Baarn, 1910), 96.

6. Theo to Gachet, 12 September 1890, Van Gogh Museum archive, b2015 v/1982, cited in Susan Alyson Stein, *Van Gogh: A Retrospective* (New York, 1986), 235.

7. Emile Bernard, "Lettres de Vincent van Gogh à Emile Bernard," 1911, cited in Stein 1986, 238.

8. Theo to Bernard, 18 September 1890, cited in *Verzamelde brieven van Vincent van Gogh* (Amsterdam, 1954), letter T56, 317.

9. Johan de Meester, "Vincent van Gogh," *Algemeen Handelsblad* 31 (December, 1890), cited in Stein 1986, 246.

10. See Johan van Gogh in van Uitert 1987, 3.

11. Hulsker 1990, 456.

12. Gauguin to Bernard, January 1891, cited in Stein 1986, 240.

13. Cited in John Rewald, "The Posthumous Fate of Vincent van Gogh 1890–1970," in *Studies in Post-Impressionism* (London, 1986), 244.

14. Johanna van Gogh-Bonger in *Letters*, XIII.

15. Cited in Stein 1986, 286.

16. Gerald van Bronkhorst, "Vincent Willem van Gogh and the Van Gogh Museum's Pre-History," *Van Gogh Museum Journal* (1995), 26.

17. Theo to Wil, 27 September 1890, Van Gogh Museum archive, b2055 v/1982.

18. The dealer Oliver Brown quoting Vincent Willem van Gogh; see Rewald 1986, 249.

19. John House, *Impressionism for England: Samuel Courtauld as Patron and Collector* [exh. cat., Courtauld Institute Galleries] (London, 1994), 13–14.

20. This suggestion comes from Louis van Tilborgh, who will explore this idea further in his forthcoming catalogue of the paintings collection of the Van Gogh Museum.

21. Letter from Johanna to Paul Gachet, 19 January 1921, Van Gogh Museum archive, b1516 v/1962.

22. Van Bronkhorst 1995, 26.

23. Van Gogh Museum archive, b6537 v/1996.

Evangelism by Other Means: Van Gogh as a Painter

Richard Kendall

"What I want and aim at is confoundedly difficult, and yet I do not think I aim too high. I want to do drawings which touch *some people"*
(VAN GOGH, IN A LETTER TO HIS BROTHER, 1882)[1]

Van Gogh's ambition to make pictures that would "touch" those around him dates from the very beginning of his career as an artist, yet was to remain central to his motivation and his working practice until the end. In later life he might phrase it differently—speaking of his wish to "express" himself, for example, or to produce paintings that would "teach" or transmit "feeling" to his contemporaries. But the sense that works of art could give form to his private experience, which in turn might be communicated directly and forcibly to others, was never to waver and has in our day become central to his extraordinary legend. So potent is this idea that Van Gogh's art is often seen as exemplary, as a model for all creative activity throughout our culture. If such a notion hardly stands up to the facts of history—Paul Cézanne, for instance, was largely hostile to the attentions of his peers, and both Edgar Degas and Camille Pissarro stressed that their canvases were appreciated by just two or three friends—its importance for our understanding of Van Gogh can hardly be overestimated. With few painters are the events of their personal history so frankly laid out before us and with few individuals—whether artists or not—

is the appeal for our involvement so heartfelt and so insistent.

In the same letter of 1882, Van Gogh went on to describe a drawing entitled *Sorrow* (fig. 1) and a group of landscape studies he had just completed, claiming, "There is at least something from my own heart in them. What I want to express, in both figure and landscape, isn't anything sentimental or melancholy, but deep anguish. In short, I want to get to the point where people say of my work: that man feels deeply, that man feels keenly." This concern to project the more somber aspects of his emotional life was by no means the only drive behind Van Gogh's art; other pictures were described as attempts to present his exhilaration or the sense of calm he experienced in front of nature. But the implication that all these projects required protracted effort, that his vocation was "confoundedly difficult" and demanded all his powers of concentration and intelligence, is another key to Van Gogh's achievement. Far from being the impetuous, mentally unstable painter of myth, for all but a few months of his working life Van Gogh could be numbered among the most industrious artists of his generation, as well as the most articulate. In more than 750 surviving letters, the majority written to his brother Theo and many of considerable length and complexity, Van Gogh left a record of lucid self-examination as both painter and human being that is among the most moving testimonies of its kind. Here we meet an individ-

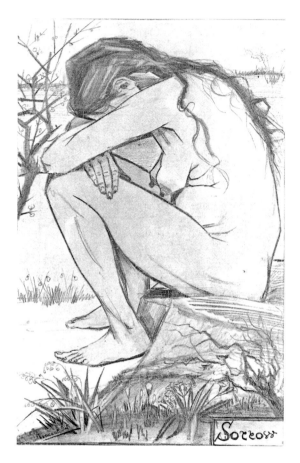

ual of pronounced intellectual tastes: the Dutchman who spoke and wrote fluent English and French; who was at home with the works of Shakespeare, George Eliot and Charles Dickens, Honoré de Balzac, Gustave Flaubert, and Emile Zola; and whose knowledge of art ranged from painters celebrated to obscure, from his own century and culture to those of the past and of remote lands. Here, above all, is the man of reason, systematically building up the resources of his own art and—generally in tranquillity—preparing to share

his feelings and perceptions with the world at large.

The now celebrated drawing *Sorrow* brings together many of the factors that proved decisive for Van Gogh's early art. It is emphatically a study of the human body, a subject he had begun to address seriously the previous year and which already seemed to offer the ultimate challenge to his skills ("More and more . . . I am becoming interested in the figure," he wrote a few months later, explaining to Theo that it "touches us as human beings more directly and personally than meadows and clouds").[2] Characteristically, *Sorrow* also represents an individual oppressed by circumstance and overcome with an emotion that is both commonplace and universal. Here the nakedness of the figure is atypical of Van Gogh's art and her dejection unusually specific, but this is one of many cases in which the artist's letters shed light on the peculiarities of his image. The model, according to correspondence with Theo and others, was Sien Hoornik, an alcoholic prostitute with whom Van Gogh shared his life and his modest quarters during much of his time in The Hague. Though their relationship was complex, Sien and her children appear to have posed for the artist as part of their domestic understanding, resulting in dozens of varied drawings and paintings of unambiguous tenderness.

Most of Van Gogh's youthful figure drawings show men, women, and children laboring in the fields or working in the grim soli-

tude of their houses, their faces resigned and their bodies distorted by age or malnourishment. Such qualities were typically rendered in monochrome, whether the granular crayon of *Sorrow* or the range of pencil, charcoal, and pen-and-ink strokes, sometimes touched with watercolor, that so effectively evoked the despair of his sitters. As the artist makes clear in the letters of this period, both technique and subject were deeply affected by his passion for graphic art of all kinds, from the etchings and engravings he had encountered as an apprentice picture dealer in Paris and London to the magazine illustrations he still collected with almost childlike enthusiasm. Principal among these were the wood engravings by a number of English artists who concerned themselves with the social issues of the day, appearing in such publications as the *Graphic* and *London News*, though Van Gogh also acquired copies of periodicals like the French *L'Illustration* and the American *Harper's*. Cutting out and preserving the scenes that moved him, among them Hubert von Herkomer's *Low Lodging House, Saint Giles'* (fig. 2), Van Gogh learned much about economy of line and the expressive power of tone, effectively laying the foundation for his first truly distinctive works of art.

In a more general sense, the period when *Sorrow* was made was also that of Van Gogh's establishment as an independent, if still timid and largely untrained, full-time artist. After several turbulent years as an art dealer, school teacher, bookshop assistant, theology student,

and lay preacher to the poor, he had again left the family home in Etten and moved in January 1882 to a modest studio in The Hague. His relations with his parents remained uneasy, especially with his pastor father who struggled to understand Van Gogh's unorthodox vocation and way of life. The artist himself had formerly experienced a phase of intense religious fervor, but now turned almost as passionately against the church and to a quite different kind of evangelism: the production of drawn and painted images of the poor and underprivileged. Already twenty-eight years of age, Van Gogh took on the challenge of the city, drawing its backyards and industrial wastelands, its populace of coal carriers and road menders, queues at soup kitchens, and work-

fig. 2 Hubert von Herkomer, *Low Lodging House, Saint Giles'*, from *Graphic*, wood engraving. Van Gogh Museum, Amsterdam (Vincent van Gogh Foundation)

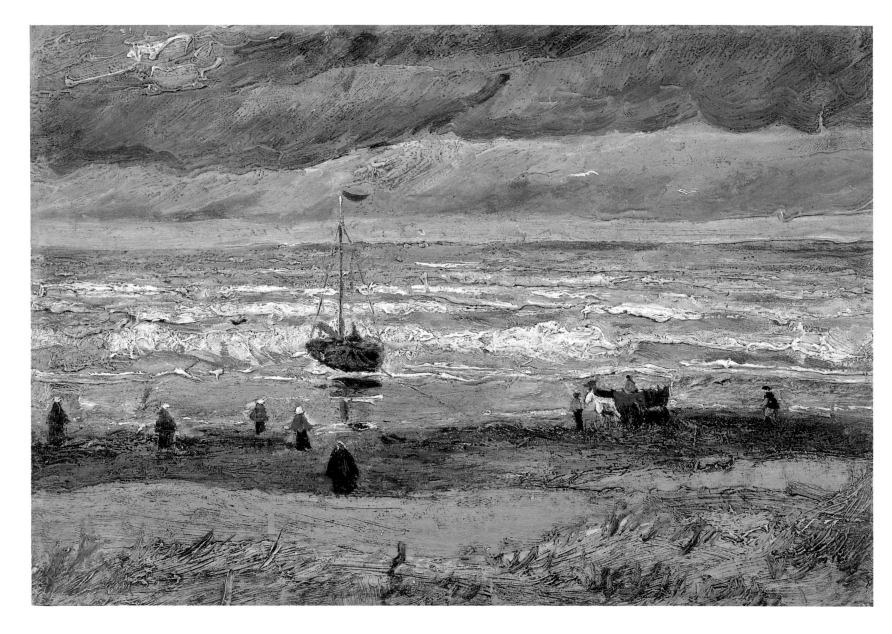

cat. 1 *Scheveningen Beach in Stormy Weather*, August 1882

house residents. During these same months Van Gogh underwent informal instruction from his relative Anton Mauve, an established artist who lent him money and initiated him into the technique of oil painting. Though still conscious of his limitations, Van Gogh began to speak with greater assurance of his skills ("some power to draw—and I think to paint also—is in me," he wrote Theo in a letter of 14 May)[3] and even to consider the possibility of sales of his work and future exhibitions. As

part of this new mood, he carefully parceled up *Sorrow* and sent it to Theo, now working for the art dealer Goupil's in Paris, announcing it as "in my opinion . . . the best figure I have drawn yet."[4]

Looking beyond the urban spectacle, Van Gogh soon discovered another subject that allowed him to combine his concern for the human condition with his other great passion: the landscape. At the nearby coastal village of Scheveningen, he began to study the harsh life

of the fishermen and their families, making pen-and-ink studies of their huddled bodies as they waited for boats to return and sketches of deserted dunes and bleak beaches. It was here, also, that he carried out some of his first private experiments with oil paint, in pictures that curiously prefigure the successes and frustrations of his subsequent encounters with the medium. When executing such works as *Scheveningen Beach in Stormy Weather* (cat. 1), for example, Van Gogh chose to paint directly

from the windswept vista, planting his easel in the sand and battling with the unpredictable summer weather. The resulting sense of immediacy is unmistakable, though the picture still bears the marks of its rough beginnings; flying sand became attached to the wet paint and it had to be partly reworked at a local inn, while subsequent attempts at conservation may have further modified its appearance. For a virtual beginner, however, the picture is surprisingly bold in conception and execution, its division into broad horizontal bands of sky, sea, and shore suggesting the thunderous conjunction of the elements and the somber rhythms of the scene. Most remarkable of all is the density of the paint itself in this relatively small composition, as if the artist were straining to express his response to the spectacle by piling on more and more color, even modeling it with his brushes to create texture and relief. At the opposite extreme to the cautious approach of most amateurs, this physical contact with the substance of paint greatly excited Van Gogh; "Painting comes easier to me than I imagined," he wrote on 20 August and, a few days later, "I know for sure that I have an instinct for color and . . . that painting is in the marrow of my bones."[5]

In other hands, a subject like *Scheveningen Beach in Stormy Weather* might have become a mere sketch of light and atmosphere, but—even at this date—Van Gogh has transformed it into an image of human vulnerability. Tiny figures of fishermen and their white-bonneted wives are set against mountainous waves, while the boat poised at the edge of the swell seems fragile rather than picturesque. This image of nature as both productive and potentially overwhelming had a special significance for the Dutch nation, finding expression in the work of such seventeenth-century landscapists as Aelbert Cuyp and Jacob van Ruisdael and painters of the sea like Jan van de Cappelle and Jan van Goyen, many of whom Van Gogh is known to have admired. A number of his senior contemporaries continued the tradition, notably members of the Hague school like Hendrik Willem Mesdag, Johannes Hendrik Weissenbruch, and Jacob Maris who had preceded Van Gogh as painters of empty dunes and darkly huddled boats. Pictures such as *Scheveningen Beach in Stormy Weather* are a modest homage to this example, reflecting Van Gogh's respect for his painterly heritage and his increasing familiarity with the personalities of Dutch art. Apart from sporadic contact with Mauve, he had already embarked on an important if short-lived friendship with Anthon van Rappard, a slightly younger painter based in Utrecht with a similar reverence for the past and a commitment to contemporary working-class themes. In their extant correspondence, dated between 1881 and 1884, the two artists shared their aspirations and criticized each other's work, with Van Gogh cautiously discouraging his colleague's leaning toward French painting: "you as a Dutchman will feel most at home in the Dutch intellec-tual climate. . . . we must never forget that we have our roots in the Dutch soil."[6]

For the next three or four years, Van Gogh was to identify himself fiercely with "Dutch soil" and with those who earned their living from it. Not only did he disregard the cosmopolitan ways of the larger cities he visited, but actively sought out the customs, the traditional characters, and the ways of rural life that survived from a simpler, preindustrial past. It was partly to immerse himself in such experiences that he decided to leave his lodgings in The Hague and bring to an end his difficult and compromising relationship with Sien and her children, leaving for the bleak rural region of Drenthe, some seventy-five miles northeast of Amsterdam, late in 1883. Both Mauve and Van Rappard had already worked in the area, and Van Gogh was soon sharing their engagement with the open skies, dark earth, and almost primitive way of life of its sparse population. He composed eloquent word pictures of what he encountered; "imagine a wide muddy road," he told Theo, "all black mud, with an infinity to the right and an endless heath to the left, a few black triangular silhouettes of sod-built huts, through the little windows of which shines the red light of the little fire, with a few pools of dirty, yellowish water that reflect the sky. . . ."[7] Though he found the isolation oppressive and completed few paintings before leaving the region, his study *Farmhouses near Hoogeveen* (cat. 2) captures both the sobriety and the comatose stillness of the wintry scene.

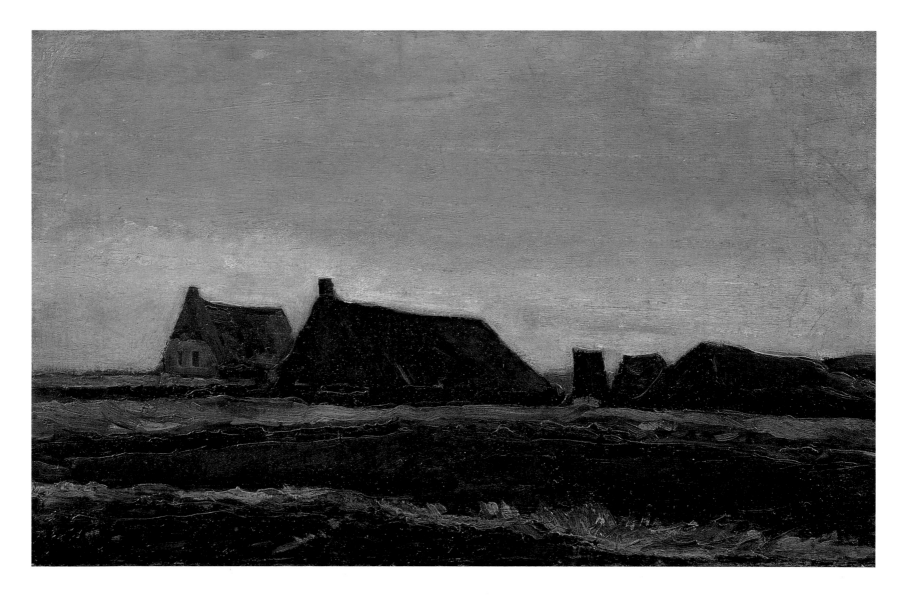

Houses like these were literally made of earth and—as with his picture of Scheveningen—Van Gogh contrived to embody something of his subject in the qualities of the paint itself, here evoking clay, damp thatch, and watery pasture in his dense impasto. The composition is similarly expressive of the theme, its massive horizontals establishing a momentum that the few vertical and diagonal accents seem powerless to counteract.

Van Gogh's concern to use his art to reach out to those around him was increasingly caught up in matters of technique. Aware of his lack of academic training, he made several attempts to submit himself to disciplined instruction, but invariably felt cramped or oppressed by his teachers or by the conventions of nineteenth-century art education. The truly

formative element of these years lay elsewhere, in Van Gogh's private dedication to the act of drawing. Drawing was a relatively cheap and portable procedure that put him on the same footing as the great artists of the past, as well as the most celebrated and humble colleagues of the present. In his letters he told Van Rappard excitedly about drawings he had seen ("Have I written to you about Lhermitte?" he asked, "he seems to be the Master of Black and White drawing")[8] and described his experiments with chalk, charcoal, and ink, often including sketches to illustrate implements and effects of hatching or tone. When he left Drenthe, another long period of residence with his parents resulted in a series of drawn studies of the country around their house that ranks with his finest early achievements. His father was now the pastor at Nuenen, near Eindhoven on the Belgian border, where a wealth of pastoral and agricultural subjects encouraged the artist into more ambitious studies of atmosphere and effects of light. A work such as *Pollard Birches with Woman and Flock of Sheep* (fig. 3)—surely among the great landscape drawings of the nineteenth century—shows both the acquired discipline of the artist and his meticulous absorption in this commonplace scene. Carefully planning his composition in pencil but refining it with a dazzling variety of pen strokes, Van Gogh's lines and hatchings carry us across the foreground stubble, around the curved trunks, under the gnarled branches of the trees, and then into the hazy distance,

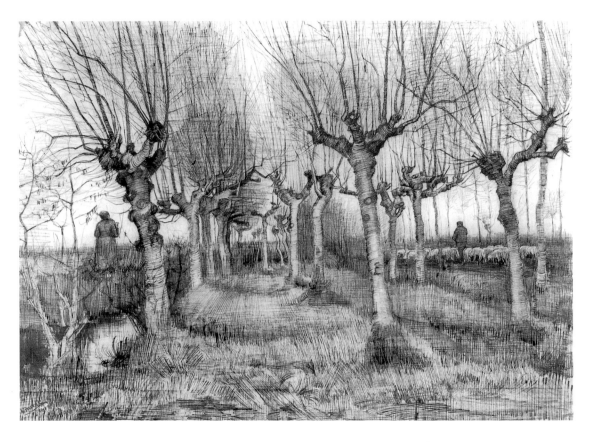

fig. 3 *Pollard Birches with Woman and Flock of Sheep*, 1884, pencil and pen. Van Gogh Museum, Amsterdam (Vincent van Gogh Foundation)

seemingly without effort but, in reality, with all the command of a master practitioner.

Even at this early date, however, Van Gogh had learned to be deeply suspicious of refinement in works of art, finding it unsympathetic to his own temperament and suggestive of insincerity in others. As he turned his attention to oil painting, he spoke dismissively of the seductive "tricks of the studio,"[9] telling Van Rappard that the institutional artists of the day "aren't worth a cent"[10] and mocking the merely "clever" qualities of their pictures; "where is

their sentiment, their human feeling?" he asked.[11] For Van Gogh, the material processes of painting were a means to an end, a range of techniques that must be mastered "only insofar as I want to say what I have to say."[12] In drawings like *Pollard Birches with Woman and Flock of Sheep*, he leaves no doubt about his command of composition and line, his powers of observation, and the management of space. But he has already realized that the communication he sought so desperately might involve the "intentional neglect of those details"

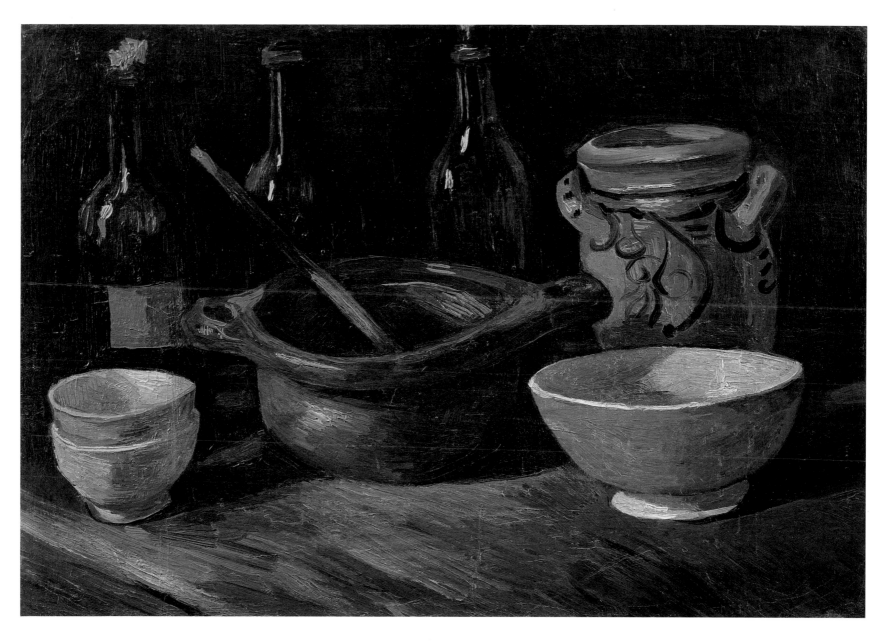

cat. 3 *Still Life with Earthenware and Bottles*, September–October 1885

that were not essential,[13] even a willful uncouthness that would set his work apart from that of his peers. Asserting that "sincerity" and "expressive force" were paramount, he admired Van Rappard's brushwork not for its slickness but because it was "personal, characteristic, accounted for, and *willed*";[14] in a memorable phrase, he urged his friend, "let our work be so savant that it *seems* naive and does not stink of our sapience."[15]

This determination to avoid the affectation of the art he saw around him was a determining factor in Van Gogh's early years. As a young art dealer in the 1870s, as a visitor to galleries and exhibitions in Paris, The Hague, Amsterdam, and elsewhere, and as a visitor to the studios of a number of Dutch painters, he had developed an informed awareness of contemporary picture making and the skills it involved. If he still acknowledged his deficiencies in cer-

tain of these areas, Van Gogh also understood that his own way forward lay elsewhere. In this important sense, his first paintings are not the failed attempts of a beginner who hoped to emulate the achievements of his superiors, but a series of more or less successful explorations of his own individuality. For all its restraint, *Still Life with Earthenware and Bottles* of 1885 (cat. 3) can be seen as an act of painterly defiance, an exercise in oil on canvas that refuses

the easy options and asserts the artist's uncompromising loyalties. Choosing the coarsest of everyday jars, bowls, and bottles, Van Gogh has stressed their uneven surfaces, their misshapen forms, and their near-arbitrary arrangement on a worn, shadowy tabletop, rejecting out of hand the bravura display of the traditional still-life painter. When he began his apprenticeship with Mauve, Van Gogh had been required to paint several groups of household objects of this kind, in the traditional introduction of the student to the fundamental qualities of tone, color, and pictorial space. Four years later, when he completed *Still Life with Earthenware and Bottles,* he was sufficiently confident to instruct a number of amateurs from Eindhoven in the same way, working alongside them and producing more than a dozen such canvases in a few weeks. But these apparently straightforward works demonstrate that Van Gogh was incapable of approaching any pictorial challenge in an entirely objective fashion; even an unpromising clutter of old earthenware could become a statement of belief, a cry for attention.

It is against this background of intensive self-education and attachment to ordinary experience that Van Gogh's preparations for his first large-scale composition, *The Potato Eaters* (cat. 6), must be seen. Living uneasily with his parents in the vicarage at Nuenen, he was now firmly committed to a career as a painter and conscious of the need to make his way in the world, both as an adult and an independent artist. Though he had openly rejected the "bourgeois" ways of the family home and now dressed and behaved like the peasants he admired, Van Gogh was still reliant on the hospitality of his long-suffering mother, father, and sisters, as well as a small allowance from his brother Theo. Attempts to promote himself locally had resulted in a few modest sales of drawings and a commission for a set of decorative panels, but Van Gogh had already set his sights on higher things. Letters to Paris kept Theo informed of his latest projects, and parcels of drawings and the occasional canvas were regularly entrusted to the post. For a time, relations with his brother cooled when Van Gogh accused him of not trying hard enough to interest his fellow dealers in the Nuenen pictures, but gradually the artist understood that his best hope lay in painting a large, distinctive canvas for submission to the annual Salon exhibition in the French capital. With this in mind, much of the winter of 1884 and early spring of 1885 was devoted to studies for a still undefined composition, designed to launch this "painter of peasant life," as he called himself in a letter written in April, into the wider artistic world.

Rather surprisingly, the earliest conception for *The Potato Eaters* seems to have been of a daylight scene, with a group of figures posed against a small, high, brightly illuminated window. In a rapid oil sketch of 1885, *Woman Sewing* (cat. 4), Van Gogh examined this possibility, placing the rectangle of sunshine centrally in the picture so that it surrounds and almost obliterates the features of the seated housewife. By contrast, her hands and dress are picked out by the light, but the result is strangely disconcerting, as if the woman's menial activity is of more importance than the personality registered in her face. The device of the central head is repeated in *Woman Winding Yarn* (cat. 5), now brought to life by a concealed window at the left that becomes more visible in a preparatory drawing. In this picture, Van Gogh has varied the empty, rectilinear surroundings of *Woman Sewing* by allowing the daylight to fall on the yarn-winding frame and by tilting the chair away from the vertical. Still hasty in execution, *Woman Winding Yarn* is more believable as a study in purposeful movement and more dynamic as a design, though the blue-black gloom of the interior seems about to engulf the entire cottage and its contents. Other drawings and paintings from these months reveal peasant men, women, and children posed against the darkness, their faces shown frontally or in stark profile, lit by an open door or by the glow of a fire as they pursue their simple tasks. Committed to his setting but still uncertain of his subject, Van Gogh made pictures of figures making baskets and sweeping the floor, darning socks and knitting, and dozens of individuals peeling, cooking, and eating their principal crop, potatoes.

In assembling these studies, Van Gogh was self-consciously adopting an established pro-

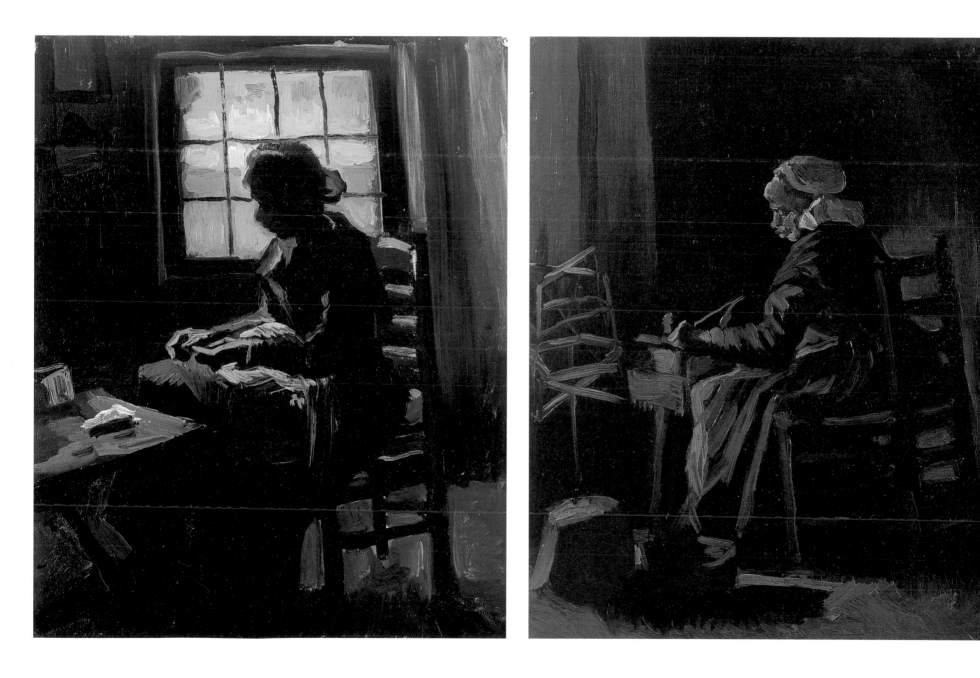

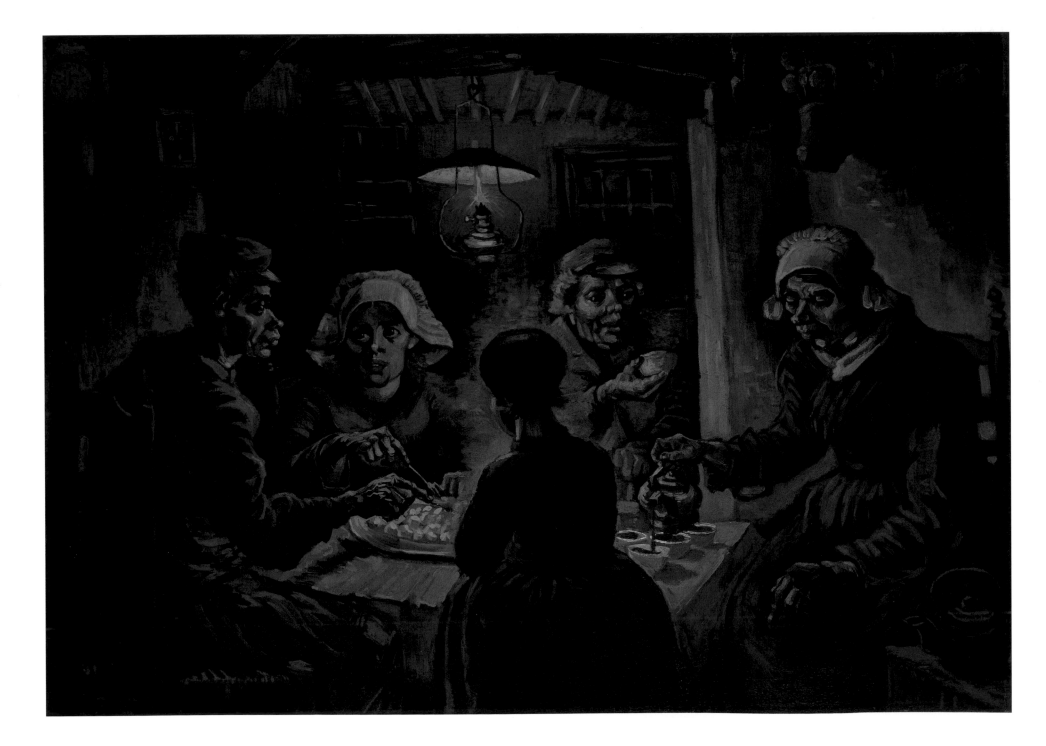

cedure for making a major work of art. As a painter became familiar with the separate components of his theme, he would make improvised sketches of the complete composition, first as drawings and then as reduced-scale experiments in tonal structure and color harmony. Early in the progress of *The Potato Eaters*, Van Gogh abandoned the diffuse effects of daylight in favor of a suspended oil lamp and a darkened room, choosing the elemental rituals of a meal to unify his group of protagonists. Following the similar arrangement of early canvases such as *Still Life with Earthenware and Bottles*, a stubborn near-symmetry continued to dominate the scene, seeming both haphazard and friezelike, even monumental, in its echoes of such biblical subjects as the *Supper at Emmaus* and the *Last Supper*. Other, more recent parallels have been suggested, from engravings in illustrated newspapers to paintings by artists known to Van Gogh—such as Charles de Groux and Jozef Israëls—all showing families at table in humble interiors. In many senses, therefore, *The Potato Eaters* aspired to become a heroic work for its own materialistic age, confronting the secular rites of a society where faith has been marginalized (a dimly perceived Crucifixion at top left appears to underline this point). For every resonance of the Bible, however, there are a dozen from other sources and traditions that haunted Van Gogh's imagination. At one extreme, he was paying homage to the dramatic manipulation of light and shadow of Rembrandt, on

the other to the vivid evocation of human types by the English illustrators, by Honoré Daumier, and, above all, by Jean-François Millet.

Some of the first drawings executed by Van Gogh at the beginning of the decade had been laborious pencil copies of works by Millet, notably after *Reaper with Sickle* and *The Sower*. For much of Van Gogh's later career, Millet was to fulfill the role of artistic father figure, his moral authority effectively replacing that of Van Gogh's natural parent (who died suddenly in 1885), and his canvases offering a model the young painter was proud to emulate. Millet had become a dominant presence in mid-nineteenth-century French realism, an artist of peasant stock who earned the respect of an entire generation with his paintings of the agricultural landscape, his quasi-religious rural subjects like *The Angelus*, and his powerful prints and drawings of weary laborers. Van Gogh knew his pictures largely in reproduction, but certain iconic images and their perceived significance were to pervade his own painterly vocabulary (in Arles in 1888, he wrote of his "longing for the infinite, of which the sower, the sheaf are the symbols").[16] On visits to both Scheveningen and Drenthe, Van Gogh found that the countryside recalled the work of his great predecessor (at the former, he wrote of nature "as strikingly gloomy and serious as the most beautiful Millet . . ."),[17] and as late as 1889 he embarked on a cycle of reworkings of Millet's themes, among them *Wheatfield with a Reaper* (cat. 58) and *The Sower*

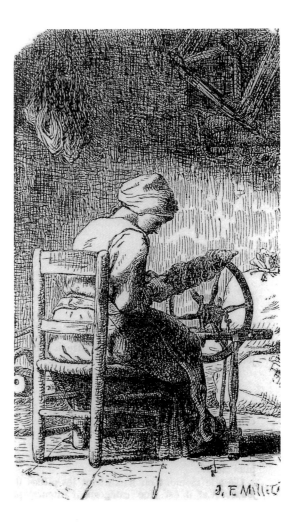

(fig. 36). In 1882, illustrations of works by Millet hung in his room at The Hague, alongside prints after Hubert von Herkomer and Rembrandt, while certain compositions by Millet undoubtedly lay behind the studies for *The Potato Eaters* and related works. Set beside the etching from Millet's picture of a young girl spinning (fig. 4), Van Gogh's *Woman Winding Yarn* becomes an almost embarrassing act of

homage, as well as a direct translation of a French prototype into the Dutch idiom. Precisely following the vertical format, the centrally placed figure, and the abruptly turned chairback of Millet's design, Van Gogh removed its last traces of picturesqueness in his bleak and crepuscular canvas.

In a letter to his brother of October 1884, Van Gogh enthused about a novel they had both been reading that was set in the heart of contemporary Paris, Zola's *Au bonheur des dames*. Observing that one of the characters "worships the modern Parisian woman," he exclaimed, "But Millet, Breton, worship the peasant woman *with the same passion*. Those two passions are one and the same." In the following paragraph, the artist tells Theo how thrilled he was by "Zola's description of a room with women in the twilight, women often already over thirty, up to fifty, such a dim, mysterious corner. I think it splendid, yes, *sublime*."[18] It was shortly after writing these words that Van Gogh painted his own group of twilight studies, a series of portraits that became a further contribution to the preparations for *The Potato Eaters*. Announcing to his brother that he was going to "paint fifty heads just for experience,"[19] he managed to persuade several men, women, and adolescents to sit for him, many of them apparently in the "dim, mysterious" light of their cottages. *Head of a Woman* (cat. 7) is one of the most confrontational of these studies, in which the artist's face—and implicitly, our own—is thrust close to the

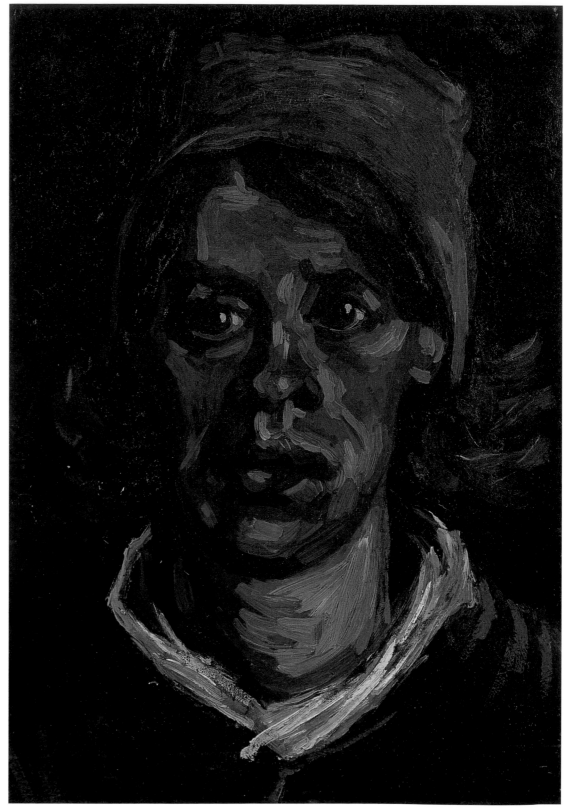

cat. 7 *Head of a Woman*, March–April 1885

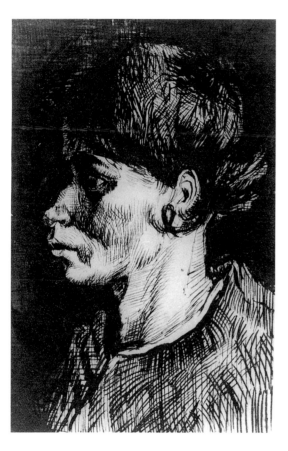

fig. 5 *Peasant Woman, Head,* 1884, pen and wash. Van Gogh Museum, Amsterdam (Vincent van Gogh Foundation)

woman's weatherbeaten, prematurely aged features and up against her rough clothing and coarsely cropped hair. Only her red hat relieves the earthy gloom, but even this is worn awkwardly rather than for decorative effect. A sketchbook drawing from these same months (fig. 5) records an equally unflattering profile of another model, posed rigidly or on sufferance, or perhaps accustomed to long hours of inertia. If at this date the painting of peasant types by artists of the Hague school was already well established, such blunt, almost intrusive close-ups could still be shocking in their rough facture and presumption of intimacy.

Van Gogh's approach to his models in these portraits is disarmingly frank, if made up of a complex set of attitudes and prejudices that is not easily disentangled. On the one hand, his commitment to painting such neglected individuals in a sustained and attentive fashion comes close to the act of "worship" he believed he shared with Millet and Jules Breton. At the same time, his emphasis on the swollen nose, lips, and chin in *Head of a Woman* approaches caricature, recalling the stylized "types" of the English illustrators and the rustic grotesques of Daumier. Van Gogh had already read Alfred Sensier's 1881 biography of Millet, in which the artist's views on the "animal" appearance of certain of his subjects were set out, reflecting a wider—if still debated and often contradictory—belief that the physiognomy of individuals expressed their character and intelligence. Even as Van Gogh wrote "I think

a peasant girl is more beautiful than a lady," [20] he could compare a particular face to a "lowing cow" or a "cockerel" and describe a male figure as "rather thick-set, somewhat like an ox, in that his whole frame has been shaped by his labor in the fields. Perhaps more of an Eskimo type, thick lips, broad nose." [21] The youthful character in *Head of a Man* (cat. 8) is physically weaker than the individual described, but Van Gogh has once more stressed his ill-formed bone structure and protuberant mouth without mockery. If there is an element of condescension—of the well-educated son of the vicarage scrutinizing his father's less fortunate parishioners—it is set against Van Gogh's sincere attempt to diminish the distance between them and his admiration for their way of life ("in many respects so much better than the civilized world," he told Theo, arguing that "one must paint the peasants as if being one of them"). [22] Still driven by his need to bring these images to a sympathetic public, Van Gogh concluded "Painting peasant life is a serious thing, and I should reproach myself if I did not try to make pictures that will rouse serious thoughts in those who think seriously about art and about life." [23]

As this series of portraits demonstrates, by the beginning of 1885 Van Gogh's fluency in the techniques of oil painting allowed him to work rapidly and with a minimum of revision. The skin hues of *Head of a Woman*, for example, were confidently brushed on with flowing, semiliquid color, while a single sweep of ocher

at the base of the neck in *Head of a Man* defines the fleshiness and volume of his body where it meets the coarseness of the jacket. Tonally these pictures are also remarkably accomplished, their overwhelming sobriety brought to life by a highlight on a collar or hat rim, or—in the case of *Head of a Man*—by a touch of pale apricot at the tip of his glowing pipe. It is characteristic of Van Gogh that, alongside such practical explorations and an engagement with realism in French literature, he found time to read a range of published treatises on aspects of the artist's craft. In such works as Charles Blanc's *Grammaire des arts du dessin*, articles on the paintings of Eugène Delacroix, and Félix Bracquemond's *On Drawing and Color*, Van Gogh encountered a more theoretical approach to these matters, excitedly reporting his discoveries to Theo and Van Rappard. What he called "the question of the analysis of colors"[24] attracted him particularly, leading to experiments with differently tinted wool threads and cautious trials on his own canvases. Even a picture as restrained as *Still Life with Earthenware and Bottles* was an opportunity to set warmer tones against cooler, or a grayish-brown tinted with yellow next to another infused with its complementary, violet.

The earliest compositional studies for the large canvas of *The Potato Eaters* (cat. 6) were drafted out in March 1885 and were directed—in the approved manner—at the broad disposition of shapes and tones within the picture rectangle. One of these, *Four Persons at a Meal*

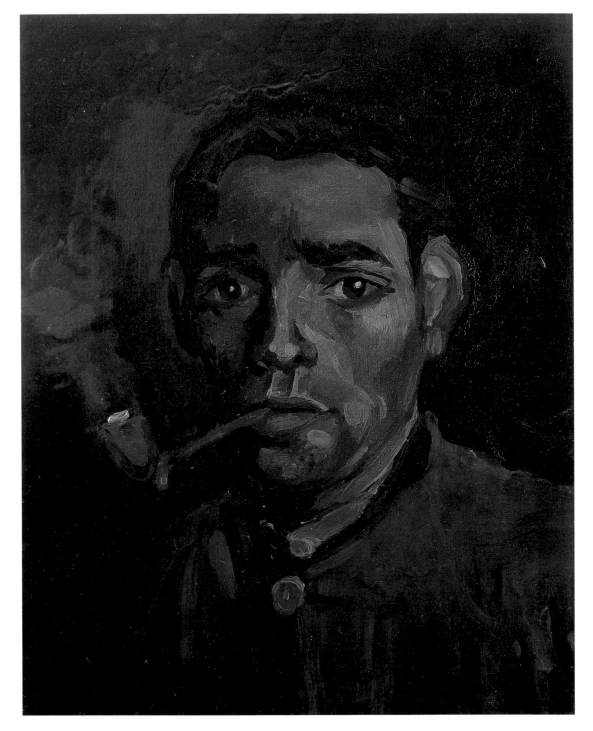

cat. 8 *Head of a Man*, December 1884–May 1885

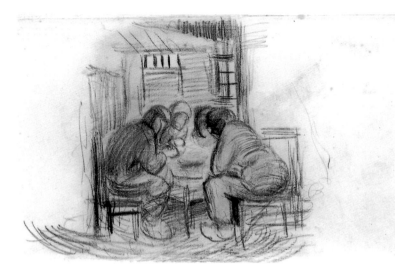

(fig. 6), reveals the extreme simplicity of Van Gogh's original conception: an almost square design with two pairs of full-length figures balancing each other at either side of a central table, their chairs echoing the rectilinear grid of the plain cottage architecture. Subsequent adjustments brought greater complexity to both the space and the human relationships, broadening the scene to allow subtly varied intervals between the protagonists, setting the table at a diagonal to the picture plane, and pushing the viewer closer to the human activity. A fifth figure—apparently a child—was introduced into the foreground, her silhouetted form heightening the halolike pool of light beyond and softening the intrusive corner of the tabletop.

By April, Van Gogh had worked on several variants of his subject in black chalk and pen and ink, as well as a highly detailed lithograph, gradually integrating into the design some of the portrait heads completed over the winter. Two attempts had also been made to explore the image in color, using a small and a medium-size canvas (both evidently painted in the cottage setting) to render it in a grayish gloom and a golden lamplight, respectively. As the days went past, Van Gogh kept his brother informed of developments, sending sketches and feverish descriptions of the different ideas competing for his attention. Reminding Theo that "one of the most beautiful things this country's painters have done is to paint *darkness* which nevertheless has *light* in it,"[25] he wrote out long extracts from Delacroix's reflections on color and explained how the neutral-looking tints of *The Potato Eaters* were made by "mixing red, blue, yellow, for instance, vermilion, Paris blue, and Naples yellow."[26] As he prepared to send the still-wet painting to his brother, he warned him that "it does not show up well against a dark background,"[27] again invoking Delacroix's principle of the "simultaneous contrast of colors" by suggesting that he hang the work on paper "the color of ripe corn";[28] "the shadows are painted blue and a gold color puts life into this," he explained.[29]

Throughout the painting of *The Potato Eaters*, Van Gogh's exhilaration was tempered by the knowledge that his contemporaries would find it disconcerting, even repulsive. Aware of the picture's aggressive appearance, he told Theo that there was still "a certain *life* in it, perhaps more than in some pictures that are absolutely faultless."[30] A few days later, he returned to the attack:

> It would be wrong, I think, to give a peasant picture a certain conventional smoothness. If a peasant picture smells of bacon, smoke, potato steam—all right, that's not unhealthy: if a stable smells of dung— all right, that belongs to a stable: if the field has the odor of ripe corn or potatoes or of guano or manure—that's healthy, especially for city people. . . . Such pictures may *teach* them something.[31]

As Van Gogh was rapidly discovering, however, these sentiments presented him with a dilemma, one which was to pursue him throughout his career and which remains largely unresolved for generations of his successors. Above all he wished to remain faithful to his sensations, to give "a true impression of what I see,"[32] as he wrote beneath a sketch of *The Potato Eaters* in one of his letters. At the same time, he felt the need to project something of this authentic experience to those around him and to the "city people" who needed to be educated in such matters. But he also knew that his choice of material and his way of painting were of precisely the kind to antagonize such an audience. In the hope that those closest to him would understand and promote his cause, Van Gogh sent copies of the lithograph of the

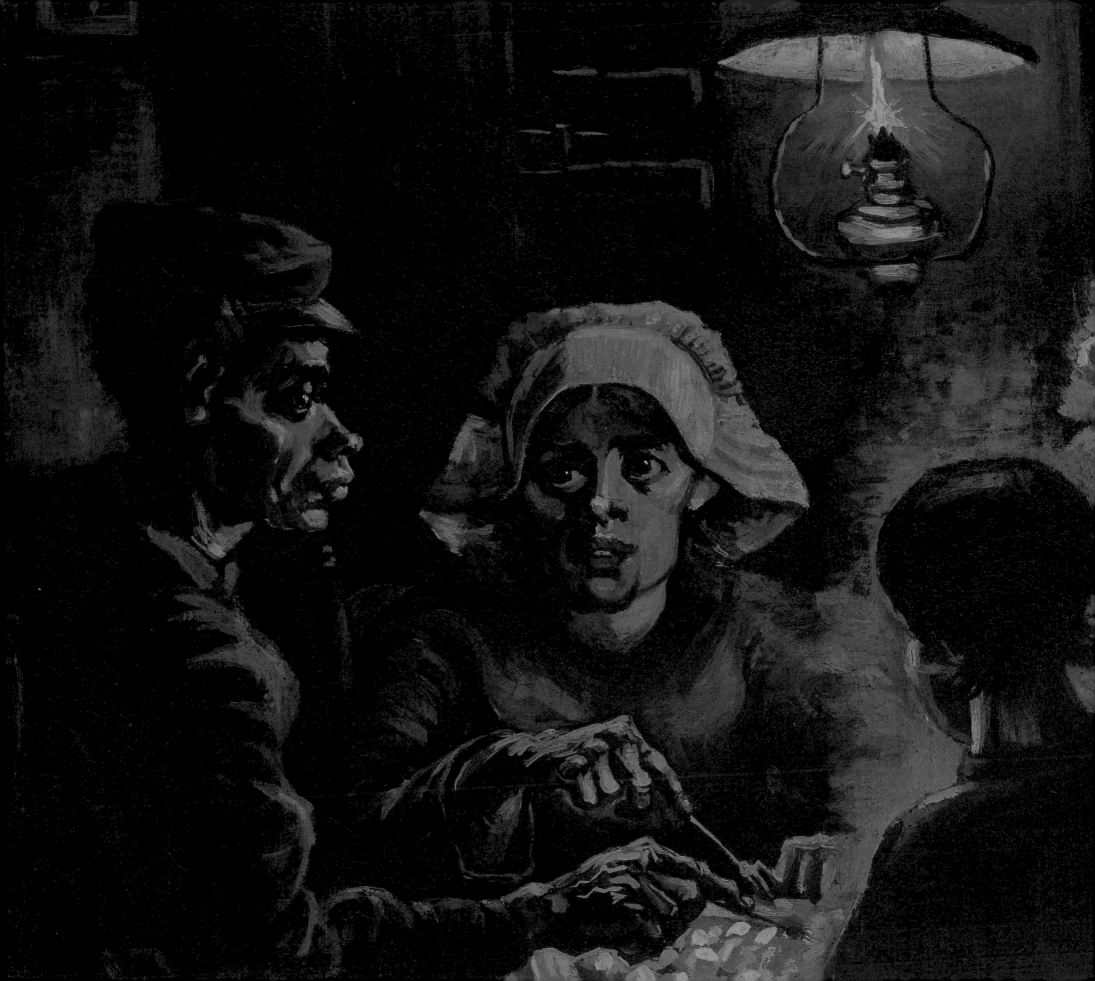

earlier version of *The Potato Eaters* to Van Rappard, Theo, and his fellow dealers, even though he was already coming to terms with his contradictory situation. Pleased by the news that Alphonse Portier—who owned a gallery in Paris and sold pictures by the impressionist circle—had recognized a distinct "personality" in his work, Van Gogh claimed bravely, "I try more and more to be myself, caring relatively little whether people approve or disapprove of it."[33]

A further challenge in completing a picture like *The Potato Eaters*, which he once again shared with many of his peers, was that of maintaining the freshness of the painted studies in a large and ambitious canvas. Van Gogh openly acknowledged the problem, trying to resolve it by throwing himself into a three-day marathon of continuous painting and finally executing the scene from memory, hoping to finish it before the surface dried. Technically, his attempt was only partly successful, leading to cracking and a loss of translucency in certain areas, as well as the darkening of some of the less stable colors. But the overall composition gave him considerable satisfaction, despite a number of localized "faults with the drawing" mentioned to his brother.[34] By broadening the design from the squat, original sketch (fig. 6), Van Gogh had effectively created a panorama of peasant life that gave expression to their numb, uncommunicative existence. As the preparatory studies show, each element had been carefully deliberated to arrive at a

sense of stilted movement, of gravity mixed with a childlike or even puppetlike awkwardness that the artist knew from his numerous visits to such cottages; "at least it is a subject I have felt," he reminded Theo somewhat defensively.[35] For Van Rappard, on the other hand, the scene as recorded in the lithograph was simply ludicrous, weakened by figures who appeared to be "posing," illogical relationships between objects like the coffeepot and the table, and passages of feeble draftsmanship. "Such work is not meant seriously," he announced in a note that precipitated the end of their friendship, cutting Van Gogh to the quick with his final flourish: "while working in such a manner, you dare invoke the names of Millet and Breton?"[36]

The resilience of Van Gogh in the face of such bitter criticism, on this occasion and in subsequent years, was formidable. Even as he digested the few words of faint praise for the recently dispatched *Potato Eaters* from Theo's colleagues, he told his brother that he had begun some new pictures of cottage interiors and exteriors, demanded news of the Paris Salon, and discussed Zola's latest novel, *Germinal*. Enamored as he was of the Nuenen countryside, Van Gogh found himself increasingly oppressed by his alienation from sympathetic society and at odds with the conventional world occupied by his parents. Shortly after Van Gogh began *The Potato Eaters*, his father died suddenly of a stroke, an event that confirmed the painter's need to shake off the shackles of

the past and establish his own independence. Perhaps nostalgically, during the summer months he revisited a number of favorite themes, consolidating his skills as a draftsman in a cycle of forceful studies of peasants in the fields, recalling Millet in rhythmic images of reapers and harvesters, and turning again to the discipline of the still life.

The subdued forms of *Basket with Potatoes* (cat. 9), probably painted in September 1885, might be a salutary reflection on his labors earlier in the year. Where he had formerly aspired to evoke the "smells of bacon, smoke, potato steam" in a complex interweaving of figures, he was now content to pile up the humblest of vegetables or scatter them almost randomly across an anonymous table. In this sense, Van Gogh may seem to have retreated from his grander ambitions, perhaps to have reduced his picture to a mere exercise in the modulation of tones and the application of paint. A hasty note to Theo, however, confirms his subtler aims in continued attention to the writings of Bracquemond and Delacroix, and his intention to produce still lifes "made especially with regard to the modeling with different colors."[37] Applying a new technical command to his modest theme, *Basket with Potatoes* is inescapably the work of the same artist who wanted the heads in his *Potato Eaters* to be "the color of a very dusty potato, unpeeled of course."[38] Each of these lumplike shapes has been scrutinized in all its individuality, its scars and variations in hue lovingly recorded, and its im-

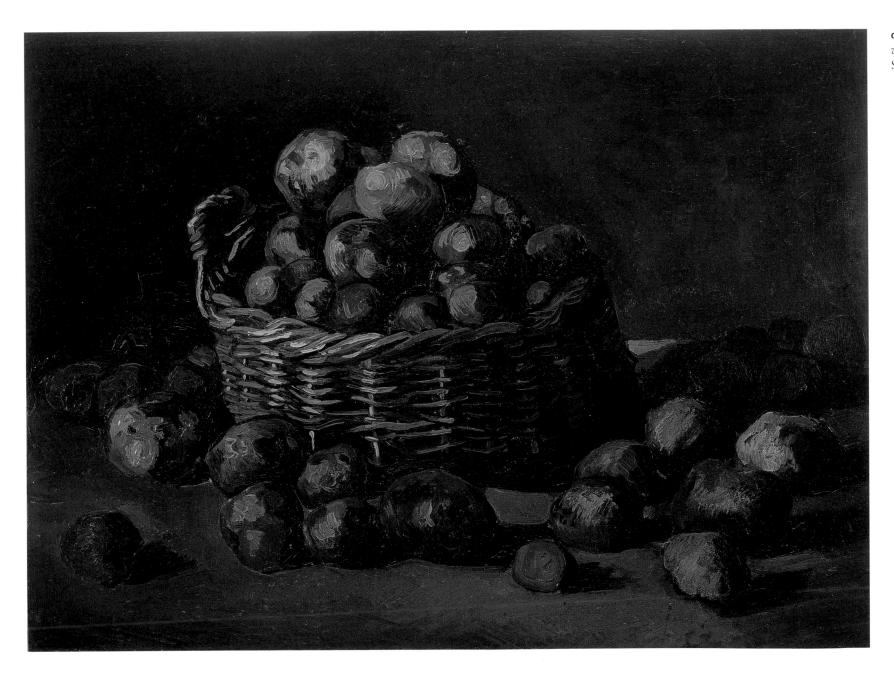

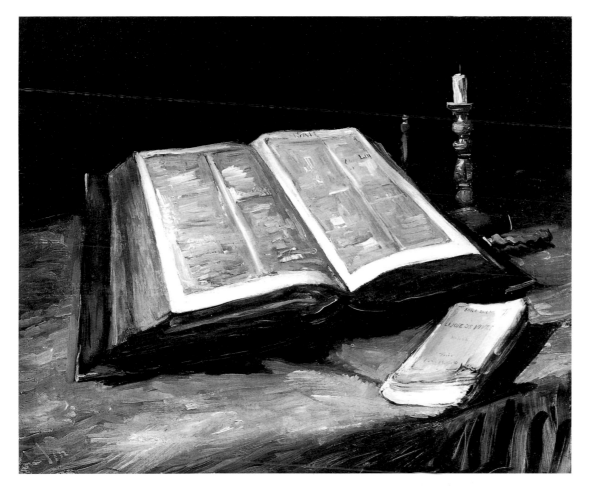

perfections of form rendered by a painter who understood the importance of such a life-giving crop. A closer look reveals that the paint itself is far from neutral: using surprisingly fluid colors, Van Gogh has again allowed the oily substance to take on the character of his subject, woven into linked strokes in the basketwork, flat and even in the background, and densely impasted in the potatoes themselves.

Two contrasted pictures of houses provide a concise epilogue to Van Gogh's Nuenen years. The first, *The Cottage* (cat. 10), might stand for his commitment to peasant life and the domestic gloom that provided the background for so many of his portrait and figure studies. Still clinging to his Dutch inheritance while progressively espousing the work of his French predecessors, Van Gogh has painted the crumbling building against an overcast, rain-filled sky and suggested the banality as much as the rustic charm of the motif. Also characteristic of these years is the presence of an earlier image—in this case, a study of a Millet-like shepherd with his flock—underneath the picture, a consequence of Van Gogh's shortage of canvas and his impetuous overpainting of an earlier work. The second painting of a house, *The Vicarage at Nuenen* (cat. 11), is emblematic of the personal rather than the artistic formation of Van Gogh's early life. It was behind this severe facade that he struggled for several years with the restrictive ways of his parents, and it was here that his increasingly outlandish behavior put a distance between them. Compared with *The Cottage*, it seems overshadowed and visibly claustrophobic, painted more out of solemn duty than painterly inclination. Though its precise date has been disputed, the rust-colored leaves on the trees in *The Vicarage at Nuenen* point to the autumn of 1885 as the moment of its execution and its role as a melancholy souvenir of past times. Van Gogh's occasional weakness for such images is more famously represented by another picture from these months, *Still Life with Bible* (fig. 7), to which he referred in a letter of late October. Here the large, weighty volume—undoubtedly associated with the artist's dead father—lies open at the Old Testament, while the new order and the promise of a new aesthetic are represented by the small, almost impertinent presence of a recent Zola novel, appropriately entitled *La joie de vivre*.

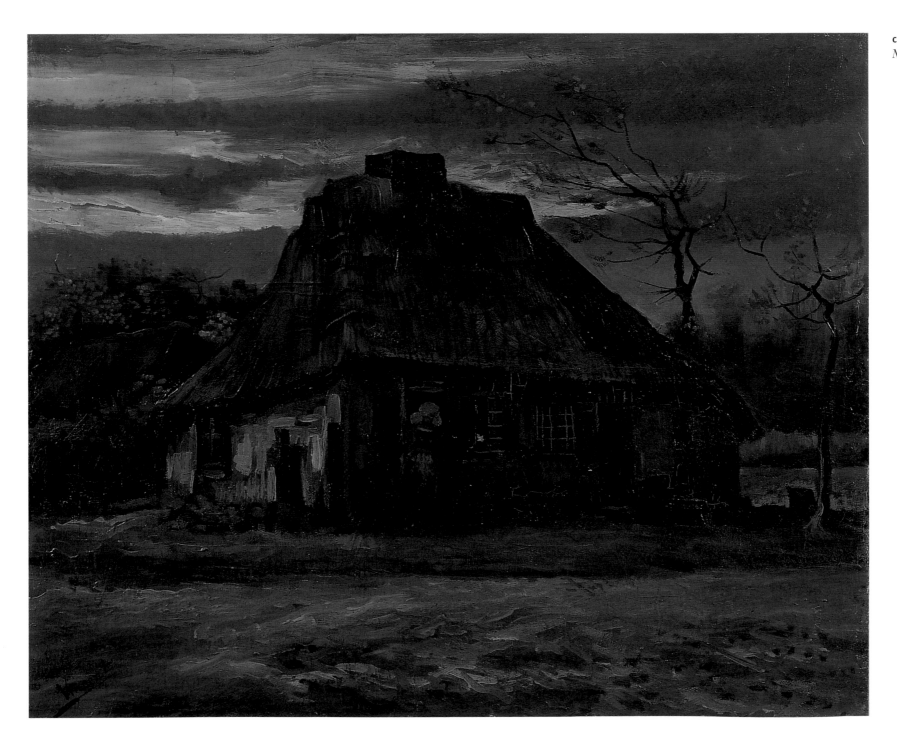

cat. 10 *The Cottage,*
May 1885

cat. 11 *The Vicarage
at Nuenen*,
October–
November 1885

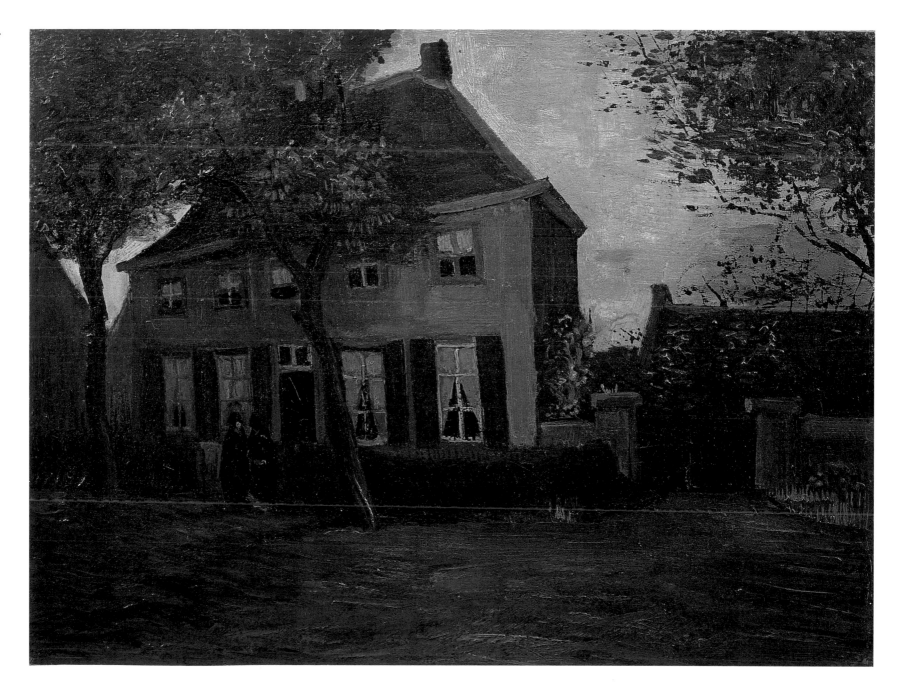

"Rubens is certainly making a strong impression on me"

Keener than ever to make his mark on the contemporary art world, yet still conscious of his technical deficiencies and his need to learn from the past, Van Gogh left Nuenen in late November 1885 and found lodgings in the city of Antwerp. He stayed there for just three months, living in real hardship on the small monthly payment sent out of kindness by Theo, and suffering from ill health, undernourishment, and persistent dental problems. But this brief spell proved critical to his career in a number of ways, not least in introducing him to the routines of the metropolitan artist and the professional rigors he would soon discover in Paris. Most immediately, Van Gogh found himself cut off from his peasant subject matter, turning instead to the dockside and the wintry and sparsely populated public spaces of the city for his first drawings and paintings. Confronted also by the need to earn money, he persuaded a number of Antwerp dealers to take canvases painted at Nuenen and planned to set himself up as a portraitist, even considering the making of signboards for fishmongers, greengrocers, and restaurants. In a more positive sense, the city boasted a number of substantial museums and galleries where he could study works from the Belgian and Dutch traditions, as well as a surprisingly cosmopolitan

range of pictures by nineteenth-century artists. It tells us much about Van Gogh's priorities that his first letter from the city was almost entirely devoted to descriptions of the paintings he had seen: "I was very much struck by Frans Hals' *Fisherboy*; *Mr. de Vos*—portrait of master of the guild—Rembrandt, *very* beautiful," he wrote to Theo after one visit, and among pictures at the Musée Moderne he admired "a beautiful portrait by Ingres, a fine portrait by David, other good things."[39]

The portraits Van Gogh himself painted were probably his finest achievement of the Antwerp months, progressing from the lugubriousness of *The Potato Eaters* to a new phase of technical and chromatic brilliance. At first glance, *Head of an Old Man* (cat. 12) might almost have been made at Nuenen, its earth brown tones, shadowy background, and resigned expression recalling such works as *Head of a Woman* (cat. 7). But as an excursion into oil painting it bursts with new confidence, the colors conjured onto the canvas in buttery flourishes, and the planes of the head and rhythms of the composition fusing into a single, sensuous whole. This fluency may have grown out of Van Gogh's earlier explorations of the medium, but it is equally plausible as the product of his changed circumstances, of the "better brushes" he had been able to buy, and of his absorption in the painterly craft of Rubens and Hals; "Rubens is certainly making a strong impression on me. . . . I am quite carried away by his way of drawing the lines

in a face with streaks of pure red," he wrote to his brother.[40] The artist also made it clear that pictures like *Head of an Old Man* were intended as "trials" for more formal portraits, perhaps to be shown to potential clients from whom he hoped to secure a commission. Other drawings and paintings of characters met in Antwerp bars and a tentative sketch for a self-portrait followed, but there is no evidence that this search for customers met with success.

In the same letter, Van Gogh went on to describe a second study of a head, this time based on a female subject: "In the woman's portrait I have brought lighter tones into the flesh, white tinted with carmine, vermilion, yellow, and a light background of gray-yellow, from which the face is separated only by black hair. Lilac tones in the dress." The significance of these words can hardly be exaggerated, combining as they do a move toward lightening the artist's palette, a greater audacity in the mixing of colors, and the free play of pigments—such as carmine, vermilion, and lilac—that had scarcely been used at Nuenen. In *Head of a Woman* (cat. 13) the results of this experiment are shockingly visible, in clashes of hot flesh tones and the coolly illuminated wall, in the plunging shadows of the hair, and crisp highlights of lips and dress. Unmistakably modern in appearance, the picture is the fruit of Van Gogh's study of Rubens on the one hand, and his dawning awareness of another kind of painting—known more by reputation than by

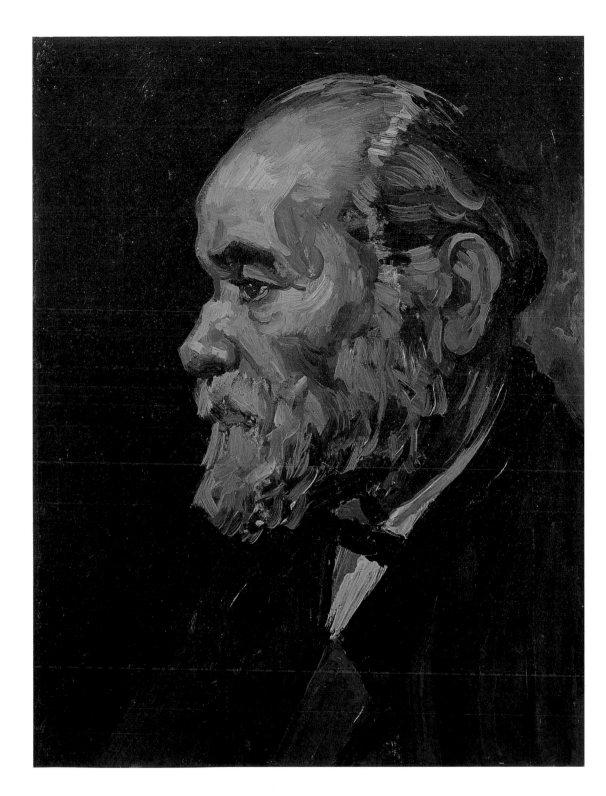

cat. 12 *Head of*
an Old Man,
December 1885

experience—on the other. *Head of a Woman* is animated by light, not just the flickering, shadowy light of the seventeenth-century masters but the brilliance of modern places of entertainment, of mirrored bars and artificial illuminations. The woman's bare chest and loose hair mark her as a barmaid or prostitute, the type of marginal individual excluded from polite portraiture who had for some time been occupying the attentions of Van Gogh's Parisian contemporaries. His letters show that the artist already knew enough about the modern French school to make allusions to Gustave Courbet and Edouard Manet, and to minor adherents of impressionism such as Jean-François Raffaëlli and Bracquemond, though Van Gogh still spoke tentatively about their more radical successors. In one of his last exchanges with Van Rappard, he mentioned that Theo had told him about "Claude Monet, a landscape painter cum *colorist*,"[41] but still speculated on the nature of this unfamiliar art; pondering some pictures by the Dutch artist Jan van Beers, he wrote, "I imagine that someone like Manet . . . is much more of a *painter* than Van Beers and paints more beautifully and artistically."[42]

As he got to know Antwerp, we can feel Van Gogh straining toward Paris and its novel tastes; he compared a view of the Antwerp dock area to the newly fashionable Japanese prints, for example, and imagined that a café concert in the city was "something like the Folies-Bergère."[43] His notebooks include top-

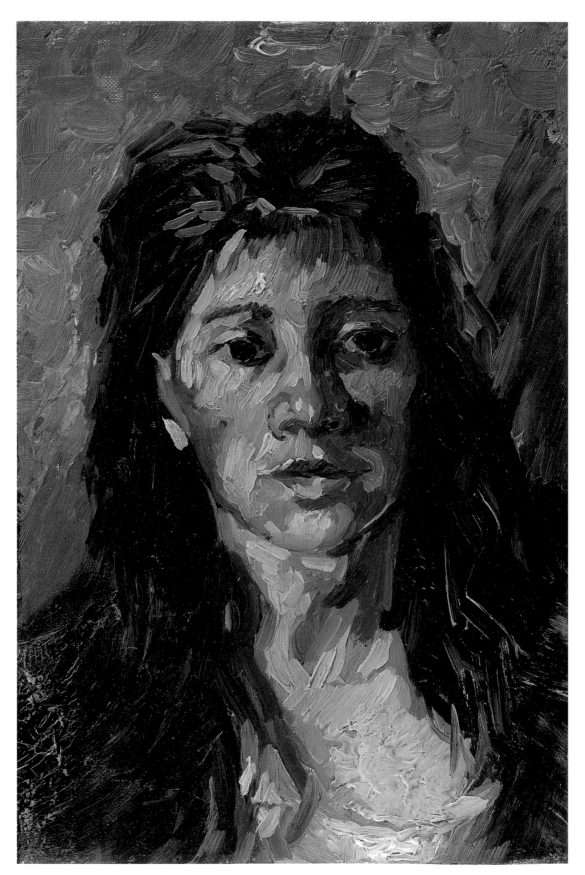

cat. 13 *Head of a Woman*, December 1885

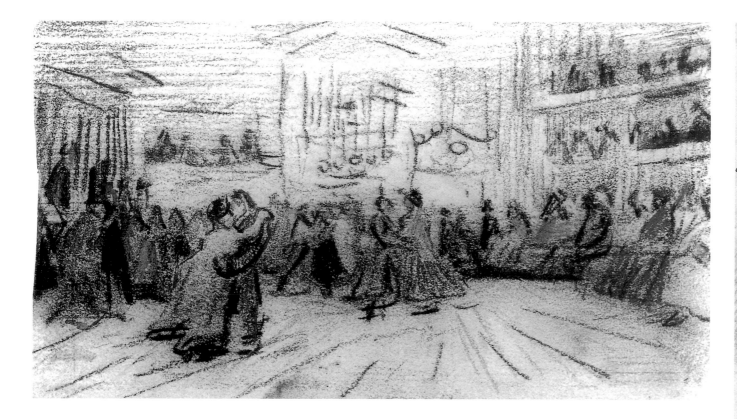

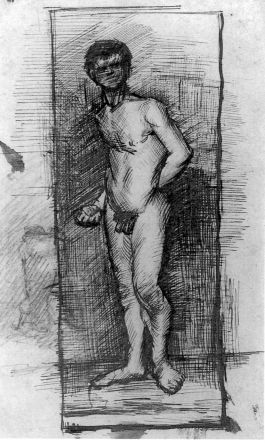

fig. 8 *Dance Hall*, 1885, black and colored chalk

fig. 9 *Male Nude, Standing*, 1886, pen and pencil

Van Gogh Museum, Amsterdam (Vincent van Gogh Foundation)

ical sketches of figures in theaters and public places, such as the spirited *Dance Hall* (fig. 8), that are unwittingly close to drawings of such places by Cézanne and Degas, both artists Van Gogh had yet to mention in his correspondence. Other sketchbook pages reveal a further motivation for his visits to such urban centers as Antwerp and Paris, that of the opportunity to draw the nude male and female model. The task of finding suitably cooperative sitters had always been a problem for the penniless and abrasive Van Gogh, while in the Dutch provinces the chances of persuading a

model to pose naked were remote. Once in Antwerp, what he described as his "immense longing to improve my knowledge of the nude" was finally assuaged, both in informal drawing clubs and in the official classes at the Académie Royale des Beaux-Arts. Here, for the first time, the thirty-two-year-old Van Gogh found himself on equal terms with his peers and subject to one of the most time-honored disciplines of their craft.

An energetic, unglamorous drawing such as *Male Nude, Standing* (fig. 9) shows how little intimidated he was by his new surroundings

and how assured he could be when left to his own devices; "I think all the fellows in the drawing class all work badly and in an absolutely wrong way," he confided to Theo, explaining how each of their studies "is correct, it is whatever you like, but it is *dead*."[44] Ironically, the only example of an oil painting to have survived from these sessions is *Skull of a Skeleton with Burning Cigarette* (cat. 14), a literal image of death that Van Gogh has brought to life with vibrant brushstrokes and fluid colors. Art classes were notoriously irreverent at this period, but to dismiss this little canvas as no more than a joke is to overlook its self-effacing, almost casual accomplishment. Negotiating the complexities of the rib cage, the rotundity of the skull, and the concavities of jaw and facial structure, Van Gogh quietly asserts his command of a notoriously difficult subject and of his new medium of preference, oil paint.

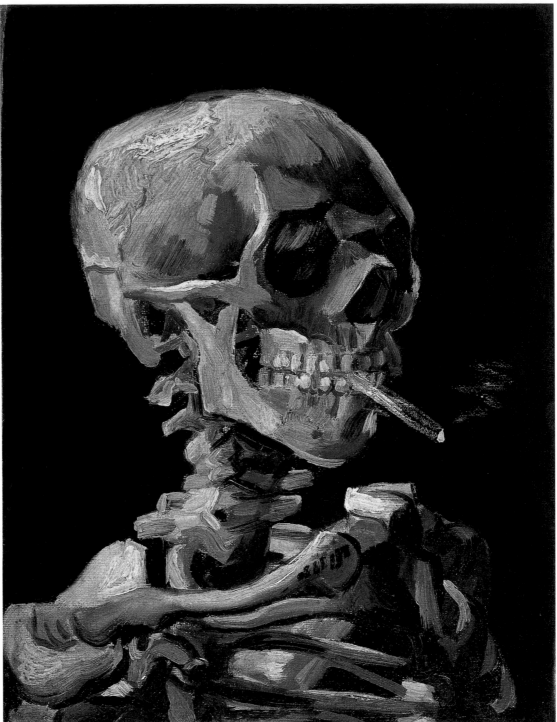

cat. 14 *Skull of a Skeleton with Burning Cigarette,* winter 1885–1886

PARIS: 1886–1888

*"What is required in art nowadays is
something very much alive, very strong
in color, very much intensified"*

During his last weeks in Antwerp, Van Gogh wrote persistently to Theo on the subject of his forthcoming removal to Paris, slowly eroding his brother's doubts and practical objections to the plan. These Antwerp letters give us an exceptionally rich insight into Van Gogh's state of mind at a pivotal moment in his career, poised as he was between years of solitary neglect in Holland and the promise of life on a wider stage. Though Theo's side of their lifetime correspondence has largely disappeared, it is movingly evident that the two brothers unburdened their thoughts to each other at length, reporting commonplace incidents, financial and emotional concerns, and moments of personal exuberance, as well as their aspirations for their respective futures in the world of art. Once Van Gogh had taken up residence with Theo in Paris, this exchange of letters was temporarily interrupted and a fundamental source of information about the artist's day-to-day activities lost. Nevertheless, a detailed picture of Van Gogh's circumstances at his moment of departure and, most revealingly, his perceptions of what a future in Paris might hold in store for him, can be reconstructed from the wealth of letters written during the final weeks in Belgium.

Several exchanges with his brother concerned those members of the family left behind in Nuenen, where their mother was attempting to settle her affairs before leaving the vicarage. It seems that Theo was anxious for Van Gogh to join his mother and help with the move, then return to a life of painting in the countryside where his costs would be lower and his physical weakness could be remedied. Van Gogh was adamant in his opposition; "There is no chance, absolutely none, of making money with my work in the country, and there is such a chance in the city. . . . going back to the country would end in stagnation," he insisted.[45] In subsequent letters he itemized the advantages of urban existence for himself as an artist and the value of measuring his work against that of other professional painters: in one memorable phrase written in Antwerp, he claimed, "I find here the friction of ideas I want."[46]

There were more prosaic reasons for his relocation to Paris, most of them centered on the question of money. If the two brothers were to share a modest apartment, Van Gogh argued, they could cut down on their living expenses and establish a regular, healthy regime that would benefit them both. Months of study and impoverishment had left him in a wretched state. "I am literally worn out and overworked," he explained to Theo, adding that he had "not had a hot dinner more than perhaps six or seven times" since he left Nuenen.[47] Other savings could be made in Paris, he pointed out,

by joining one of the large teaching studios where instruction was based on the nude model, supervised by such established artists as Jean-Léon Gérôme, Alexandre Cabanel, or Fernand Cormon, and by improving his draftsmanship through copying in the great museums. Envisioning a modest yet idyllic existence, Van Gogh's ingenuity often carried him away: "If I rent a garret in Paris, and bring my paintbox and drawing materials with me, then I can finish what is most pressing at once—those studies from the ancients, which certainly will help me a great deal when I go to Cormon's. I can go and draw at the Louvre or at the Ecole des Beaux-Arts."[48]

After much prevarication, in late February or early March of 1886 Van Gogh left Antwerp on the spur of the moment and traveled by train to Paris, where he settled himself in his brother's Montmartre rooms. Some impression of his appearance and state of health can be gleaned from one of many studies of his own features made soon after his arrival, *Self-Portrait* (cat. 15), and a sheet of drawings of about that time (fig. 10). *Self-Portrait* is a disconcerting work, depicting a formally attired, rather avuncular individual who might be in his mid-fifties were it not for the dense growth of his ginger hair and luxuriant moustache and beard. His skin is pallid, the deeply shadowed face and furrowed brow suggesting a solemnity that borders on the tragic. In contrast to the vividly colored *Head of a Woman* painted in Antwerp, this picture is effectively confined

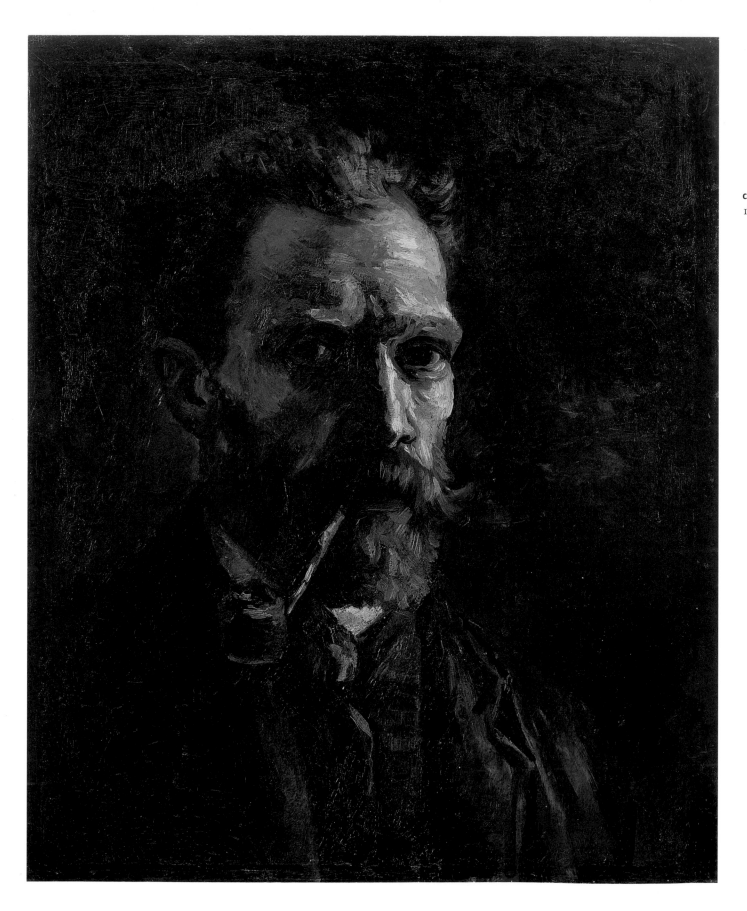

cat. 15 *Self-Portrait,*
1886

fig. 10 *Two Self-Portraits*, 1886, pencil and pen. Van Gogh Museum, Amsterdam (Vincent van Gogh Foundation)

to grays and browns, as if the artist had chosen to present himself in the guise of the most solemn of old masters. Such role-playing—and the element of grim introspection implicit in it—was to become a major obsession in the self-portraits painted in Paris, but on this occasion it probably had a more pragmatic purpose. Van Gogh was again preoccupied by the need to earn his living and alert to the possibilities of commercial portraiture, for which he would need suitable examples of his work to show prospective sitters. Coupled with this was a need to offer the world—and perhaps himself—an image of his personality at its most collected, both to gain a sympathetic audience at studios and galleries, and to counterbalance a tendency toward hot-headedness and eccentricity in his daily behavior. The drawing *Two Self-Portraits* (fig. 10), though linked to a similarly restrained canvas, is altogether less guarded, allowing the fierce gaze of the artist's eyes and his tense, knotted eyebrows to dominate his features and act as a focus for the rest of the composition. Unexpectedly prefiguring the self-portraits of his later years, these drawn studies remind us of the extent to which the self-perception of an artist—even one as apparently impulsive as Van Gogh—can be modified according to circumstance, technique, and creative volition.

Within a couple of months, the two brothers moved to a larger apartment a few streets away, on the rue Lepic, where over the next two years Van Gogh was to live, work, and transform himself as an artist. Sweeping though this statement may seem, it reflects an important progression in almost every aspect of Van Gogh's practice and his sense of vocation, often prompted—or provoked—by his volatile relationship with Theo. If their earlier letters seemed to reflect a relationship of exceptional closeness, exemplified on Theo's side by his belief in Vincent's talents and loyal financial help, and on Vincent's by his emotional forthrightness with his brother, there had also been misunderstandings and periods of estrangement. Most frequently, their arguments were polarized between Theo's progression to a formal, increasingly influential status in the art trade and Van Gogh's still frustrated desire to sell his pictures through the same system, as well as his outbursts of irascible behavior. Writing from Antwerp, Van Gogh had petulantly summarized the situation:

> You may be of the opinion that I am an impossible character—but that's absolutely *your own* business. For instance, I *need not* care, and *I am not going to.* I know that there are times when you think differently and better of me, but I know too that your business routine induces you again and again to lapse into the old evil with regard to me. What I seek is so straightforward that in the end you cannot but give in.[49]

In Paris, they appear to have reached an accommodation, Theo putting at his brother's disposal his considerable knowledge of deal-

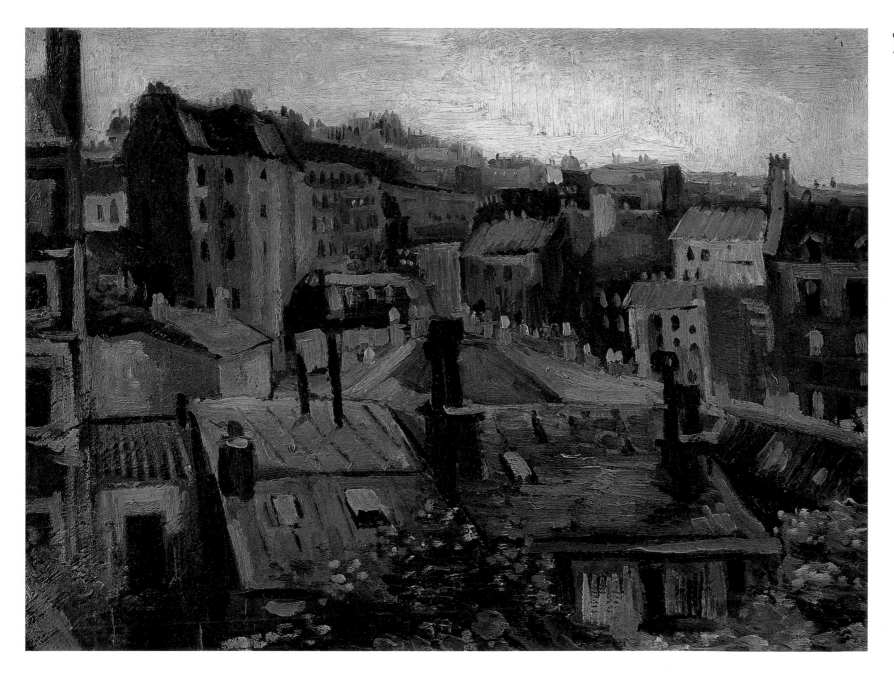

cat. 16 *Roofs in Paris*, 1886

ers, patrons, and practitioners, and Vincent providing his brother with companionship during the latter's own ill-health and amorous entanglements. As the months went by, the artist was able to establish his own contacts and perhaps reciprocate his brother's help, meeting a younger generation of painters still outside Theo's orbit and enlarging his awareness of the Parisian avant-garde.

On arriving in a new town or city, Van Gogh's characteristic response was to take long walks through the streets, public spaces, and surrounding countryside, and to explore its appearance in a series of sketchbook or paper-based studies and smaller paintings. Paris was no exception, the painter beginning with the vicinity of the brothers' flat on the rue Lepic and soon embracing the sweeping views from the heights of Montmartre itself. His first attempts at such picture making could be tentative, with a work such as *Roofs in Paris* (cat. 16) apparently carried out from the security of an apartment window and In the knowledge that such rooftop landscapes were already a familiar genre. The muted browns and metallic grays of the canvas seem to record overcast weather and also point to the artist's need to find other suitable subjects—such as still lifes and portraits—when the elements made outdoor painting impossible. His high vantage point is evidence of some audacity—especially for an artist habituated to the flatness of Holland—but this early work, like the somber

Self-Portrait, shows him clinging to past practices as he assimilated his new surroundings.

In a sketchbook drawing of early 1886, *The Moulin de Blute-Fin* (fig. 11), the artist attacks a more challenging view of the city with appropriate vigor, scribbling down the broad outlines of one of the once-celebrated windmills of Montmartre and a glimpse of the gardens that still survived at the city's periphery. Expanding this mill-dominated vista in several related canvases, such as *The Hill of Montmartre with Stone Quarry* (cat. 17), the painter of Dutch landscapes seems to have been reassured by the conjunction of rural and urban elements in this unfamiliar terrain. In his confident canvas, the fresh greens of grass and foliage suggest that spring or summer has arrived, encouraging the artist to work in the open air—as he had done at Drenthe and Nuenen—and to respond sensuously to drifting clouds and lengthening shadows. Several other aspects of the composition, however, hint at more complex challenges and delights still to come. In the foreground, a small-scale industrial enterprise is engaged in digging limestone from the hill, here painted by Van Gogh from a similar site to that used by another recent visitor to the city, the Dutch artist Matthew Maris. This limestone, in its turn, was made into the famous plaster of paris, paradoxically the very material used to make casts of sculpture for use in drawing classes. And in the distance, this same windmill was by now

a tourist attraction, an outpost of the network of bars, restaurants, and public entertainments already providing the stimulus for paintings by Van Gogh's less timid—or less pastorally inclined—artistic peers.

If there is an element of nostalgia in the appearance of windmills in a dozen of these early views of Paris, pictures like *The Hill of Montmartre with Stone Quarry* also announce themselves as unmistakably French. Turning his back on the flat Dutch landscape, Van Gogh seems to glory in lofty horizons and tumbling descents, in chance configurations of forms and in unaccustomed modulations of light. Even the warm, blond atmosphere of these Montmartre vistas invokes a foreign sensibility, that of Camille Corot and the mid-century realists, for example, with more than a hint of the pictorial brashness of Manet and his still active circle of followers. Here too is a comparable engagement with humble materials and seemingly casual design, energized by a fierce attentiveness to the qualities of the chosen scene. In *The Hill of Montmartre with Stone Quarry*, Van Gogh skillfully contrasts the softness of the sky with the coarse vegetation of the hillside, the untidy foreground debris with the minutely recorded fence posts and windmill sails in the middle distance. As we know from his letters, this concern for detail was directly linked in Van Gogh's mind with his admiration for naturalist literature and its commitment to the most banal sites and human

encounters. Even before he moved to the city, the novels he read and exchanged with Theo—such as those by Zola, Maupassant, and the Goncourt brothers—had helped to define his taste for Paris, while their accounts of certain locations may have led him to some of his first urban subjects. In a larger picture of the quarry setting, for example, the artist stressed even further the socially ill-defined nature of such areas, including in his picture a small, half-silhouetted couple who might almost be engaged in a Zolaesque assignation at the city's limits.

For much of 1886, Van Gogh proceeded with the slow assimilation of the art around him in the capital and the cautious—and sometimes eccentric—advancement of his own painting. A series of dark still lifes of bottles and food shows his loyalty to a mode he had perfected at Nuenen, if now more deeply informed by works on similar themes by artists such as Théodule Ribot and Adolphe Monticelli. *A Pair of Shoes* (cat. 18) is similarly reminiscent of his own *Potato Eaters*, in its matter-of-fact description of the elements of working-class existence and the blunt, unaffected way in which it has been composed. More imaginatively, such studies can be seen as an extension of his self-portraiture, as further expressions of character imposed on inanimate objects, and as declarations of social and perhaps political allegiance. Using a palette dominated by blacks and umbers, Van Gogh has rendered

fig. 11 *The Moulin de Blute-Fin*, 1886, pencil. Van Gogh Museum, Amsterdam (Vincent van Gogh Foundation)

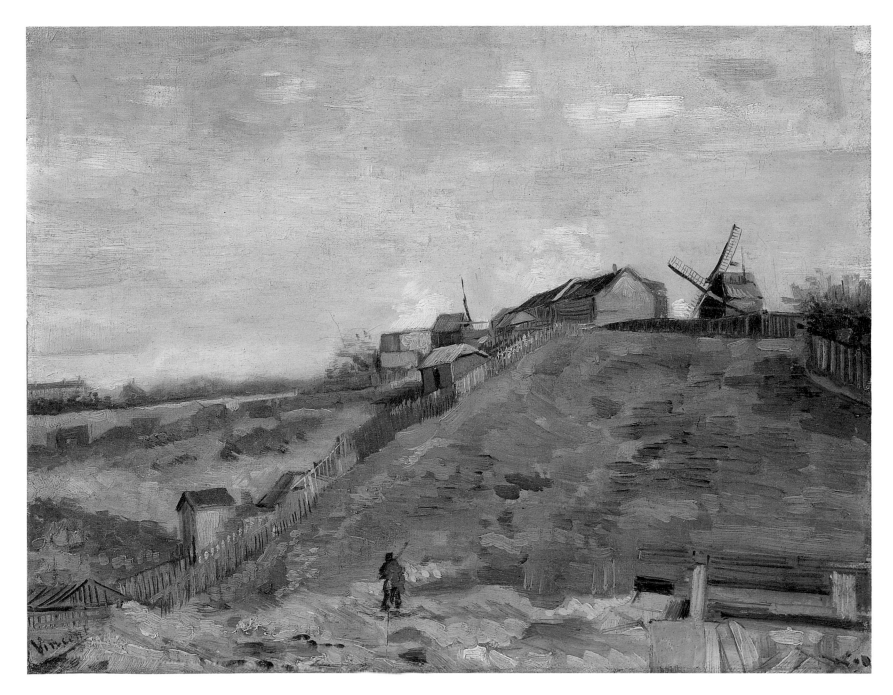

cat. 17 *The Hill of Montmartre with Stone Quarry,* 1886

the battered shoes with the same kind of con-
cerned scrutiny he once brought to his peas-
ant models, again infusing them with life
through his nervous brushwork and sharp con-
trasts of tone. Tackling his subject frontally—
like many of the Nuenen portraits—the artist
chooses to draw the shoes from their least leg-
ible angle and lingers over their crumpled,
leathery identity.

As in a number of earlier paintings, *A Pair
of Shoes* was executed over a previous work as
a way of saving on canvas, in this case at the
expense of a view of two-story houses in
Antwerp, Paris, or some other city. An almost
equally contested picture surface can be found
in the bizarre *Flying Fox* (cat. 19), a nightmar-
ish confection of sweeping brushstrokes and
dense paint that has few equals in Van Gogh's
oeuvre. Apparently executed at speed, this
broadly brushed sketch has been shown to rep-
resent a stuffed animal—in fact, an Indone-
sian Kalong—which the artist may have seen
in a private collection or a Paris museum, such
as the Jardin des Plantes. About this time Van
Gogh also carried out some drawings and
paintings of stuffed birds, among them an owl,
a kingfisher, and a parrot, typically acknowl-
edging the artificiality of their status in his
finished work of art. Unlike these works, how-
ever, the tones and colors of *Flying Fox* seem
intended to evoke a real nocturnal encounter,
or perhaps the kind of spine-chilling literary
experience known to Van Gogh in such sto-
ries as Edgar Allan Poe's *Tales*.

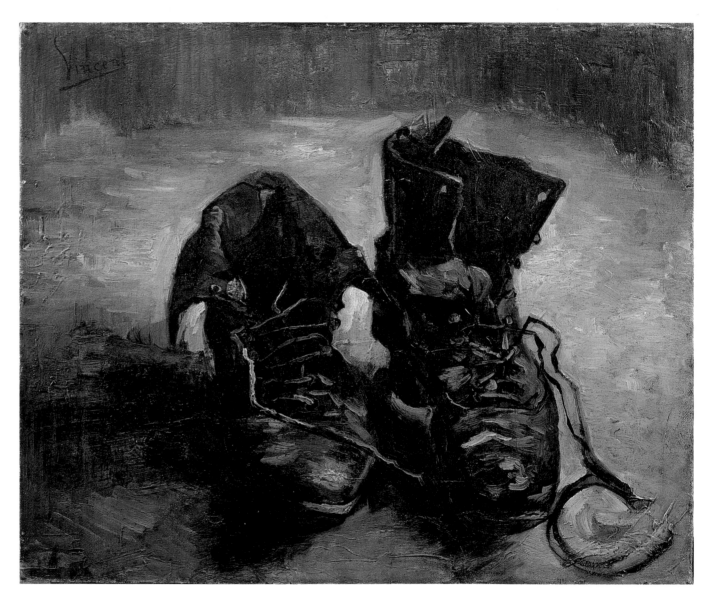

cat. 18 *A Pair of
Shoes*, 1885

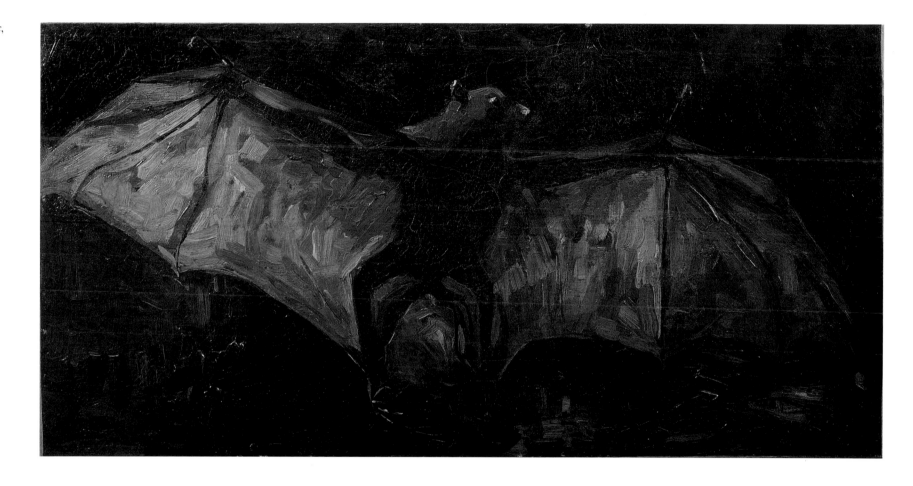

In one of the few letters to have survived from the Paris years, sent to Theo in the summer of 1886 when he was briefly away from the city, Van Gogh announced:

> I painted the pendant to those flowers which you have. A branch of white lilies—white, pink, green—against black, something like black Japanese lacquer with mother-of-pearl, which you know—then a bunch of orange tiger lilies against a blue background, then a bunch of dahlias, violet against a yellow background, and red gladioli in a blue vase against light yellow.[50]

During the summer and autumn months, he continued to work on more than thirty of these flower pieces, favoring large, sumptuous displays of blossoms arranged in a variety of decorative pots and vases. One of these canvases, a confection of red, pink, and cream flowers in a jug that has survived in the family (fig. 12), was *Vase with Autumn Asters* (cat. 20), a multi-hued explosion of visual audacity that seems to herald a new departure in his art. Partly under Theo's guidance, Van Gogh had continued to broaden his acquaintance with painting of all kinds, finally coming face-to-face with impressionist pictures and discovering for himself the brilliance of their color and the originality of their rural and metropolitan themes. In May of the same year he would have seen the latest of the series of impres-

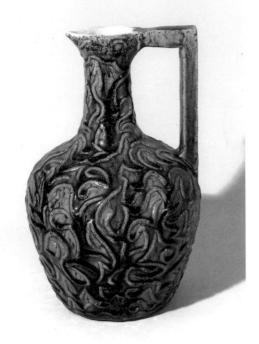

fig. 12 Earthenware
vase from the
Van Gogh family
collection. Van
Gogh Museum,
Amsterdam
(Vincent van
Gogh Foundation)

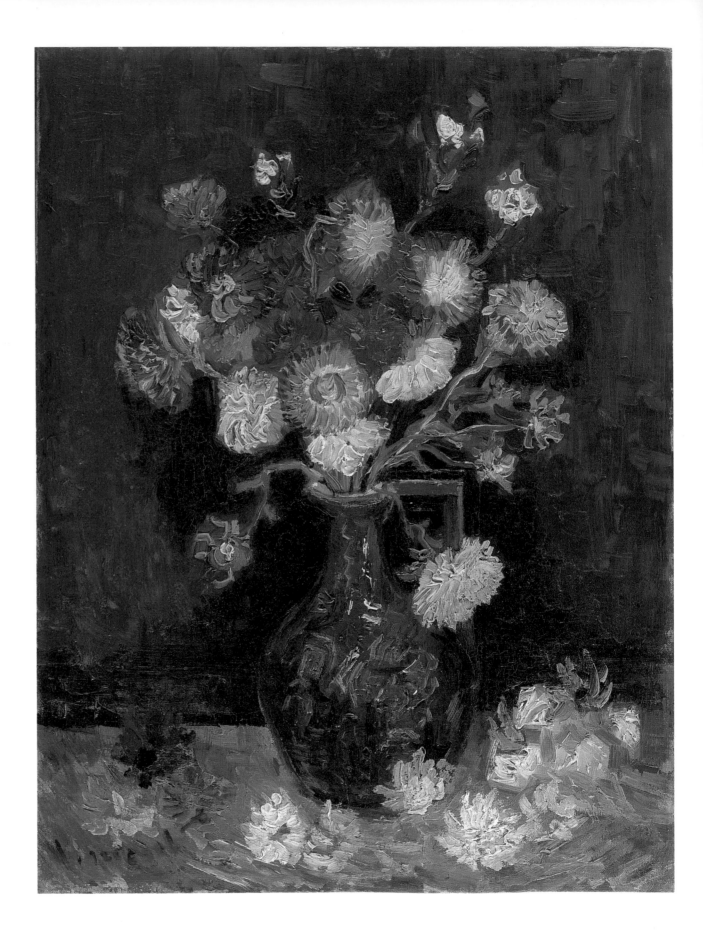

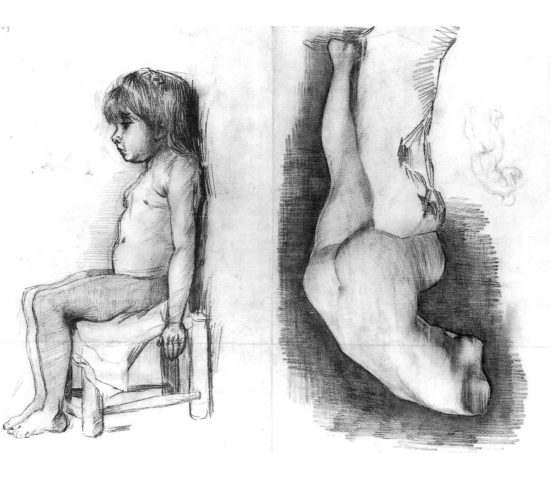

ing seems barely containable, the thick slabs and smearings of red in *Vase with Autumn Asters* threatening to overwhelm the touches of complementary green, and the petals and leaves as much modeled into the sensuous color as painstakingly described by it.

While completing *Vase with Autumn Asters*, Van Gogh evidently felt that the tonal and compositional balance of his picture needed some last-minute adjustment. A rather unimpressionist area of black-brown shadow was extended downward by several inches to lower the edge of the table, while a scattering of fallen blossoms was added over the already dried paint around the base of the vase, bringing fresh interest to this part of the design. As at Nuenen, the artist's vehemence on the canvas could still coexist with a sense of his own technical limitations, principally in such matters as the disposition of form and the drawing of the human figure. The struggle with flower painting was part of this continuing process of self-education, one that is apparent throughout much of 1886, though not always with the consequences Van Gogh had anticipated. His plan to make studies from paintings in the Louvre, for example, has left few traces in his sketchbooks and portfolios, and even the months spent in the studio of Cormon proved disappointing from a practical point of view. The double sheet of drawings made about this time, *Nude Girl, Sitting, and Plaster Statuette* (fig. 13), shows Van Gogh submitting to the traditional disciplines of his craft, working in monochrome

sionist exhibitions, reporting to an artist friend, "though *not* being one of the club yet I have much admired certain impressionist pictures— *Degas* nude figures—*Claude Monet* landscape."[51]

Vase with Autumn Asters was clearly stimulated by a new pictorial catholicism; by the complex flower studies of the leading colorist of the previous generation, Delacroix, for example; by still lifes Van Gogh is known to have admired at the Paris Salon, such as those by Ernest Quost and Georges Jeannin; and by recently completed paintings of sunflowers by

Monet, of chrysanthemums by Armand Guillaumin, and of peonies by Auguste Renoir. But common to all these sources was a preoccupation with color, not only recorded in its natural profusion but amplified and celebrated in the rich matter of oil paint. As Van Gogh's letters make clear, it was the opportunity to explore and juxtapose the most brilliant hues that provided the immediate pretext for these pictures, carrying forward the "analysis of color" he had begun so grimly at Nuenen. By now this enthusiasm for the possibilities of paint-

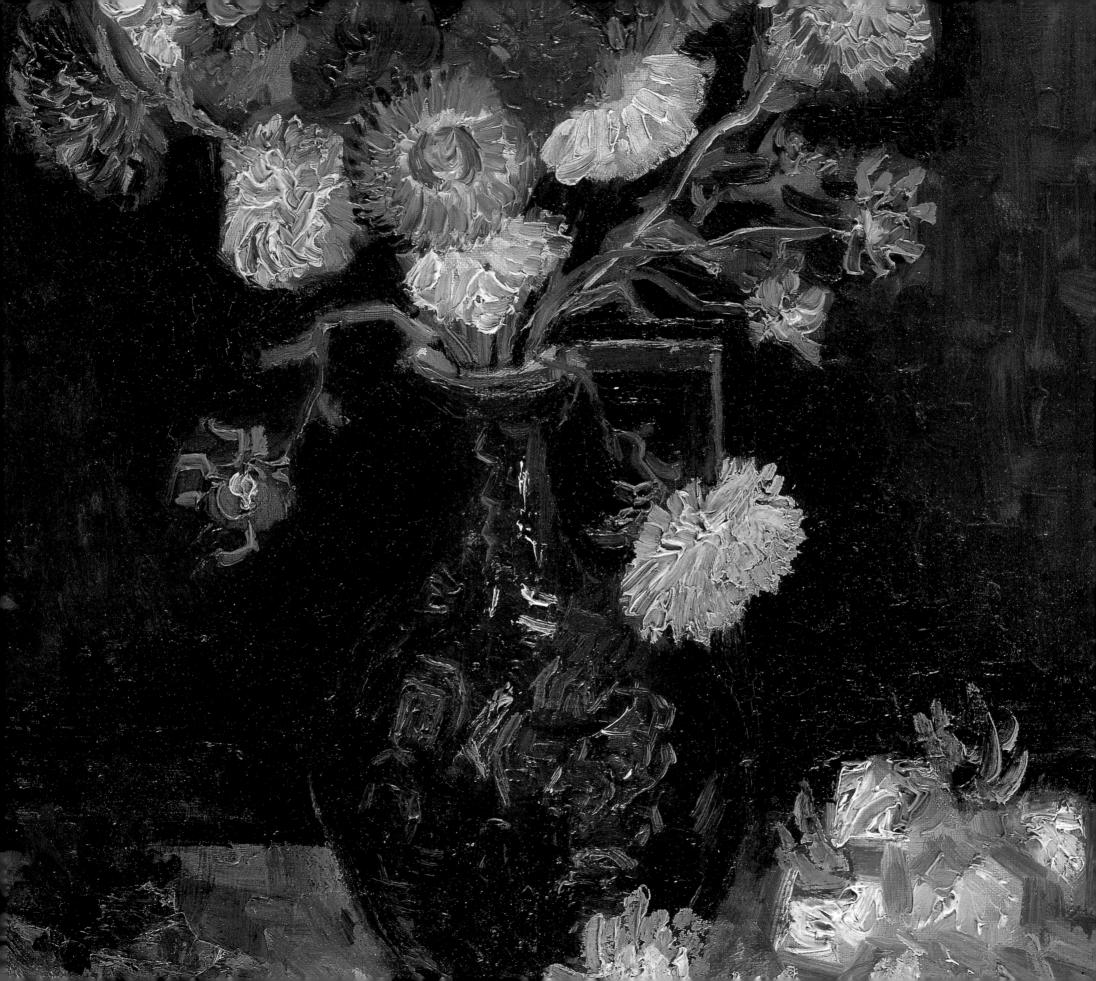

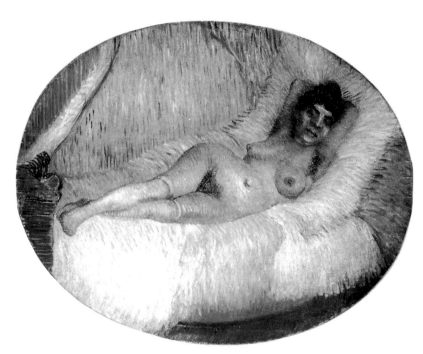

neoimpressionism, symbolism, idealism, and other still-emergent factions. Almost as soon as he had discovered impressionism, it seemed, Van Gogh was obliged to come to grips with the complexities of its successors.

Between the winter of 1886 and the spring of 1887, Van Gogh effectively crossed the divide into contemporary art; the inky tones and rustic themes of Nuenen were set aside, his loyalties to the realism of Millet, Breton, and Ribot brought up-to-date, and his belief in the salutary teaching of the academic regime abandoned. In their place, a fresh and dazzling gamut of painterly possibilities opened up, from the still half-absorbed lessons of the senior impressionists to the even more radical practices of the next generation. Soon he was painting pictures of street scenes and prostitutes that recall the work of Manet and Degas, such as *Nude Woman, Reclining* (fig. 14), interiors of cafés in the manner of Renoir and Jean-Louis Forain, and kitchen gardens that are virtual homages to Camille Pissarro, all the while moving closer to the ideas of his younger friends. Still capable of irascible behavior, he now found himself accepted as an equal by his colleagues and admired for those very qualities that had caused such difficulty in the past: his doggedness, his surprising ways with line and color, and his imperative need for self-expression. With his religious inclinations all but defunct, Van Gogh was confronted by a new language of communication, or rather several languages that vied with each other in their urgency and clamorousness. From this point on, his missionary zeal found a different kind of outlet—and a direct appeal to the emotions of his audience—in the vernacular of paint.

Summarizing his freshly formulated ambition in a letter to the obscure English painter Horace Livens, Van Gogh now stressed the importance of "a sincere personal feeling for color," describing his project as "struggling for life and progress in art."[52] It is this transitional Van Gogh, caught almost literally as he revised his self-image, that is preserved in two small studies of his head and shoulders from the beginning of 1887. In one, *Self-Portrait with Felt Hat* (cat. 21), the artist affects the blue-trimmed jacket and bow tie of the *boulevardier*, parading as a successful painter or even as a self-made entrepreneur like his art-dealer brother Theo (from whom he may have borrowed the outfit). The attempt at deception fails, of course, but the picture is altogether more compelling as a work of art in consequence. Not for the first time, it is the irregularities and contradictions that make the painting—the disproportionately large hat and delicate body, and the broad, staring brow—so that we are left with a haunting image of social and psychological discomfiture. The second work, *Self-Portrait with Straw Hat* (cat. 22), is less confrontational, if more outlandish as a sartorial statement. Now seated obliquely to the picture plane, the artist glances back at himself in three-quarter view, sport-

from plaster casts of approved antique statuary and the naked—and atypically youthful—living model. Both exercises were completed with considerable aplomb, but both must have seemed remote from Van Gogh's daily contacts with new kinds of art and their technical challenges. Help was at hand from Cormon's circle, however, if from an unexpected quarter. By the time he left the studio, he had met several other students and young painters who were to achieve prominence in the next decade, among them Henri de Toulouse-Lautrec, Louis Anquetin, and Emile Bernard, and through them was introduced to a wider circle of writers and artists who aligned themselves with

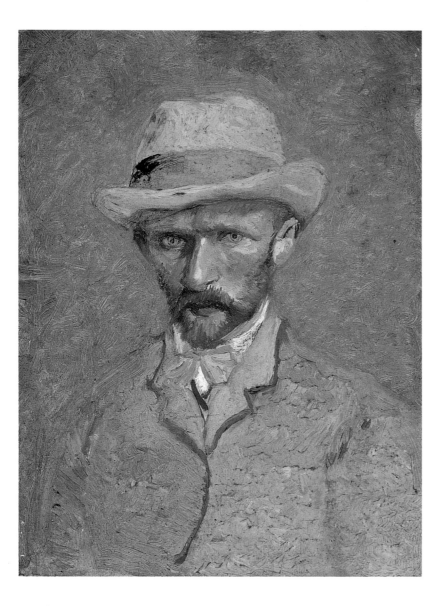

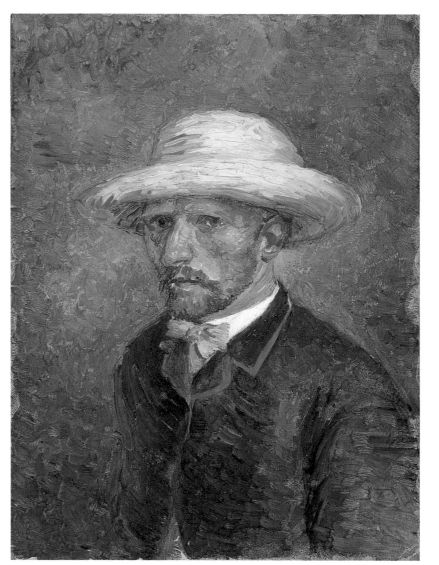

ing the same improbably fashionable jacket (here rendered in blue rather than pinkish gray) and unexpectedly summery headgear. Where *Self-Portrait with Felt Hat* was almost frighteningly defiant, its companion reveals the timid side of Van Gogh's nature, that of the country-bred pastor's son who fails to conceal his embarrassment in affected urban garb or in any kind of public role.

Almost as striking in both works is the freshly observed color and warm light that bathes the artist's head, effectively set off by cooler green-blues in the wall behind. This hot-cold opposition is ingeniously maintained within the figures themselves, where touches of bright red between jacket and collar contrast with the powder-blue tie, strokes of vermilion around the eyes heighten their metallic pupils, and passages of orange, ocher, and brown in the face reveal glimpses of blue-gray surface beneath. Van Gogh rarely chose to paint on this miniature scale, these two studies representing early, cautious steps in his attempt to come to terms with the novelties around him. There are also signs that the small brushes he used and the modest size of the supports gave the artist trouble (his fingerprints, where he struggled to hold the pictures, can clearly be seen at the edges of both paintings), but there is no mistaking the inventiveness of his technique. These are images conceived and executed in color, their fragmentary brushmarks generating confrontations of tone and hue that announce a redefined painterly self-consciousness. If some of this audacity was undoubtedly prompted by Van Gogh's exposure to mainstream impressionism, there is increasing evidence that other factors had now entered the equation.

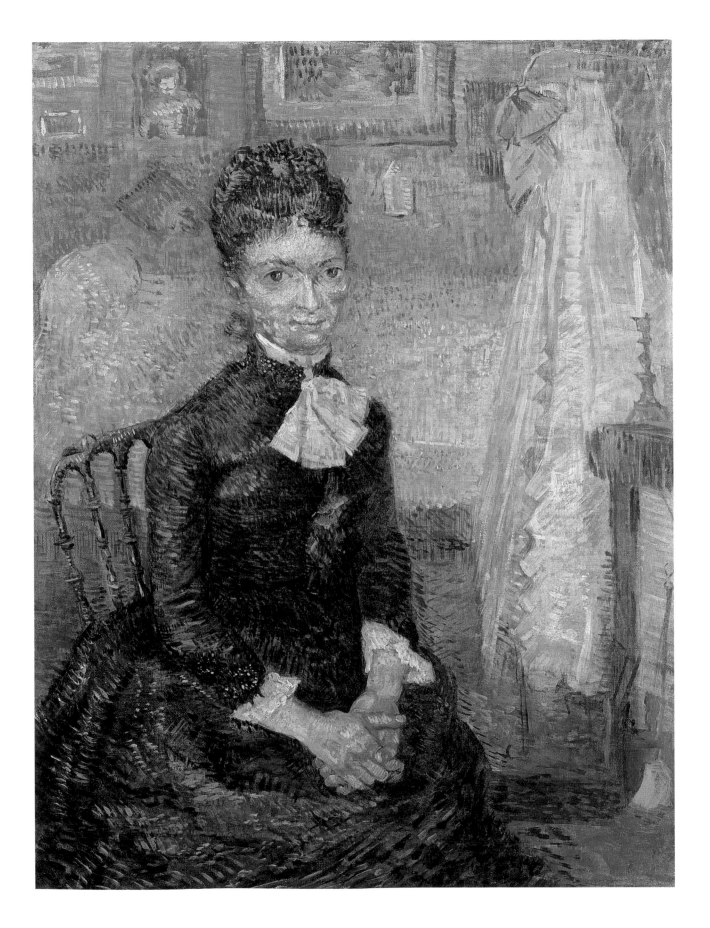

As long ago as May 1886, Van Gogh had witnessed the sensational appearance at the eighth impressionist exhibition of the canvases of Georges Seurat and his circle, which introduced a more methodical application of color to subjects that were typically bold, light toned, and urban. Known variously as pointillism, divisionism, and neoimpressionism, variants of this technique were soon adopted by a wide range of artists, from novices such as Toulouse-Lautrec to established figures like Camille Pissarro. Other independent exhibitions extended Van Gogh's familiarity with their work and with individual practitioners, among them Paul Signac, Charles Angrand, and Lucien Pissarro (one of Camille's sons), while his encounters at Cormon's studio seem to have encouraged Van Gogh's determination to put some of their innovations to the test. *Mother by a Cradle, Portrait of Leonie Rose Davy-Charbuy* (cat. 23), painted in the early spring of 1887, was one of the first of such extended experiments, here applied to a formal three-quarter-length portrait and a complex domestic setting. More subdued in tonality—as befits its subject—than the two self-portraits, the work is nevertheless constructed from myriads of tiny dots, dashes, and flickers of paint that cumulatively suggest the play of light on a modern bourgeois interior. Van Gogh had first brushed in a wash of thinned color over the broad areas of his composition, in a procedure favored by Seurat and several of his disciples, then built up an improvised lattice of fine strokes of con-

trasted hue. If his technique is neither consistent nor clearly directed by the theories in circulation around him, it must have seemed to the artist to be extraordinarily and thrillingly new.

Portraits of women in their homes—and even studies of middle-class mothers with newborn babies lying in their cribs—were not uncommon in impressionist circles and it is likely that Van Gogh had a prototype by Berthe Morisot or Degas in mind when creating this work. The circumstances in which he came to paint Madame Davy-Charbuy, the niece of the wife of the art dealer Pierre Martin, are unknown, but here at last Van Gogh appears to have found the kind of prosperous sitter from whom he hoped to earn his way in the city. But it was the artist's new metropolitan friend, Toulouse-Lautrec, with his own low-keyed variant of divisionist technique, who arguably had the most direct impact on the picture's appearance. A portrait of Toulouse-Lautrec's mother painted a few months earlier shows her seated in the foreground in a purple dress with furniture and drapes beyond, while the same delicate weave of brushstrokes and watercolor-like tones define the subdued domestic light. At this date, Toulouse-Lautrec—like Van Gogh—still clung to the broad tenets of realism, his modest interest in the pictorial notions of his colleagues taking second place to an incisive engagement with the humanity of his subjects. Just as the nervously maternal Madame Davy-Charbuy is allowed to dominate Van

Gogh's concerns, so the intense personality of the Dutchman himself radiates outward from Lautrec's roughly contemporary *Portrait of Vincent van Gogh* (fig. 15). Here Van Gogh is seen as the wiry, orange-bearded individual of legend, as described in the written and painted accounts of several acquaintances and now depicted in an unmistakably new milieu: the faceless, mirror-hung, metropolitan bar.

Dividing his time between the city's rural periphery and its less grand boulevards, Van Gogh was gradually to formulate his own vision of Paris, inflected by—yet ultimately distinct from—the perceptions of those artists with whom he now associated. His *Boulevard de Clichy* (cat. 24), for example, a view of the broad and populous thoroughfare dividing the southern slopes of Montmartre from the northern quarters of the city, belonged to a classic impressionist genre that had been linked with Renoir, Gustave Caillebotte, Pissarro, and others for more than a decade. In a variant of the same scene in pastel on paper, Van Gogh even included a gesture of homage to Degas (whose current studio was a matter of yards away from the site) in the distinctive device of a pair of truncated passersby in the foreground, a detail omitted from the final work. By the early spring of 1887, when Van Gogh's picture was executed, a more radical handling of color and an unaccustomed painterly discipline had entered such works. Still feeling his way in unfamiliar artistic territory, Van Gogh has imposed a loose grid of horizontal and vertical

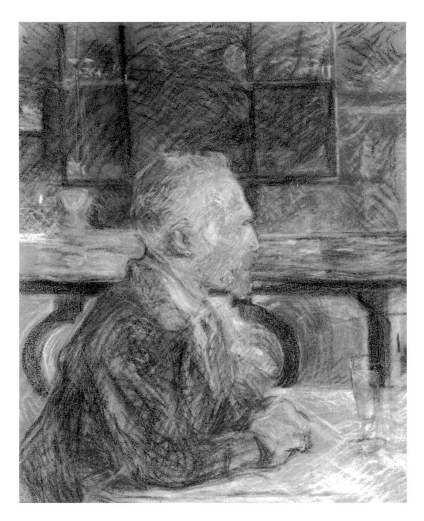

fig. 15 Henri de Toulouse-Lautrec, *Portrait of Vincent van Gogh*, 1887, pastel on cardboard. Van Gogh Museum, Amsterdam (Vincent van Gogh Foundation)

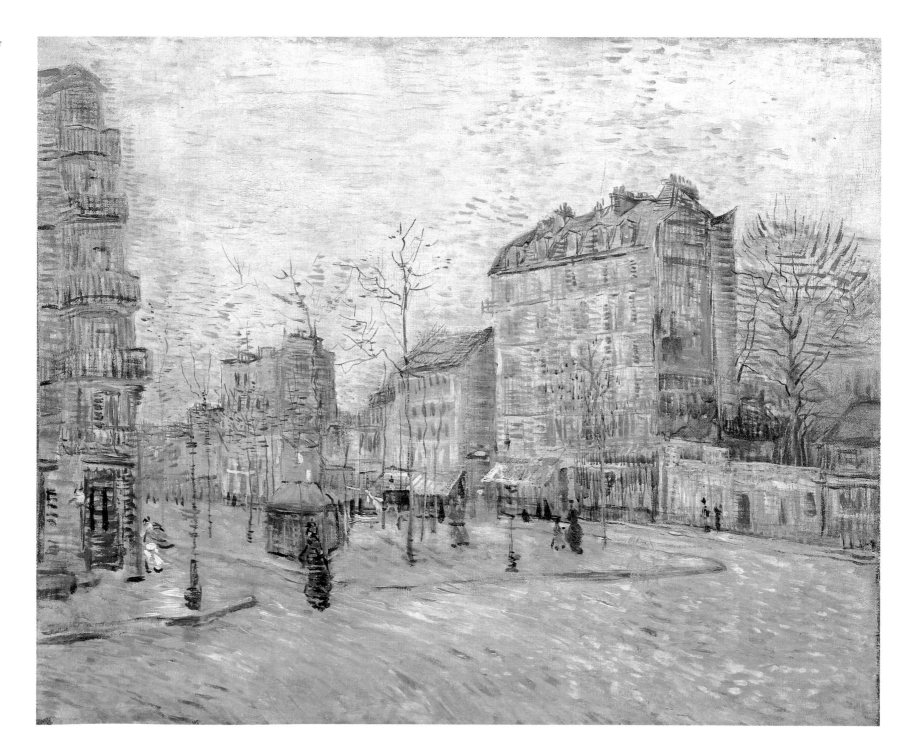

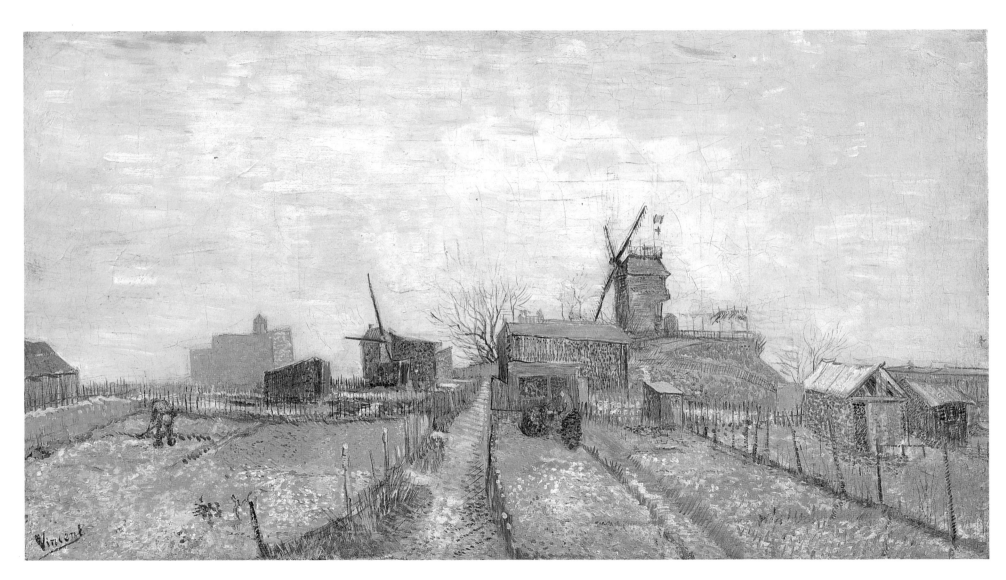

cat. 25 *Vegetable Gardens and the Moulin de Blute-Fin on Montmartre,* 1887

fig. 16 Drawing of a perspective frame, 1882, sketch in letter 223. Van Gogh Museum, Amsterdam (Vincent van Gogh Foundation)

brushmarks on the scene, not just in the architecture but in such unexpected areas as the sky and the sparse foliage of the trees. What might have been a desiccated system in other hands, however, becomes a bristling, nervous web of visual energy, fusing line with color in a dozen different ways. Pedestrians are outlined in purple, pavements edged with green, until it is only the pervasive touches of frosty white paint and the underlying beige of the canvas that seem to prevent an eruption of the artist's palette.

In *Vegetable Gardens and the Moulin de Blute-Fin on Montmartre* (cat. 25), painted at about the same time, Van Gogh returns to a more subdued tonality and to imagery first confronted the previous spring. What is new here is the pronounced horizontal format and the scale of the canvas—half as wide again as that of the *Boulevard de Clichy*—as well as Van Gogh's courage in tackling such an uneventful, even formless clutter of spaces. If the windmills provide a nominal focus for the scene, it is the ragged allotments, paths, and improvised huts that are the real object of the painter's affection. His eye lingers on fence posts and clumps of weeds, on the differently textured surfaces of tilled and overgrown plots, his brushes rendering all of them in differentiated dabs and fine hatchings of fresh color. It is as if Van Gogh's evolving technique has briefly overlapped with memories of the countryside, a possibility strengthened by the presence in the middle distance of three labor-

ing figures, all of whom might have stepped from his Nuenen repertoire. This sense of continuity and of self-conscious progression is borne out by a close scrutiny of the picture surface, where pencil lines beneath the paint reveal the artist's struggles with his rather amorphous composition. Traces of a taller, more top-heavy mill can be seen in the sky, while hints of a penciled grid across the canvas suggest Van Gogh's reliance on the perspective frame mentioned in letters both before and after the Paris period. This structure (fig. 16), of a kind used for centuries to study spatial recession and pictorial design, shows that Van Gogh was still battling with inexperience and willing to learn from the simplest expedients. His success in bringing to completion a complex work like *Vegetable Gardens and the Moulin de Blute-Fin on Montmartre*, however, one of a group of increasingly ambitious canvases of Montmartre allotments, seems to indicate that this particular fight was almost over.

It is tempting to read the superb little painting *Flowerpot with Chives* (cat. 26) as another somewhat sentimental reflection on rural life by the newly urbanized Dutchman. By bringing this miniature kitchen garden into the apartment he shared with Theo, Van Gogh was able to enjoy fresh spring color, earthy textures, and the chance to contrive another painted composition beyond the reach of the weather. As so often with Van Gogh, such small, unprepossessing canvases find him at

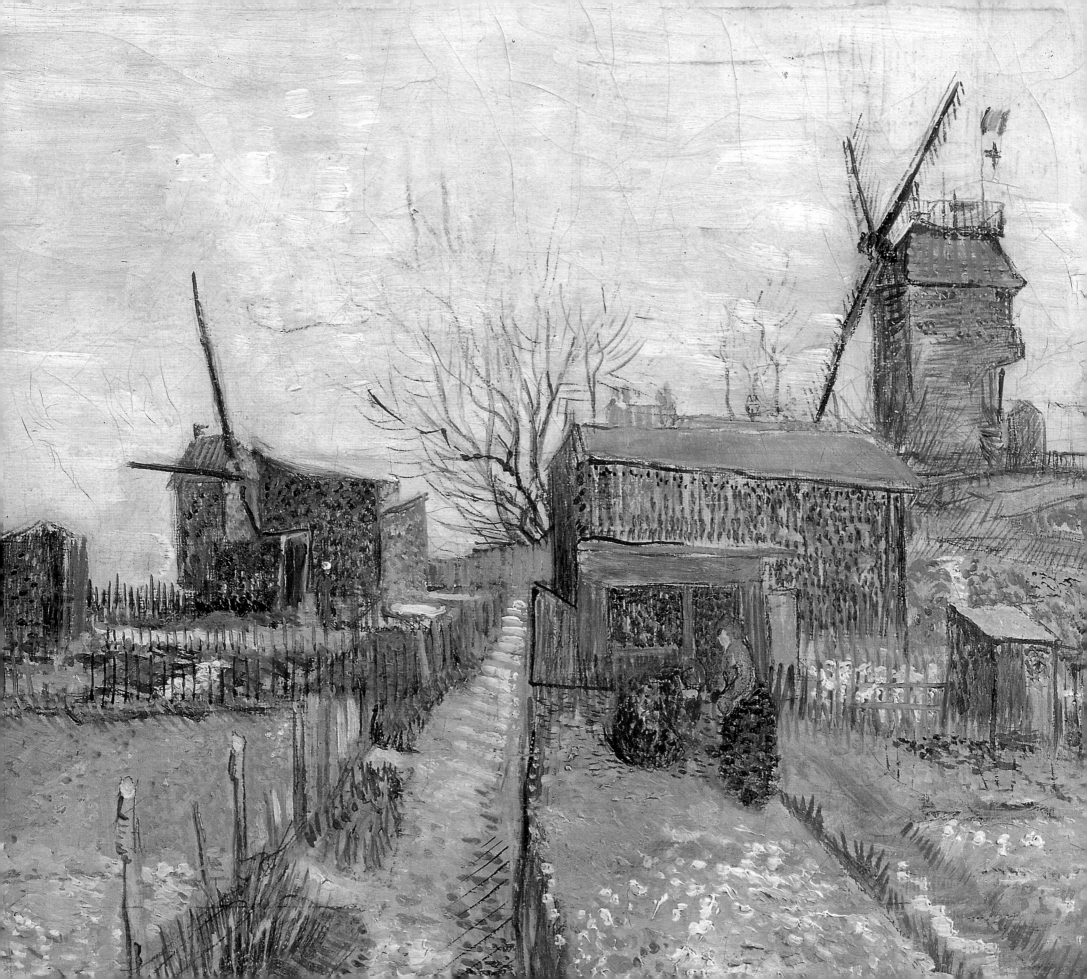

cat. 25 Detail

cat. 26 *Flowerpot with Chives*, 1887

his most unguarded, revealing his working methods in their most lucid form and free from grander rhetoric. In painting the chives themselves, for example, the artist has chosen a fine brush and a range of sharp mineral greens, his fine vertical strokes summarizing to perfection the pale stems and abundant growth of the shoots. Within this mass, streaks of complementary brick red, crimson, and purple discreetly exploit his new understanding of color theory, establishing a partnership of answering hues that is echoed in wall, tabletop, and flowerpot. Almost centrally placed, the pot is subtly counterbalanced by a bunch of picked chives at lower right, while two or three straying leaves explore the space around the pot and heighten passages of tonal contrast. An unexpected aspect of the work is the haziness of the background wall, which on closer inspection turns out to have been "wiped" with a brush or cloth at an advanced stage in the picture's execution. Proof that this occurred after the resolution of the initial image is found at the center of the upper edge, where the artist's signature and the date "1887" can be seen *beneath* the blurred paint, suggesting that certain elements of the design—and perhaps the wallpaper pattern itself—were added some time later.

The same terra-cotta-and-green wallpaper is emphatically present in *Still Life with Carafe and Lemons* (cat. 27), but there the similarity between the two pictures ends. Where *Flowerpot with Chives* might be seen as an exercise in

late impressionism, *Still Life with Carafe and Lemons* is radical in structure and purpose, no longer dwelling on the pleasures of dappled light or the sensuous experience of nature but on the expressive rhythms of art itself. Here the sensitive drawing of organic form is replaced by stark outlines and rudimentary modeling, the plausible roundness of a flowerpot by the almost flat silhouette of a painted flask. Alarmingly, the bright green tabletop seems to plunge toward the floor rather than out at the viewer, while the vividly three-dimensional fruit dish cuts into the picture plane as if about to detach itself from the ensemble. Whatever Van Gogh's ambitions were for this painting, they did not include the reassurance of his audience or the continuance of the great tradition of still-life painting, once so prominent in Dutch art. Even more than the Nuenen canvases of bottles, jugs, and vegetables, *Still Life with Carafe and Lemons* asserts the right of the artist to invent and modify, and to build his picture from a fusion of sensation with painterly engineering. Van Gogh clearly felt proud enough of the picture to sign and date it with a flourish, perhaps sensing that it had brought to fruition many of the earlier experiments of the year. Though the paint is thin, the purposeful interplay of reds and greens in wall and table, and purplish shadows beneath yellow lemons, is achieved with aplomb, and every relationship between contours is finely considered, as a series of last-minute adjustments with a needle-fine brush vividly demonstrates.

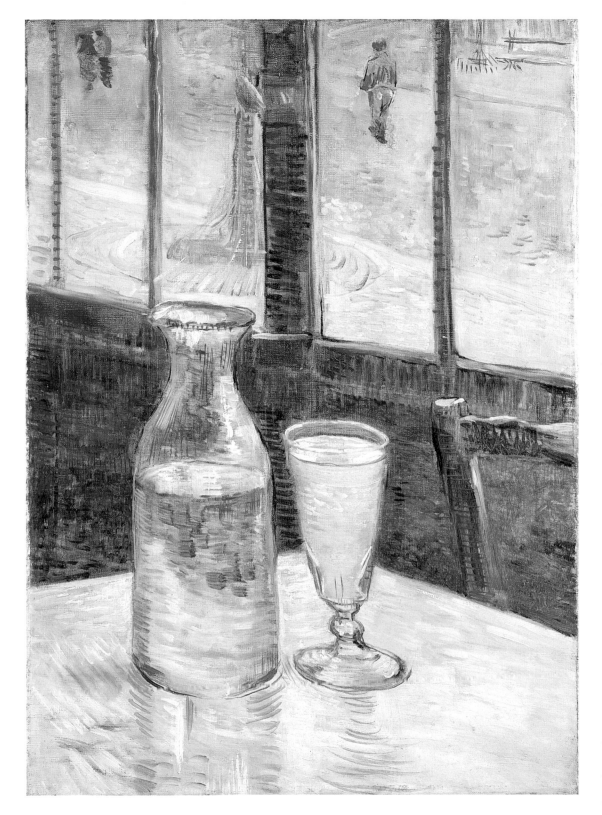

The radicalism of *Still Life with Carafe and Lemons* reveals how far Van Gogh's art had traveled in his stay of little more than twelve months in the capital. As ever, his progress was far from systematic; he does not seem to have followed new principles or techniques to their logical conclusion, for example, but tended to respond to chance encounters with individual pictures, with sympathetic fellow painters, or with freshly stimulating subjects. But by the early summer of 1887, he had mastered in his own distinctive way many of the idioms of his avant-garde friends, alternating between them in a sometimes disconcerting manner and expressing a pictorial curiosity—even a kind of playfulness—that contrasts sharply with his former gravity. It is difficult not to see another tabletop arrangement, *Glass of Absinthe and a Carafe* (cat. 28), in this light, as part of a witty pairing with the similarly scaled *Still Life with Carafe and Lemons* that reflects as much on their respective styles as on their content. Self-consciously recalling the feather-light touch of Lautrec and even one of that artist's earlier canvases, Van Gogh's *Glass of Absinthe and a Carafe* is likewise respectful of conventional space and the logic of light and shade. If *Still Life with Carafe and Lemons* seems perversely to contradict such qualities, a second look at both works shows a tantalizing unity in their compositional structure. Where the vertical background forms and shadowed diagonal in the former describe the café window, a similar geometry in the latter represents wallpaper

and a green table edge. Whatever the origin of this curious diptych, such inventiveness also marks a loosening of Van Gogh's strict dependence on firsthand contact with his motif, formerly the cornerstone of his art. At least one of these pictures must have been made as a synthetic response to the other, raising the possibility that entire passages of paint—such as the rather insubstantial street scene in *Glass of Absinthe and a Carafe* or the patterned background of *Still Life with Carafe and Lemons* (which reappears as a *horizontal* design in another work)—were freely invented for pictorial reasons.

The still life, the café interior, and the city street had all emerged as topical, implicitly progressive themes among the urban artists with whom Van Gogh now fraternized. In this same year, for instance, Bernard made a virtual manifesto of a decorative pattern of jugs and fruit, inscribing on it the words "First Essay in Synthetism and Simplification." Toulouse-Lautrec famously pursued the outer reaches of sensation in his studies of bars and dance halls, while Anquetin and Signac depicted nighttime shops and suburban highways in their latest abrasive canvases. Van Gogh was drawn to the art of all these individuals, exchanging paintings with several of them and developing a friendship with Bernard (fig. 17) that continued by letter even after he had left Paris for Arles. What little we know of his social encounters suggests that Van Gogh entered energetically and sometimes violently

into their debates without attaching himself to any faction, warning Bernard not to become "sectarian, narrow-minded"[53] over the matter of pointillism. Increasingly secure in his own talent, Van Gogh was able to report to Livens that he had "found four dealers who have exhibited studies of mine"[54] and even discovered a role as an exhibition promoter in his own right. In the spring of 1887 he organized a display of Japanese prints at the Café Tambourin, later in the year becoming a prime mover behind an ambitious show at the Grand Bouillon restaurant in the avenue de Clichy, where his works, as well as those by Anquetin, Bernard, Lautrec, and others, attracted some attention but only modest sales (Paul Gauguin was among its enthusiastic visitors). A paint-

ing from the summer months, *Interior of a Restaurant* (fig. 18), may show one of his own canvases hanging on the wall of such an establishment, emphasizing Van Gogh's continuing need to promote his output and perhaps his lingering concern to establish contact—through his art—with the ordinary city dweller.

Van Gogh's few surviving references to his own painting from this period stress the energizing, life-giving capacity of the medium and its essentially unpredictable nature. In the scattered phrases of a letter to his young sister Wil, he came as close to formulating a private testimony as at any point in his career; tenderly discouraging Wil from excessive study, he urged her to "amuse yourself too

fig. 17 Vincent van Gogh and Emile Bernard at Asnières, 1886, photograph. Van Gogh Museum, Amsterdam

fig. 18 *Interior of a Restaurant*, 1887, oil on canvas. Rijksmuseum Kröller-Müller, Otterlo

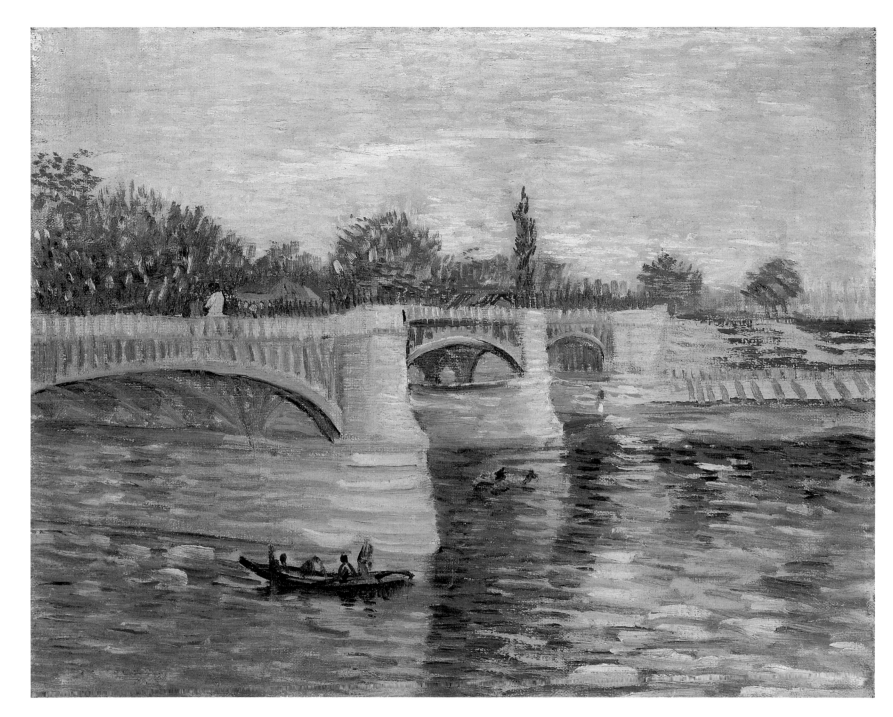

cat. 29 *The Seine with the Pont de la Grande Jatte*, summer 1887

much rather than too little, and do not take art and love too seriously. One can do so very little about it oneself: it is mainly a question of temperament."[55] He recommended the naturalist writers to her, explaining that "they paint life as they feel it themselves, and thus they satisfy the need we all feel of being told the truth."[56] In a later paragraph he was unusually explicit about his hard-won beliefs: "What is required in art nowadays is something very much alive, very strong in color, very much intensified."[57] Much of Van Gogh's remaining work from the Paris period can be seen as the expression of these ideals, as a vibrant outpouring of deeply felt sensations and evocative forms that were "true"—even in a modern city—by virtue of their genuineness.

In *The Seine with the Pont de la Grande Jatte* (cat. 29), it is the leap-frogging structures of the bridge itself that define this dramatic truth, its scale accentuated by the tiny figures in boats

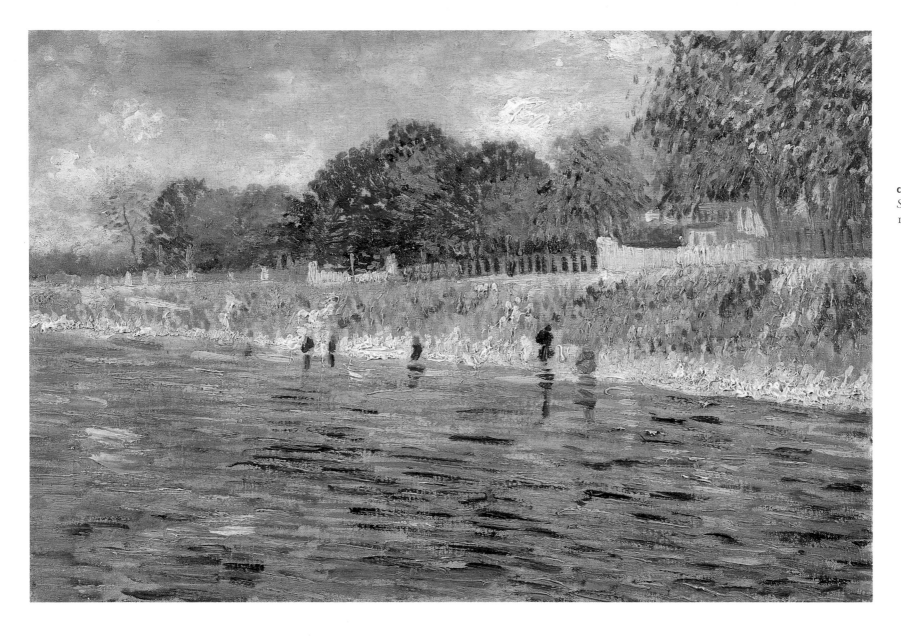

on the river below. Slight anomalies in scale and perspective suggest the urgency of Van Gogh's project, as he tackled the confrontation between industrial strength and human insignificance—a familiar theme in the contemporary novel, and in the work of painters from Monet and Caillebotte in the previous decade to Bernard and Anquetin in his own. Reversing the positions of subject and viewer, Van Gogh positioned himself on just such a bridge to paint *Banks of the Seine* (cat. 30), a study of the river and its adjoining parks and gardens that speaks eloquently of his interest in Seurat and Signac. Creating a work "very strong in color, very much intensified," Van Gogh has woven a dense tapestry of subtly varied brushmarks, the horizontal thrust of the river answered by embroiderings of summer pinks, yellows, and lush greens, the softness of the clouds offset by the multihued stippling of the riverbank. Threads of red and deep blue unify this sensuous image, their richness adding to the conviction that Van Gogh experienced the view—and almost certainly painted it— at firsthand. Urging the reclusive Bernard to work more often in the open air, he told him, "in the studios one not only does not learn much about painting, but not even much good about the art of living."[58]

Both of these small pictures were executed near Asnières, a suburb of Paris where Bernard was currently living. Over the summer of 1887, Van Gogh frequently set out from the city

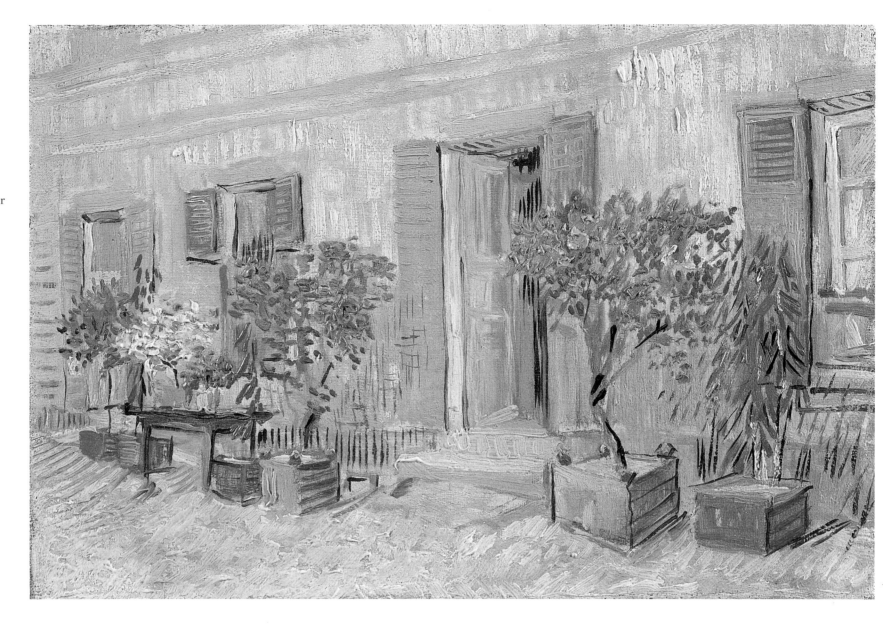

cat. 31 *Restaurant at Asnières*, summer 1887

with canvases, paints, and easel on his back and worked in this area, deepening his friendship with Bernard and occasionally painting outdoors with companions like Signac. His contemporaries tell us that Van Gogh would often return with a number of small, energetically brushed pictures he had painted that day, such as the sparkling lemon-yellow *Restaurant at Asnières* (cat. 31). Combining the chromatic boldness of a Japanese print with his own painterly shorthand, these canvases are un-

surpassed in their economy of means and clarity of purpose. Richly laden brushfuls of white, ocher, and a spectrum of yellows seem to take on the material life of the shadowy restaurant facade, while slashes of Prussian blue and viridian fix the shrubs in the hot summer air. Even more than at Nuenen, however, Van Gogh was now mindful of the need to produce larger and more exacting compositions, both to measure himself against his contemporaries and to catch the eye of prospective buyers. One of

the most ambitious canvases of this period was *Courting Couples in the Voyer d'Argenson Park in Asnières* (cat. 32), an elaborate conjunction of the practical learning and painterly initiatives of the previous twelve months. Remaining just this side of gaudiness, the picture simmers with seasonal heat and dense color, echoing the flower pieces of 1886 and Van Gogh's excited response to Rubens and Delacroix, as well as the lessons of impressionism and his encounters with its successors. As a subject, it main-

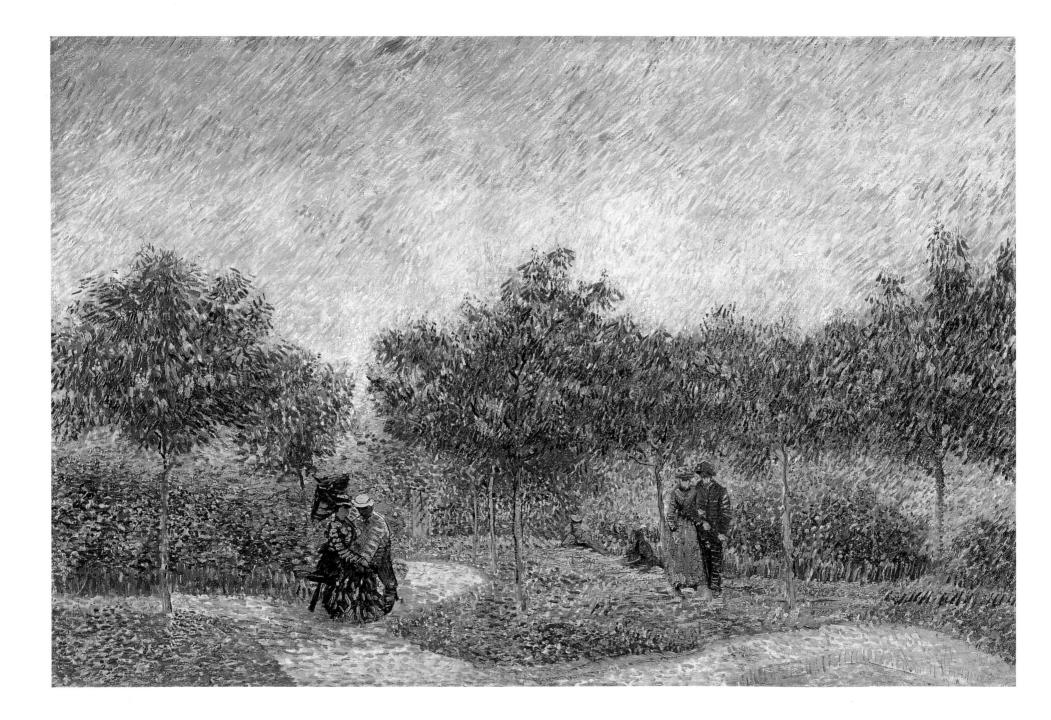

tains his equivocal love affair with the city, blending a mass of sky and foliage with the structures of a formal park and the heady delights of the open air with the rituals of bourgeois courtship. And in terms of technique, the work aspires to—and largely achieves— a grand design in the manner of Van Gogh's great predecessors, locking together draftsmanship, nuanced brushwork, and pictorial rhythm in a continuous, spacious whole.

For all its accomplishment, *Courting Couples in the Voyer d'Argenson Park in Asnières* remains a slightly unsettling work, a further product of Van Gogh's excluded, even paranoid, vision of the urban milieu and of domestic contentment. Using his own modified version of Seurat and Signac's divisionism, the artist has built the entire image from dense clusters of color, carefully nuanced and orchestrated according to their descriptive function. The paths, for example, are lightly broken by horizontal dashes that suggest gravel; the sky flows in parallel waves of grays, beiges, and yellowish blues; while areas of foliage are variously dappled and fragmented into blossoms and blocklike leaves. Unlike Seurat's serenely organized canvases, the result is unstable and near turbulent, as if too many sensations or too strong a personal engagement has been condensed into this single canvas. In a letter written some weeks later, Van Gogh hinted at a suggestive equation between such pictorial qualities and his own emotional experience—claiming, for example, that "there

are certain colors which cause each other to shine brilliantly, which form a *couple*, which complete each other like man and woman"[59]— and there can be little doubt that the haunting but rather awkward figures in this complex painting carried a similar burden.

By contrast, a group of pastoral scenes made alongside these grander compositions seem almost carefree, largely devoid of human content and dominant, organizing form. *Trees and Undergrowth* (cat. 33) finds the artist at the edge of a thicket, presumably in another Parisian park, looking out toward the distant sunlight from his cool, leafy seclusion. Apart from the horizontal strip of yellow-green light and the answering axis of lilac-green tree trunks, all is dissolved in shifting, fragmentary tones and myriad touches of light and shadow. Van Gogh may have had in mind similar subjects by Monet, an artist he continued to revere in his letters, and images such as *Trees and Undergrowth* certainly recall the more untroubled, celebratory qualities of early impressionism. At first glance, another canvas from this period, *A Park in Spring* (cat. 34), seems to need only a few holidaymakers or a parasol-wielding picnic party to complete its idyllic vision. Again, the profusion of nature rather than the organizing hand of man is allowed to determine the scene, with only a vestigial central pathway bringing order to the flower-strewn chaos.

It might also be said of both works that they are pictures of solitude and artistic struggle,

as Van Gogh—like Monet and those of his colleagues who continued to paint directly from the landscape—pitched his practical resources against the ultimate challenge of nature. Almost featureless subjects like these seemed to heighten the elemental confrontation, providing the purest conditions for research into light, color, and the endlessly elusive nature of painting itself. Deceptively simple in appearance, an examination of *Trees and Undergrowth* and *A Park in Spring* reveals that both were the result of subtle planning and complex negotiation on the canvas surface, and that each benefited from Van Gogh's new fluency in the languages of art. A partial clue to his approach is found in correspondence from these months, when Van Gogh told a fellow painter "I did a dozen landscapes too, frankly *green* frankly *blue*."[60] What he does not specify is that both canvases were prepared with a ground of warm red-brown, precisely the tone to throw his subsequent blues and greens into maximum relief. As the dabs of bright color were applied, this rich underlayer was left visible between the strokes and in places a sharp instrument—probably the pointed end of the brush—was used to scratch away excess paint and reassert the original surface. A gently insistent dialogue resulted, the mysterious depths of forest and undergrowth hinted at in the deeper color but the sparkle of light finally dominating both scenes.

The difficulty of bringing articulation to such ill-defined subjects is brought home by

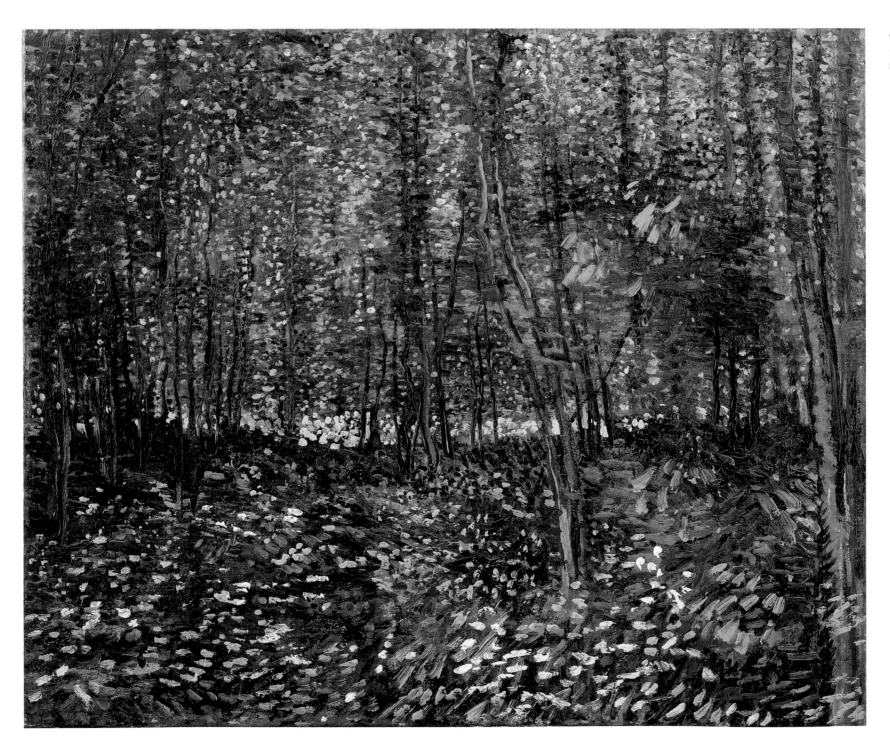

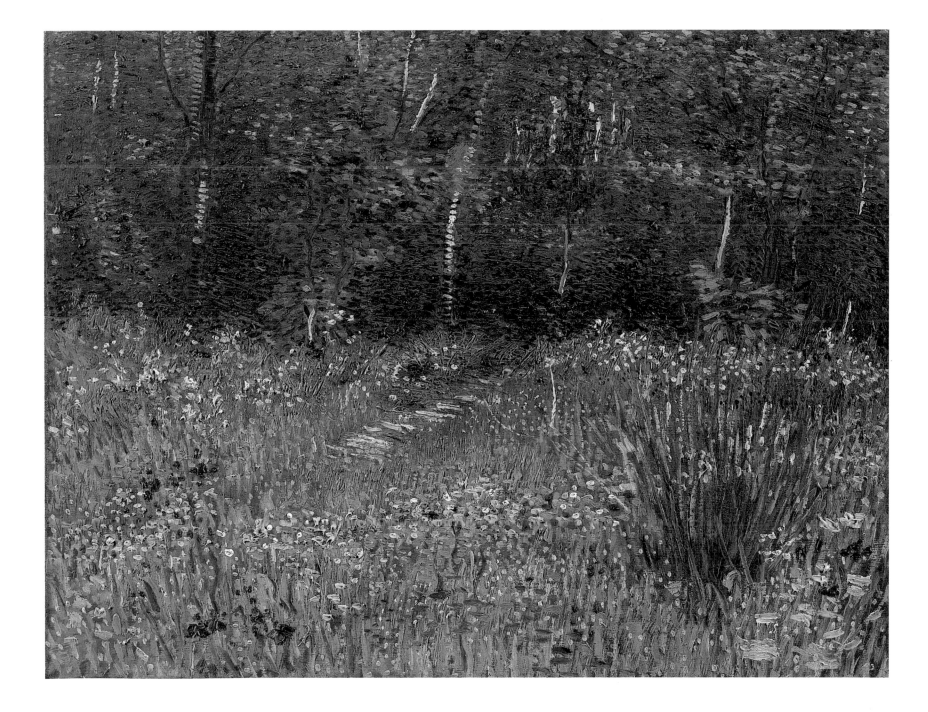

the recent discovery of a finely ruled grid beneath *A Park in Spring* (fig. 19). Continuing the practice begun in Nuenen and already applied in Paris in *Vegetable Gardens and the Moulin de Blute-Fin on Montmartre* (cat. 25), Van Gogh clearly erected his perspective frame in front of the flowering meadow and relied on its pattern of regular threads to help locate the principal masses of the motif. If conventional perspective forms are conspicuously lacking from the finished painting, Van Gogh's determination to establish space and depth is dazzlingly evident in his controlled marshaling of brushstrokes. As the eye moves from middle distance to foreground, hazy touches and broader flourishes are progressively overtaken by points or disks of brilliant color that resolve themselves into individual flowers and leaves beneath the artist's feet.

Van Gogh was the first to acknowledge that many of his smaller canvases were essentially studies, ranging from technical exercises and mementoes of visits, to preparatory trials for a public-scale "picture" in the nineteenth-century sense of the word. Before he left Paris for Arles, he embarked on several other major projects, partly with his exhibition prospects in mind and partly to conduct experiments on a more demanding scale. If his preference for portable canvases and rapid execution limited his room for maneuver, some of the compositions undertaken toward the end of 1887 were unquestionably to pave the way for the classic statements of the Provençal years. One of

fig. 19 Infrared photograph showing grid of *A Park in Spring.* Van Gogh Museum, Amsterdam

these, the life-size *Portrait of a Restaurant Owner, Possibly Lucien Martin* (cat. 35), is typically uncompromising, setting the burly head and shoulders of the sitter against a brightly lit background and confidently using an old master format for a boldly contemporary subject. Attempting to emulate his predecessors in technique as well as design, or simply struggling with this unfamiliar expanse of canvas, Van Gogh has built up a crustlike paint surface and labored over both texture and color.

The streaked creamy-beige wall, for example, was once both plainer and flatter, and the present mid-gray jacket has been modeled over a deeper blue, while the face reveals strokes of almost every tint on the artist's palette. Van Gogh's desire to do justice to his subject may have been prompted by the portrait's origins and the identity of the model. It has been suggested that the latter was Lucien Martin, the proprietor of the Grand Bouillon restaurant where the artist and his friends showed their

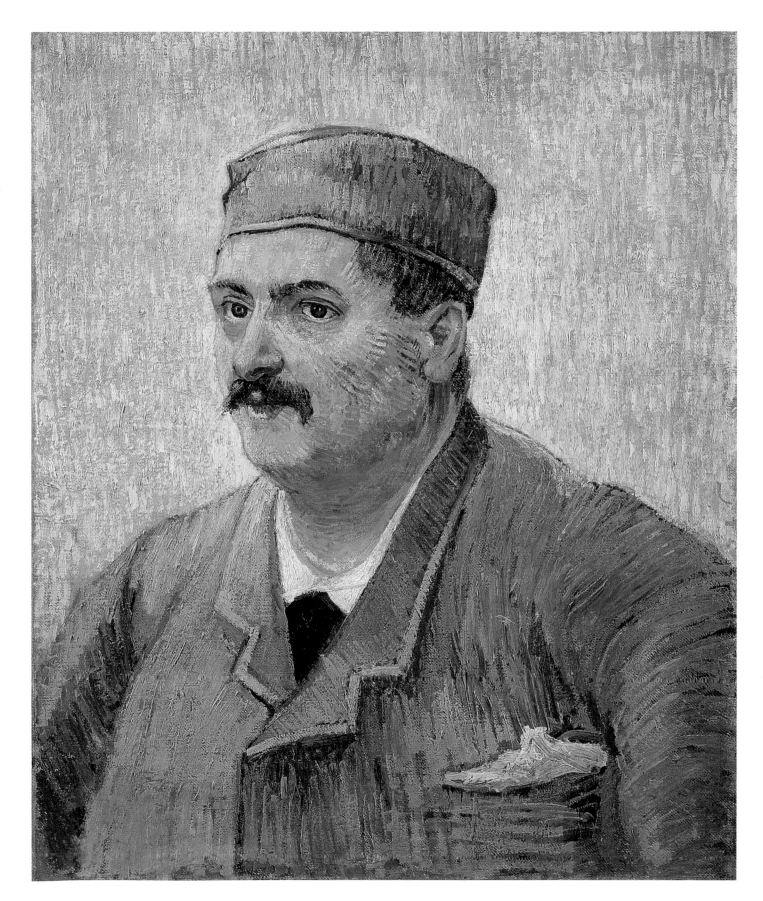

cat. 35 *Portrait of a Restaurant Owner, Possibly Lucien Martin*, 1887

work in November 1887, and it was perhaps Van Gogh's wish to stand out on this occasion—or conceivably to mark the owner's participation—that aroused his unusual ambitions.

If the portrait of Lucien Martin was indeed included in the November show, it joined an increasing number of works by Van Gogh known to have been exhibited in dealers' galleries and elsewhere during his Paris years. After reclaiming some of his pictures from a display at the Café Tambourin, for example, Van Gogh was able to announce that the color merchant Père Tanguy had "put a canvas I've just done in his window."[61] In December, the large *Courting Couples in the Voyer d'Argenson Park at Asnières* was installed in the rehearsal room of the Théâtre Libre Antoine on the rue Blanche, not far from where Van Gogh lived, and the following spring his painting *Romans Parisiens* was accepted for the Independent group exhibition. For the time being, it seems, Van Gogh had chosen to broaden his appeal to the market, abandoning his attempt to persuade the leading dealers in impressionism—such as Portier and Durand-Ruel—to take work on a regular basis and identifying himself with more peripheral venues. Though little is known of his relationship with Theo at this time, Van Gogh appears to have arrived at an appreciation of his brother's delicate position at the well-established firm of Boussod et Valadon (as Goupil's was now known) and admired his pioneering efforts in promoting the work of still controversial figures like Degas, Monet,

Alfred Sisley, and Pissarro, for whom Theo sold pictures or organized modest exhibitions during these difficult years.

Like many of his less fortunate peers, Van Gogh found the stoutly republican Père Tanguy—an unusual combination of paint seller and informal art dealer—a generous and sympathetic support when his funds were low. Tanguy was occasionally willing to accept pictures in exchange for canvases and colors, almost inadvertently accumulating a stock of works by the city's rising stars, among them the still little-known Cézanne and younger painters like Gauguin and Bernard. Van Gogh and Bernard both painted portraits of the dealer that capture something of his unaffected yet substantial presence, the largest of Van Gogh's three studies (fig. 20) joining his most complex pictorial statements about a fellow human being. Surrounded by the rainbow hues of the Japanese prints that the artist—and presumably the sitter—so much admired, Tanguy is positioned centrally and symmetrically in the same affectionate way that Van Gogh had formerly arranged his still lifes. Among the last pictures painted before his departure for the South, the *Portrait of Père Tanguy* shows Van Gogh employing his skills in a large, encyclopedic composition and taking stock, both emotionally and technically, of his checkered career in the city.

Autobiography of a different kind—and other lightly coded farewells to Paris—are implicit in several paintings from the final months

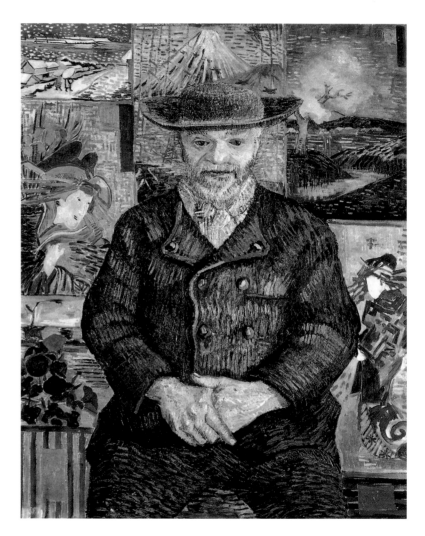

of 1887. The large canvas entitled *Romans Parisiens* was one of a series of still lifes based on arrangements of books begun earlier in the year that Van Gogh was to continue after his move to Arles. Looking back to the *Still Life with Bible* (fig. 7), painted shortly before his departure from Nuenen, these pictures invite us to identify the artist with his daily reading

fig. 20 *Portrait of Père Tanguy, Half-Length*, 1887–1888, oil on canvas. Musée Rodin, Paris

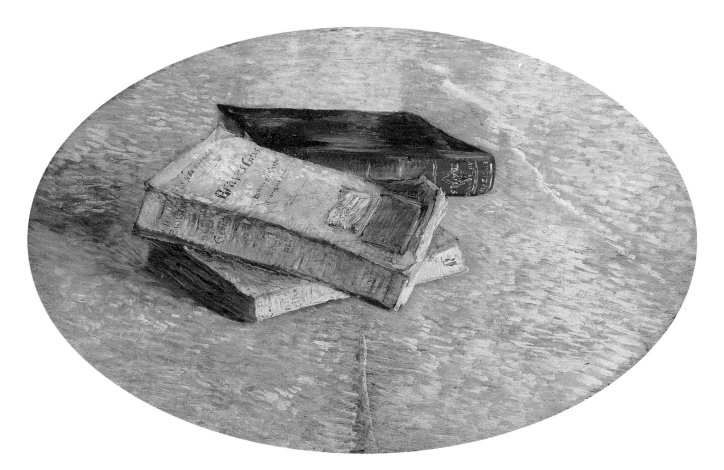

tachment to the naturalist novel. If Richepin was associated with late romanticism, Zola's and Goncourt's stories—dealing with events surrounding a Paris department store and the tragic fate of a young prostitute, respectively—situate the artist's tastes firmly within metropolitan realism, marking his resistance to the symbolist-oriented literature that was already in the ascendant.

A wide range of other pictorial preoccupations contributed to the final appearance of *Still Life with Books*, a work unusually painted on an oval wooden panel. The choice of this format had many historical precedents, but here it allowed Van Gogh to play wittily—and in a way that oddly prefigures cubism—with the idea of a circular table shown in perspective. Examination reveals that the panel once formed part of a tea chest, an inscription in Japanese characters on the reverse associating it with a firm established to export goods to France in the late 1870s and early 1880s. Surprisingly, therefore, this very Parisian-looking painting is a further token of Van Gogh's attachment to Japan, joining a catalogue that includes numerous remarks in his letters, the purchase and display of Ukiyoe prints, and a deep admiration for the real or imagined qualities of Japanese artists themselves.

For more than a quarter of a century French painters had been aware of the accomplishments of Japanese printmakers, at first emulating their style but gradually aspiring to a similar freedom of invention. In Van Gogh's

cat. 36 *Still Life with Books*, 1887

and perhaps to mark another turning point in his life. Earlier in 1887 he had completed the small *Still Life with Books* (cat. 36), a more tentative composition that focuses on the physical and literary character of the chosen volumes. Not just their colors and shapes are recorded, but also the worn corners, broken spines, and roughly attached labels that mark

them out as much-used objects, in the same way that his paintings of shoes and boots suggest their abraded familiarity. The painter has taken some pains to inscribe titles on the individual books (Zola's *Au bonheur des dames*, Goncourt's *La Fille Elisa*, and Richepin's *Braves Gens*), allowing us to link them directly with his known reading habits and his stubborn at-

fig. 21 Keisai Eisen, *Courtesan*, c. 1820s, woodblock print. Private collection

fig. 22 Cover of *Paris Illustré*, May 1886. Van Gogh Museum, Amsterdam (in exhibition)

fig. 23 *The Courtesan*, 1887 (tracing of fig. 22), pencil, pen, and ink. Van Gogh Museum, Amsterdam (in exhibition)

The Courtesan (cat. 37), it is the strident, un-inhibited color of the Japanese tradition that has seized his imagination rather than its refinement or graphic precision. When kept away from the light, Japanese prints often re-tain their brilliant juxtapositions of deep blues, crimsons, and jade greens, stimulating many of Van Gogh's peers to intensify their palettes and construct their designs from planes of sat-urated color. Choosing a color reproduction of a print by Keisai Eisen (fig. 21) from the periodical *Paris Illustré* (fig. 22), Van Gogh took liberties with the original, enlarging it through

the process of tracing (fig. 23), freely rework-ing the patterns and hues of the kimono, and creating a fantastical border of bamboos, water, and lilypads from other Japanese prints that bears no relation to Eisen's design. A sub-stantially less modified version of the print can be glimpsed in the background of the *Portrait of Père Tanguy*, again emphasizing the near-anarchistic freedom the artist has allowed him-self in *The Courtesan*. Unlike even the freshest Japanese work, Van Gogh has chosen colors that are not just dense in hue but thickly mod-eled in bars, furrows, and superimposed crusts

of paint, as if to pile color on color and achieve the ultimate in chromatic saturation. Where the gold background to the central figure is largely flat, the improbable scene behind is ri-otously spacious, asserting Van Gogh's dis-tance from—as much as his dependence on—the revered Japanese prototype.

An explosion of color of another order is represented by *Still Life with Quinces and Lemons* (cat. 38), a canvas completed at the very end of the Paris period. It is hardly an exaggera-tion to describe this as a picture about the ex-pressive possibilities of yellow itself, not only

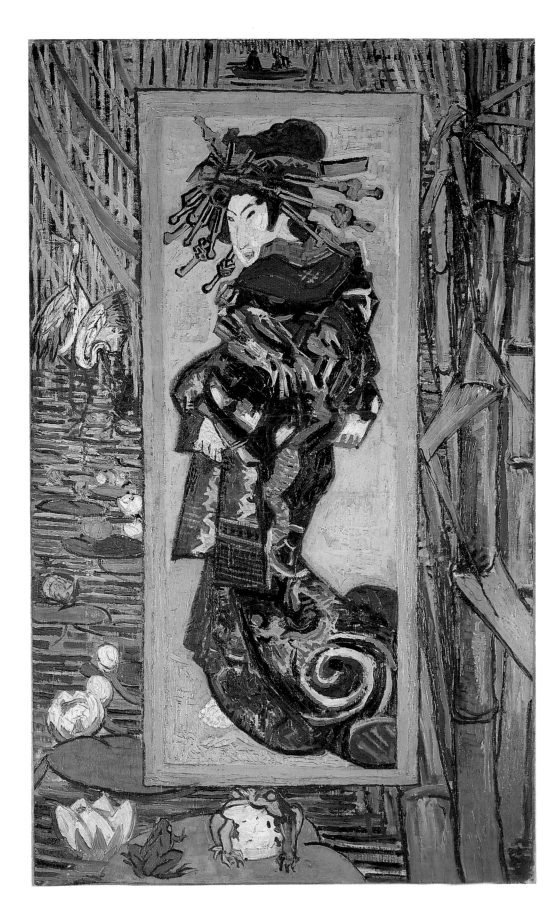

cat. 37 *The Courtesan* (after Eisen), 1887

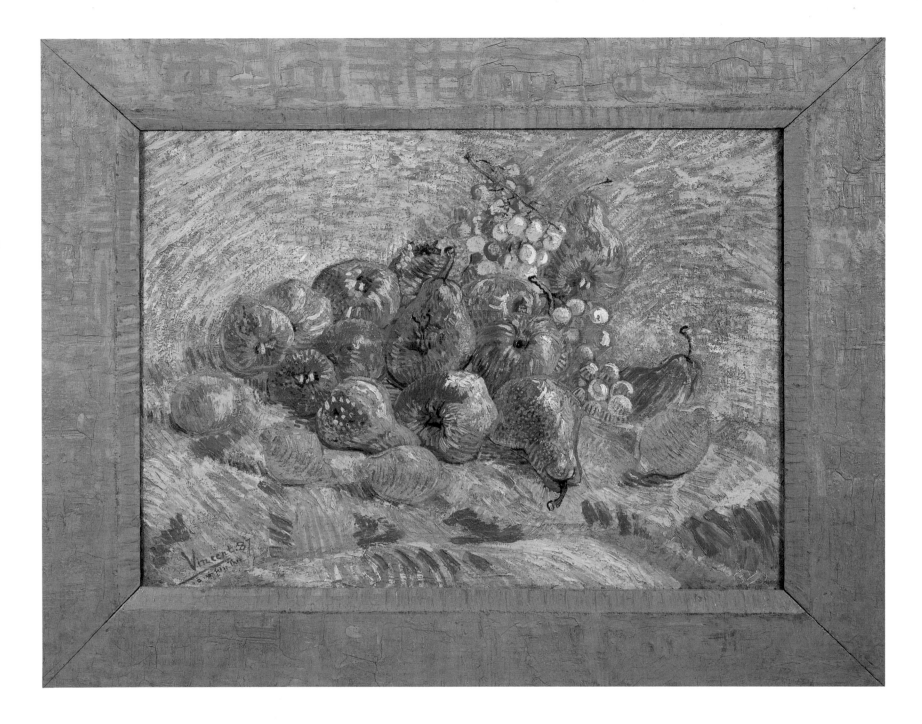

in the chromes, deep siennas, green-ochers, and scintillating warm silvers of the fruit and surrounding cloth, but in the gilded light of late summer or early autumn that suffuses them all. Few pictures of this period demonstrate so forcefully the steps Van Gogh had taken since he left Holland, where a picture like *Basket with Potatoes* (cat. 9)—a study in the more modest key of deep brown—seemed to celebrate a cautious traditionalism and a near-fatalistic sobriety. Once again choosing the most commonplace of objects, in the later work the artist has transposed the simple pattern of fruits into realms of hallucinatory sensuousness that seem to offer a foretaste of the Mediterranean. When he began his famous paintings of sunflowers in Arles, Van Gogh explicitly compared their colors to the "still lifes of quinces and lemons that I did some time ago,"[62] and other letters spell out the significance he attached to the color yellow as an emblem of

the health-giving sun. The surface of the still life shows how hard won this new virtuosity was, constructed from layer upon layer of contrasted tones and a bravura display of brushmarks large and small. Discrete touches of opposing hues were added to impose coherence on this sumptuousness, a few strokes of sky blue beneath a lemon, for example, or hatchings of red, green, and pink in the remaining fruits. This is not, in other words, a casually improvised study but another pondered statement by an artist now sure of his means. The presence of a signature and a dedication "to my brother Theo" confirms its status, as does the broad wooden picture frame especially decorated by the artist himself. Along with such contemporaries as Degas, Pissarro, and Seurat, Van Gogh had emphatic views on the colors of frames best suited to his pictures and an experimental interest in decorating borders and canvas edges to achieve an appropriate harmony. Two years previously he had told Theo that *The Potato Eaters* would stand out "well on a wall papered in the deep color of ripe corn,"[63] and in a matter of months, in Arles, he would recall that "Cézanne looks good in gold."[64]

The dedication to his brother of *Still Life with Quinces and Lemons* is open to a number of interpretations. Van Gogh habitually entrusted Theo with the bulk of his pictures, storing them in his rooms, sending them to his brother when he was at a distance, or presenting them as gifts to be hung on the walls of the Paris apartment. The few inscribed canvases tend to mark moments of significance, either the completion of a painting thought to be especially successful or an occasion of shared emotion between the brothers. The cohabitation of Vincent and Theo had been a stormy affair, prejudiced by the poor health of both individuals and their different standards of living and social behavior. In such circumstances, the offering of a glowing, sun-filled still life might have been a gesture of reconciliation or perhaps a symbolic token of the therapeutic light that Van Gogh believed both of them needed. In the most transparent way, the painter seems to open himself to his brother, laying bare the complexity of his sensations and attempting to cross the divide that separates them.

An uninscribed but equally imploring canvas from these months is *Self-Portrait as an Artist* (cat. 39), a picture given to Theo shortly before Vincent left Paris and evidently intended as a summation of his personal and creative identity. By posing himself at the easel with palette and brushes in hand, Van Gogh confronted his brother in the role and with the apparatus of the established painter he now considered himself to be. His face, however, tells a different and altogether more complex story. Far from expressing his self-satisfaction at mid-career, Van Gogh's features epitomize the insecurity of a painter who has yet to find a market, and an individual racked by conflicting urges and bodily weakness. Looking straight back at his brother, Vincent both approaches him and keeps his distance, deeply conscious of their affinity yet already acknowledging his own destructive potential.

Self-Portrait as an Artist was probably the last of a sequence of more than a dozen such portraits painted toward the end of 1887 and the beginning of 1888. As Van Gogh was later to recall, these final months in the city were to be overshadowed by bitterly cold weather and his own excessive drinking, and by a weak stomach exacerbated by "the damned foul wine of Paris and the filthy fat of the beefsteaks."[65] His slender means rarely allowed him to hire models, forcing him once more to compose still lifes in his studio and to contemplate his own sickly and uncertain features. Elements of both preoccupations surface in the ghoulish painting *Skull* (fig. 24), a sparse and unlovely composition that has none of the stylishness of the work on a similar theme painted in Antwerp almost exactly two years before (cat. 14). Another small study, *Self-Portrait* (cat. 40), has been dated to several moments in the Paris sojourn, but its vision of the bare-headed and crop-haired artist certainly shares a bleakness of outlook with this later group.

Though the size of *Self-Portrait* and its cardboard support link it with the two earlier Paris self-portraits (cats. 21 and 22), it is impossible to overlook its deep originality as an act of painting, even on this tiny scale. No longer relying on costume or accessories to boost his self-presentation, the artist has au-

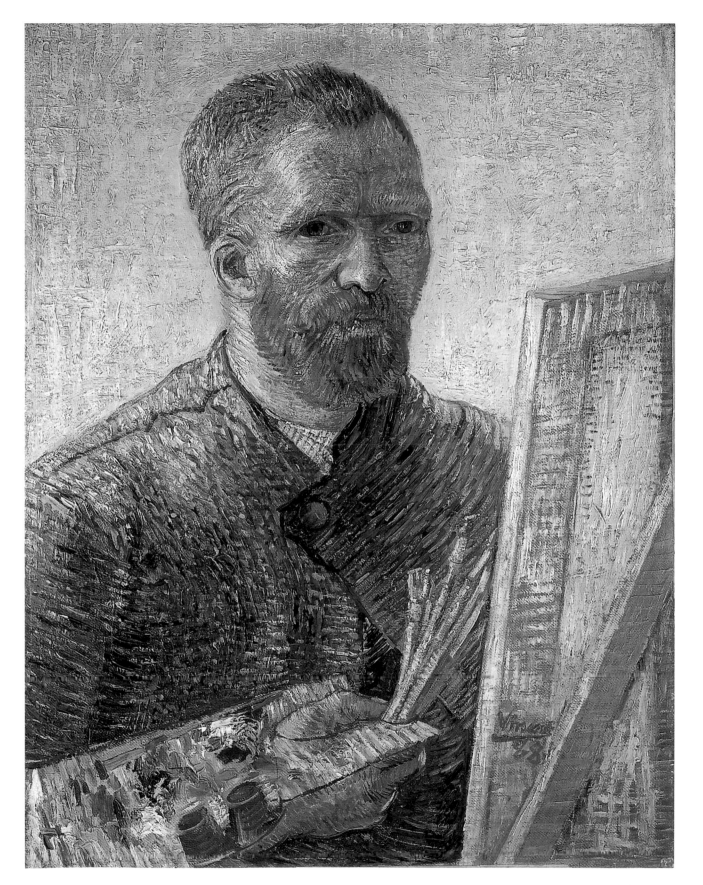

cat. **39** *Self-Portrait
as an Artist*, winter
1887–1888

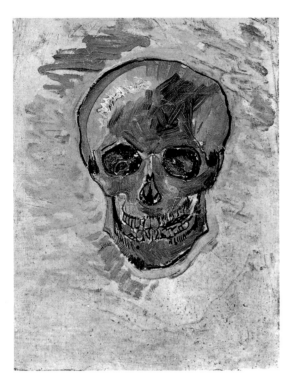

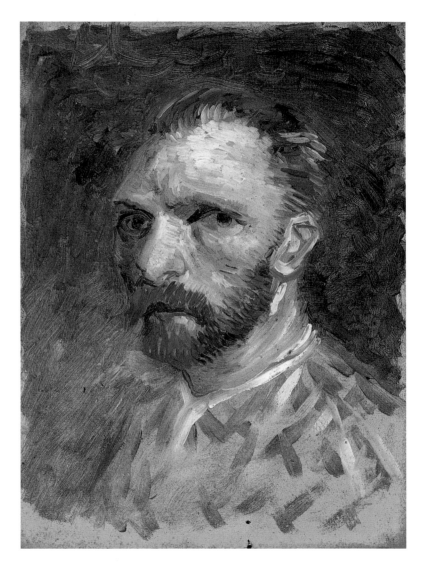

daciously constructed his image in blocks of thick, unapologetic color, especially noticeable in the reds, ochers, and purples of his beard and hair. These rectangular bars of paint are one of the lasting legacies of the Paris years, originating in the bold brushwork of the studies for *The Potato Eaters* but finding a new lease on life in the extraordinary variety of painting techniques—many of them idiosyncratically related to the divisionism of Seurat and his followers—that Van Gogh had explored in the city. Now definitively turning his back on such systems, the artist also abandoned any links he might have had with their scientific pretension and theoretical rigor; in Arles, he

wrote, "As for stippling and haloes and other things, I think they are real discoveries, but we must already see to it that this technique does not become a universal dogma. . . ."[66] In their place, he had evolved a wonderfully potent language of his own, fusing drawing and color in a series of separate yet rhythmically linked strokes of paint that allowed him to model form, animate space, and project his subject matter with unprecedented vitality.

Arguably the first masterpiece carried out in Van Gogh's new painterly shorthand was *Self-Portrait with Felt Hat* (cat. 41), an image that is economical in handling yet exceptionally rich as a human document. So lucid is the lattice of paint that its evolution can be reconstructed stroke by stroke, from the initial laying-in of dark tones of blue in the background and red-purple in the jacket, to the addition of final highlights in the face, beard, and hat. In such pictures, Van Gogh's longitudinal strokes are arranged into a weave of color, plaiting together adjacent hues but allowing earlier tints and textures to break through this intricate, superimposed tracery. The same process can be used to define structure, creating basketwork-like ridges and concavities in the artist's face, and plotting the rise and fall of contours across his hat and shoulders. Pointillism has been left far behind in this urgent flux, which now resembles the ebb and flow of pictorial forces as much as the arid "analysis of color" described in the correspondence from Nuenen. If warm and cool

fig. 24 *Skull*, 1887–1888, oil on canvas. Van Gogh Museum, Amsterdam (Vincent van Gogh Foundation)

cat. 40 *Self-Portrait*, January–March 1887

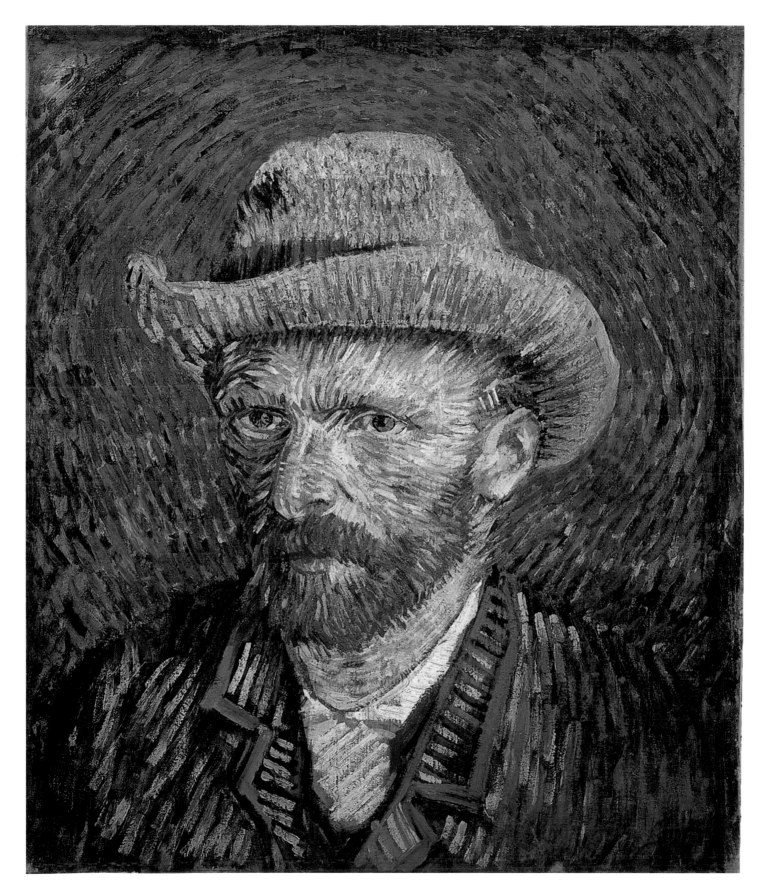

cat. 41 *Self-Portrait with Felt Hat,* winter 1887–1888

pigments are everywhere contrasted, and if complementary oranges and blues, reds and greens are frequently found in proximity, such relationships hardly account for the adjacent lilacs, dove grays, and streaks of leaf green in the hat brim or the rainbowlike concentration of tints in the sitter's face. In more than one sense, *Self-Portrait with Felt Hat* shows Van Gogh as his own man, as an utterly distinct colorist who has learned to blend draftsmanship and a controlled mastery of paint into a formidable whole.

To turn from *Self-Portrait with Felt Hat* to look again at *Self-Portrait as an Artist* is to move from the inspired study to the self-conscious, old masterly statement. Where the composition of the former is simplicity itself, each of the elements in the latter appears burdened with meaning and redolent of weeks of struggle. The artist himself acknowledged both its awkwardness and its ambition in a long description of the work sent from Arles to his sister Wil. It showed, he explained,

> A pinkish gray face with green eyes, ash-colored hair, wrinkles on the forehead and around the mouth, stiff, wooden, a very red beard, considerably neglected and mournful, but the lips are full, a blue peasant's blouse of coarse linen. . . . You will say that this resembles somewhat, for instance, the face of Death . . .—it isn't an easy job to paint oneself—at any rate if it is to be *different* from a photograph.[67]

Much has been written about the historic and contemporary echoes in this picture, from Van Gogh's familiarity with Rembrandt's *Self-Portrait at the Easel* in the Louvre and the possible impact of an exhibition of artists' self-portraits in the same gallery in February of 1888, to a hypothetical encounter with Cézanne's *Self-Portrait with Palette* of about the same date. But none of these examples helps in understanding the dense crust of color on Van Gogh's picture in general, nor the startling concentration of hues on the broad plane of his palette in particular. For Van Gogh, the impasted surface of his canvas was testimony to his dedication and to the demands of the task, and to a seriousness that united him to the masters of the past. His palette was a more modern sign; chaotically arranged by orthodox standards, its mounds and smears of paint are loud with primary and secondary tints, which in their turn reverberate throughout the chromatic structure of the image according to Van Gogh's private logic. Studiedly eccentric even as he attempts to fix his place in history, the artist seems to advertise his erudition as well as his hard-won independence of all creeds and systems.

In January or February 1888, Van Gogh signed and dated his *Self-Portrait as an Artist* and presented it to Theo, who kept it on his apartment wall long after his brother left the city. For many months the artist had been planning to move south, lured by the prospect of warmer weather and exhausted by the demands and temptations of urban life. Several

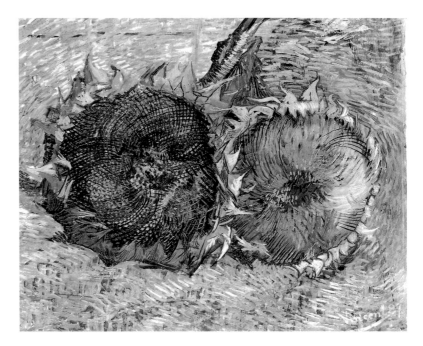

fig. 25 *Two Cut Sunflowers*, 1887, oil on canvas. Kunstmuseum, Bern

paintings carried out in the winter seem pervaded by a longing for better times, not just the light-infused *Still Life with Quinces and Lemons* and the quasi-Oriental *Portrait of Père Tanguy*, but such inescapably symbolic works as a series of pictures of dried sunflowers, one of which was later acquired by Degas for his private collection (fig. 25). Another such vision is perhaps *Self-Portrait with Straw Hat* (cat. 42), a broadly executed study that shares its pale background and its depiction of the painter in a wrap-over smock with *Self-Portrait as an Artist*, while its striped, freshly colored facture aligns itself with *Self-Portrait with Felt Hat*. Some specialists have dated the picture to the summer in Arles, but it is as likely that its affinities with these late Paris canvases suggest an

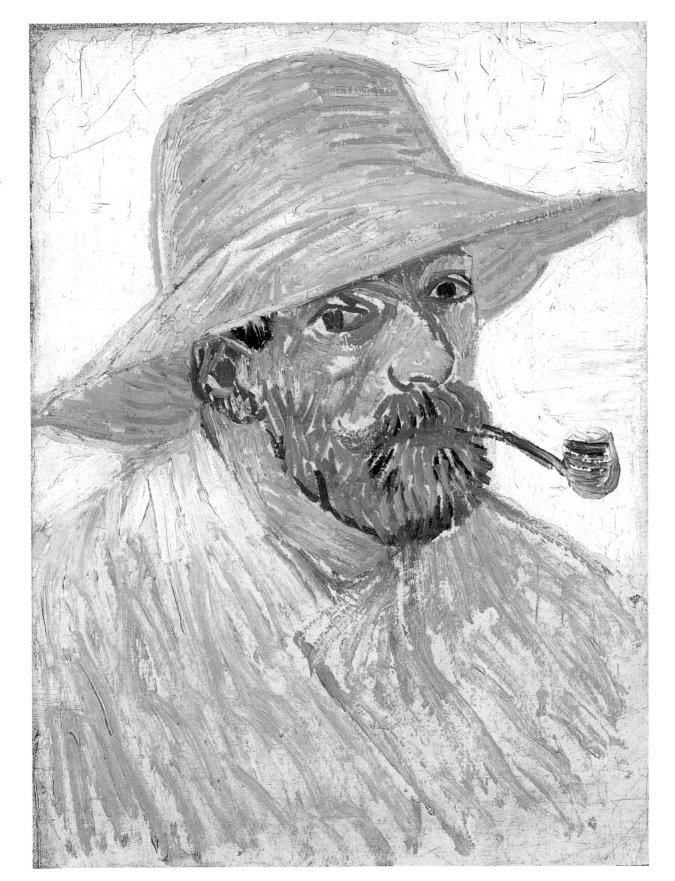

cat. 42 *Self-Portrait with Straw Hat,* 1887

imaginative leap—and an appropriate change of headgear—into the next phase of his working life. Attached as he was to his painter friends in Paris and to the mutually supportive life he shared with Theo, Van Gogh already envisaged a simpler, more productive existence in faraway Provence. In his last weeks in the metropolis, he is known to have fraternized with Bernard and Gauguin, to have continued his contacts with Guillaumin and Camille and Lucien Pissarro, and to have finally made the acquaintance of Seurat. In an event that might have been symbolic had it not been entirely haphazard, on 19 February Vincent and Theo made their first visit together to Seurat's studio; within hours, the painter had turned his back on the city and set out on the long train journey to Arles.

ARLES: 1888–1889

"Aren't we seeking intensity of thought rather than tranquillity of touch?"

The act of metamorphosis by which Van Gogh reinvented himself in Arles is one of the most startling phenomena of his career. If the years in Paris had been profoundly formative, the pictures he made there were arguably as remarkable for their breadth of experimentation and diversity of scale, subject, and finish as for their individual distinction. After a matter of weeks in Provence, however, Van Gogh had established a consistency of execution and a clarity of formal means that have defined his creative personality ever since. Classic images followed each other in breathtaking succession, from the paintings of the drawbridge in Arles in March 1888 to the studies of blossom trees (cat. 44) and flower-strewn fields (cat. 45), completed in April and May, respectively, often accompanied by pen-and-ink drawings that are ranked with the finest works of modern draftsmanship. In reality, of course, such a transformation took time and intense effort, and was built on the self-conscious and forward-looking explorations of the last months in Paris. But there can be no doubt of the rush of stimulus that followed the artist's move to Provence, which was evident in both letters and pictures from his first days in Arles.

As he traveled south, Van Gogh immediately began to identify subjects for new pic-tures in the unfamiliar terrain through which he passed. On 21 February he described his recent journey in a note to Theo:

> I noticed a magnificent landscape of huge yellow rocks, piled up in the strangest and most imposing forms. In the little village between the rocks were rows of small round trees with olive-green or gray-green leaves, which I think were lemon trees. But here in Arles the country seems flat. I have seen some splendid red stretches of soil planted with vines, with a background of the most delicate lilac.[68]

Conditions in Provence were far from idyllic, however, not least the weather, which presented the artist with a heavy fall of snow and freezing temperatures instead of southern sunshine. Arriving with very little money and with no friends in the town, Van Gogh rented a room near the railway station and soon reported himself painting "an old Arlésienne, a landscape in the snow, a view of a small part of a street with a butcher's shop."[69] As in the years before his move to Paris, long and detailed letters were soon documenting his opinions and the events of his daily life. Making light of his straitened circumstances, Van Gogh held forth on matters of art, picture dealing, literature, and the human condition, and the progress of his own paintings and drawings, not just to his brother but to correspondents such as his sister Wil, Bernard, and Gauguin. A few days later, for example, he returned to

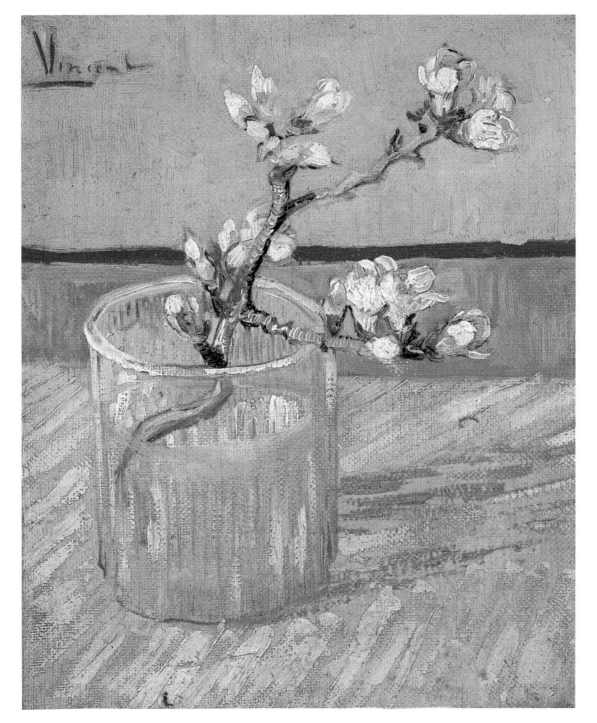

cat. **43** *Sprig of Flowering Almond Blossom in a Glass*, February–March 1888

a discussion with Theo on the latter's efforts to promote impressionism outside France, telling his brother of a note he had received from Gauguin and reflecting on his own submissions to the forthcoming Independent group exhibition. Returning to more immediate concerns, Van Gogh noted that it was still "freezing hard" in Arles and described his attempts at painting snowscapes, adding that he had finished "two little studies of an almond blossom branch already in flower in spite of it."[70]

Small though it is, *Sprig of Flowering Almond Blossom in a Glass* (cat. 43) is like an eloquent proclamation of things to come—not just of the arrival of spring, but of the imminent blossoming of Van Gogh's art. Economical in technique, modest in subject, and bursting with pictorial life, this tiny canvas joins a line of minor masterpieces that punctuated his working life, here suffused for the first time with the light of southern climes. In places the picture is almost crude, for example where the putty-colored priming has been left uncovered in the lower half of the composition, or where late additions to the gray background have overlapped the artist's signature and the horizontal stripe of vermilion. But, quite unexpectedly, this frankness seems to heighten rather than reduce the actuality of the principal image, an exquisitely observed almond branch whose every corrugation of twig and delicacy of petal has been rendered with the lightest of touches. If a key to the success of the Arles pictures can be found, it is surely in

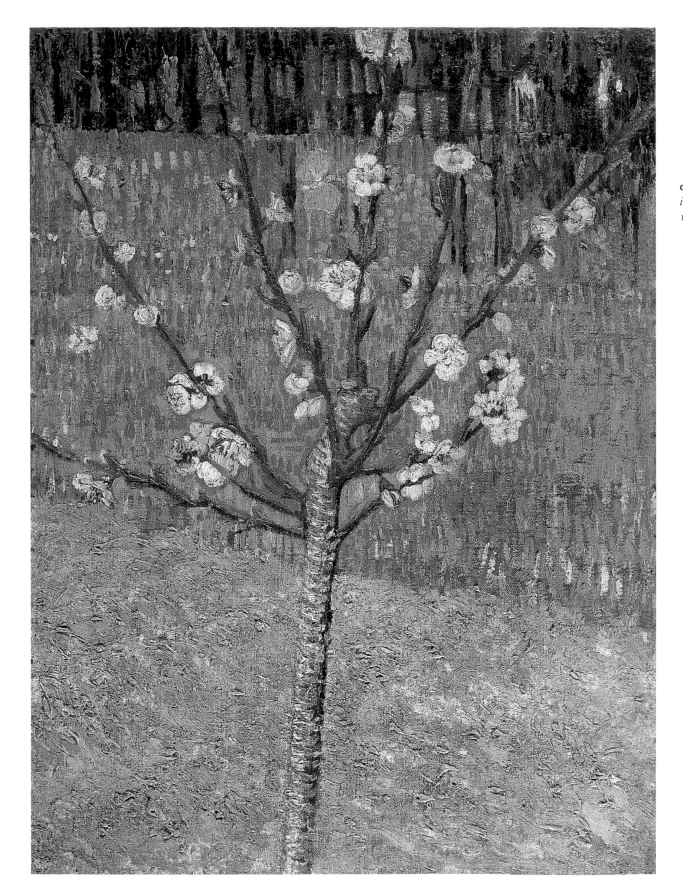

cat. 44 *Almond Tree in Blossom*, April 1888

fig. 26 Drawing of blossom triptych, 1888, sketch in letter 447. Van Gogh Museum, Amsterdam (Vincent van Gogh Foundation)

this fierce attachment to the natural world, now combined with an expansiveness of handling that owes much to the emancipatory experience of Paris.

Van Gogh's excitement at the visual spectacle around him—especially the peach, almond, and plum blossom—is dramatically spelled out in this first Provençal spring. Initially hampered by the weather, he was soon painting steadily outdoors: "I have been working on a size 20 canvas in the open air in an orchard, lilac plowland, a reed fence, two pink peach trees against a sky of glorious blue and white. Probably the best landscape I have done,"[71] he wrote Theo, adding a few days later, "I want to paint a Provençal orchard of astounding gaiety. . . . the work I'm doing here is better than in the Asnières country last spring."[72] Almost twenty light-filled canvases of flowering trees resulted, leading to more

practical problems: "I am using a tremendous lot of colors and canvases,"[73] he complained, including a list of more than a hundred tubes of paint he needed ("20 Flake white, big tubes; 10 ditto zinc white; 15 malachite green, double tubes, 10 chrome yellow . . . ").[74]

Almond Tree in Blossom (cat. 44) is one of the extraordinary set of canvases made in April 1888, which Van Gogh considered to be among his finest accomplishments to date. Some were conceived as triptychs (fig. 26), with a vertical canvas in the center and horizontal compositions at either side, but all emerged from an unusually sustained and productive period of creative activity. Recent research into these pictures has shown how critical the artist was of the canvas available locally and how fastidious he could be over prepared grounds and the textures and constituents of his paints. But once in front of his subject, as he explained to Bernard, all was improvisation:

My brush has no system at all. I hit the canvas with irregular touches of the brush, which I leave as they are. Patches of thickly laid-on color, spots of canvas left uncovered, here and there portions that are left absolutely unfinished, repetitions, savageries. . . . Working directly on the spot all the time, I tried to grasp what is essential in the drawing—later I fill in the spaces which are bounded by contours—either expressed or not, but in any case *felt*—with tones which are also simplified. . . .[75]

Seeing these canvases as a continuous cycle of images, Van Gogh explained to his brother that he worked on them after returning to the studio: "I am now trying every day to touch them up and give them a certain unity."[76] *Almond Tree in Blossom* shows the result of all these strategies, from the impetuously applied flowers and crisply delineated branches to the dense textures running from foreground to distant trees. Throughout, the paint is dry and fragmented, the outcome of Van Gogh's preference for chalky canvas primings and of the "irregular touches of the brush" about which he boasted to Bernard. Less typical of this group of works is the honey-brown tonality that pervades much of the canvas, evidently the consequence of the artist's current experiments with technique. The possibility that some of the color harmonies have changed—due to the deterioration of fugitive pigments—has also been highlighted in examinations of the paint used in such works. Van Gogh was alert to the existence of such questionable colors, and his own description of the picture as showing "a violet trunk and white flowers, with a big yellow butterfly on one of the clusters"[77] is both sufficient to identify the canvas and indicative of later reworking by the artist himself or the fading of unreliable hues.

As the fields of blossom disappeared, Van Gogh applied himself in earnest to other subjects in the town and its outlying districts. He found the local inhabitants largely indifferent to his presence and returned their lack of in-

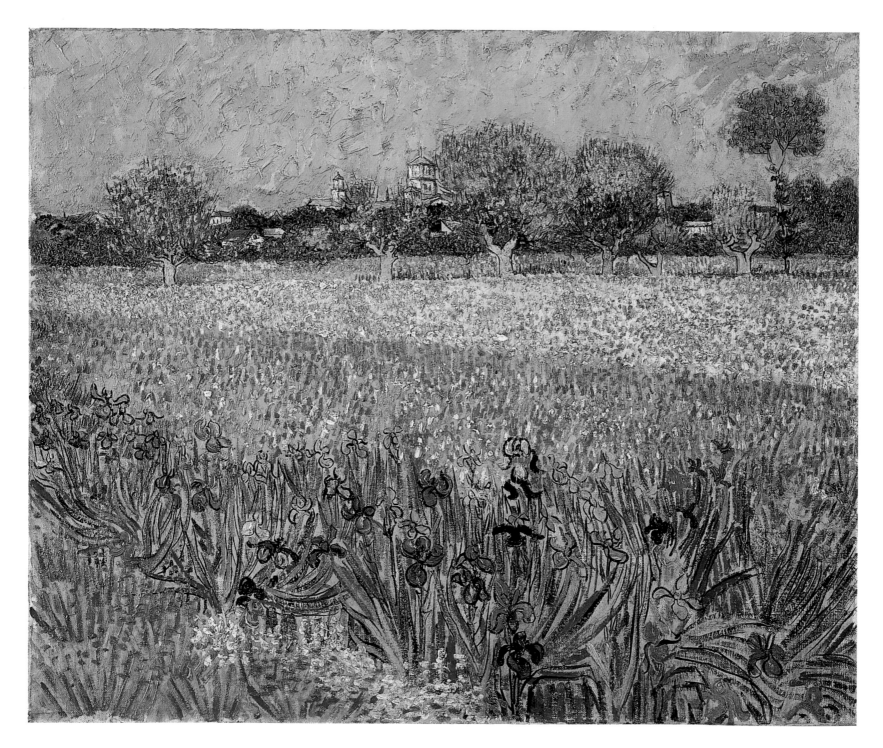

cat. 45 *Field with Flowers near Arles,* April–May 1888

terest by ignoring the streets, squares, and historic buildings of Arles itself, though he briefly and tantalizingly considered making pictures of the bullfights held in the town's Roman arena. After his years in Paris, the artist was clearly intoxicated by this new contact with nature, now bursting into the colors of late spring and early summer with each successive day. Pictures like *Field with Flowers near Arles* (cat. 45), of April–May, seem to erupt with forms that burst through the soil, sparkle in the light, and sway in the breeze, and with a palette of hues that express the "limidity of the atmosphere" described to Bernard.[78] Painted with exceptional directness and concentration, this canvas—like *Almond Tree in Blossom*—effectively crosses new frontiers, palpably expressing the artist's experience as he walks through bristling grass and reaches out to touch the flowers at his feet. Something of this exhilaration is also transmitted in the confident energy with which Van Gogh tackled such a deep, panoramic subject. Just twelve months earlier he had struggled with both the drawing and the composition of another distant scene, *Vegetable Gardens and the Moulin de Blute-Fin on Montmartre* (cat. 25), completing the work with the help of his perspective frame and in a pale variant of a technique borrowed from one of his younger peers. Now the generous application of paint is unmistakably his own, along with the vivid structuring of the canvas into blocks of tone, color, and texture. From letters of this period it is known that Van Gogh thought often of

similar vistas by Monet, Seurat, and others that he had seen in Paris, telling Theo in June, for example, how much he regretted missing an exhibition of recent Monet paintings of the South of France. But the fusion of painterly drawing with saturated color in a work like *Field with Flowers near Arles* marks Van Gogh's new mastery, not just over his art but over his Mediterranean environment; as he modestly suggested to his brother, "I am getting an eye for this kind of country."[79]

The high, distant horizons of his Arles landscapes—with their curious echoes of Holland—remind us just how earthy and sensuously grounded was Van Gogh's vision of the Provençal countryside. Looking down at the ditches, pathways, hedges, flowers and weeds, and every kind of crop and pasture he encountered, he left a record of his own passage across the terrain and his tactile familiarity with its humblest elements. Where figures appear they are generally remote, lending scale to the interminable plains or a more localized animation to the flickering, windswept farmland. *Wheatfield* (cat. 46) is entirely unpopulated, only a red-roofed farm building and some vestigial tracks introducing coherence and purpose to this swirling mass of color. As in *Field with Flowers near Arles*, the density of color is continuous throughout the canvas, making no allowance for the weakening of tones in the distance and threatening to flatten all its forms toward the picture plane. Fighting against this is the steep, raked per-

spective, hurtling the viewer forward into the rainbow-hued field as the artist himself must have advanced along the path he painted in the foreground. Where once Van Gogh aimed to move his audience with scenes of peasant life, he now urges them to share his sensations of coarse vegetation, damp shadows, and cornfield blossoms, of a gamut of tones from near-white to deep blue-black, of the sheer urgency of his engagement with nature. As always, the artist was acutely conscious of his own procedures. After "a day spent in the full sun" in June, he told Bernard:

> I couldn't help thinking of Cézanne from time to time, at exactly those moments when I realized how clumsy his touch in certain studies is. . . . I have sometimes worked excessively fast. Is it a fault? I couldn't help it. For instance, I painted a size 30 canvas, the *Summer Evening*, at a single sitting. Take it up again?— impossible; destroy it?—why should I! You see, I went out to do it expressly while the mistral was raging. Aren't we seeking intensity of thought rather than tranquillity of touch?[80]

Van Gogh's thoughts turned once more to Cézanne as he was painting one of the undoubted masterworks of his Provençal period, *The Harvest* (cat. 47). He had seen a picture by Cézanne on a similar theme at Portier's in Paris and now recalled how the older artist "rendered so forcibly . . . the harsh side of

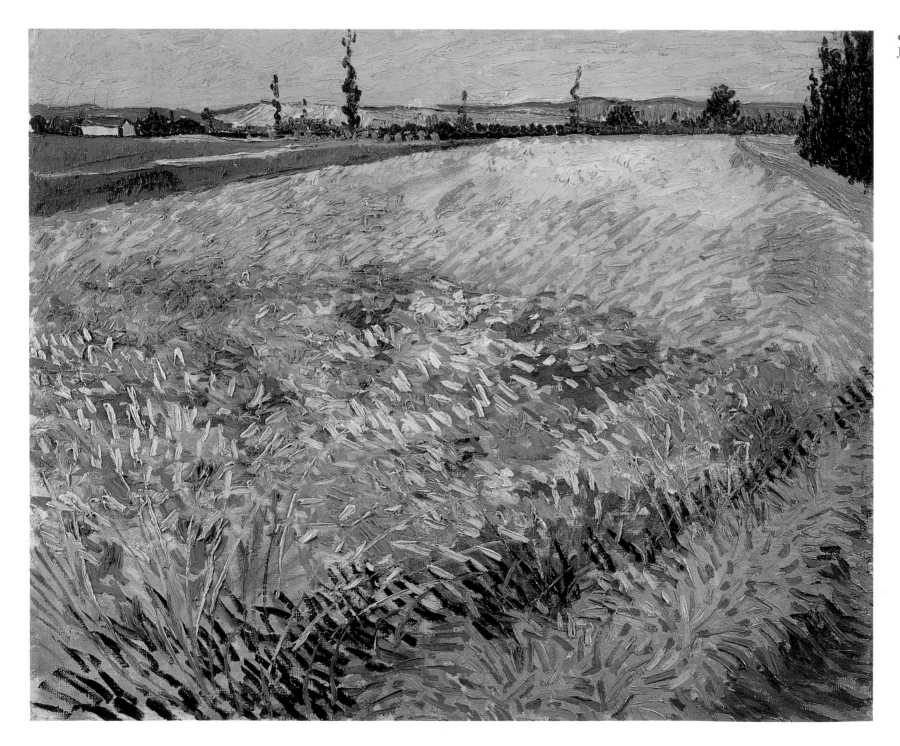

cat. 46 *Wheatfield,*
June 1888

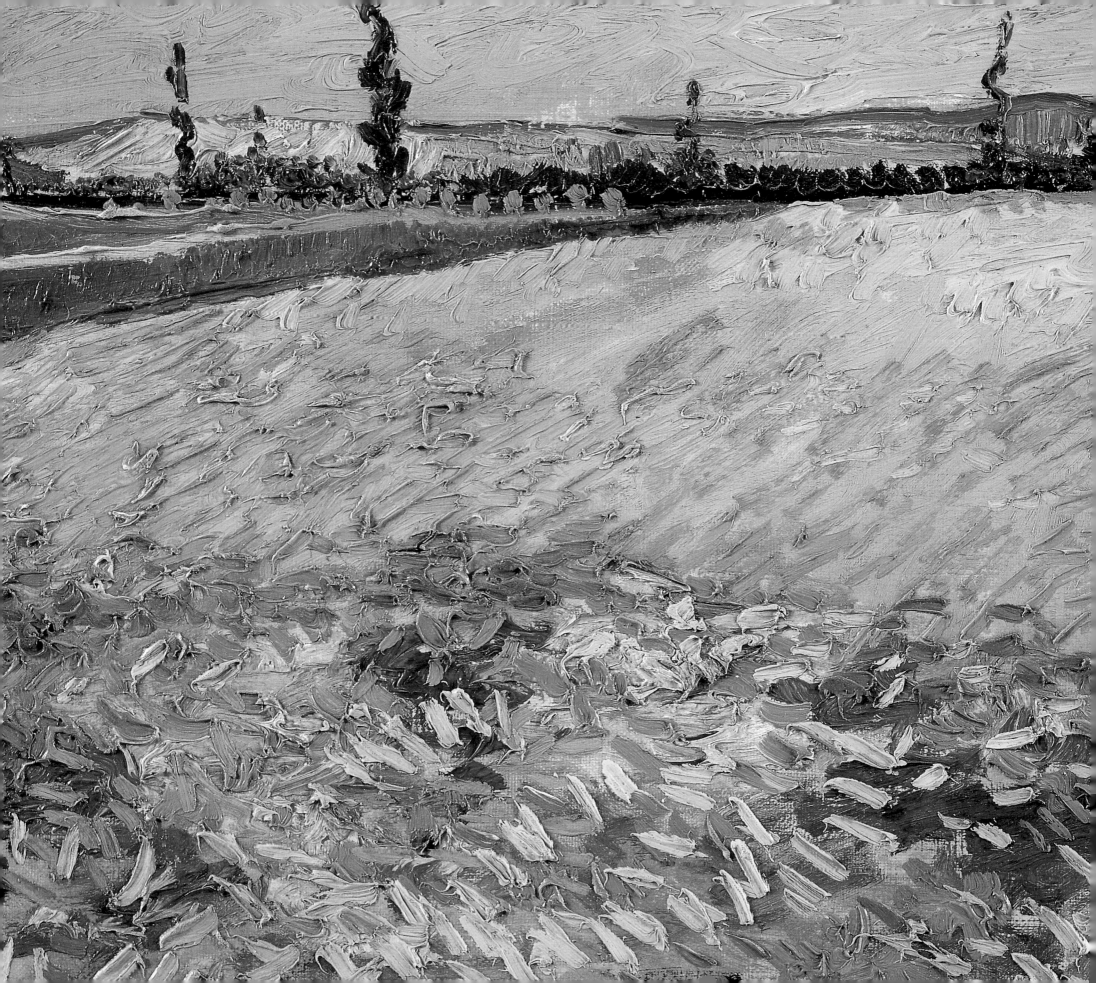

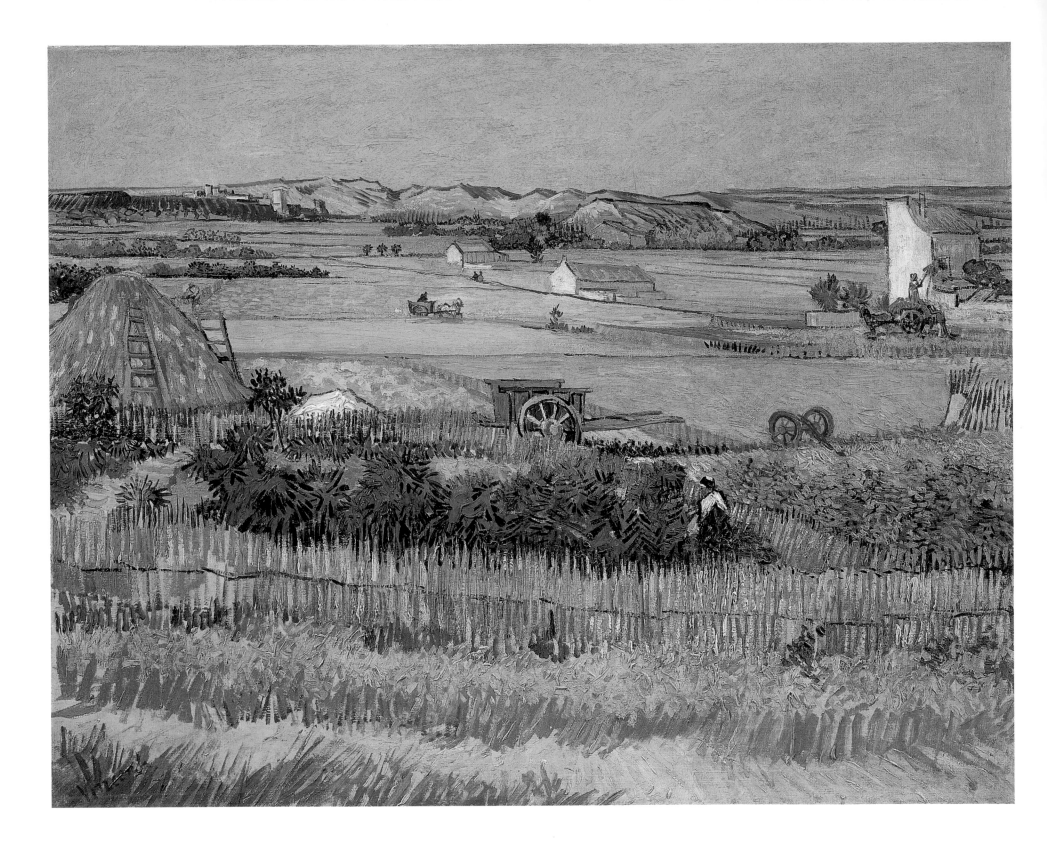

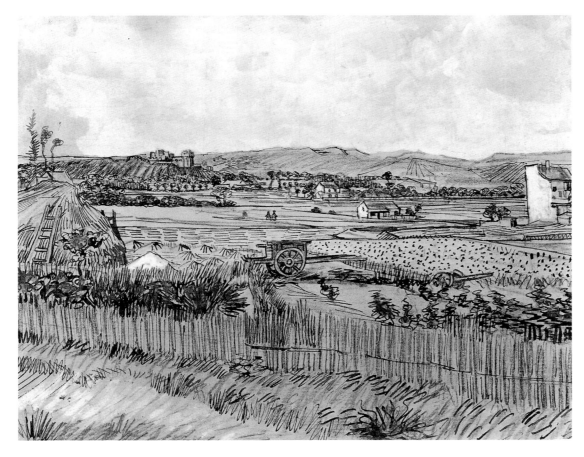

cat. 47 *The Harvest*, June 1888

fig. 27 *Harvest in Provence*, 1888, pen and watercolor. Fogg Art Museum, Harvard University Art Museums, Cambridge, Massachusetts

Provence," even as he eulogized the countryside scorched by the summer sun: "Everywhere now there is old gold, bronze, copper, one might say, and this with the green azure of the sky blanched with heat."[81] He reminded Theo that "the country near Aix where Cézanne works is just the same as this, it is still the Crau,"[82] and chose a very Cézanne-like open valley with distant mountains as the subject for his large canvas. The resulting image is entirely respectful of Cézanne's marshaled spaces and tremulous design, the cornfields receding in strictly observed ranks and the articulation of every bush, cart, and farmhouse related to the whole. Into this exquisitely modulated structure, however, Van Gogh contrives to build other elements unique to his own sensations of the terrain; the scorching dryness of the soil, the terra-cottas and gilded ochers of the fields, and the unforgiving light, with its near-hallucinatory effects of glare and saturated hue. Rarely have such qualities been more authentic and rarely more artfully contrived; the drafting out of forms in the upper part of the canvas, for example, was effected in bright blue paint, that of the lower composition in brilliant green, both designed to set off the later oranges and yellows to maximum advantage. Many areas—such as the more remote fields and foreground bushes—were clearly blocked in with flat tones of a single hue to establish a broad harmony, then broken up with passages of detail or bars of contrasting color. Within this pattern, distinctive tints (like the gold-apricot of the rooftops) are made to reappear elsewhere, leading the eye across the canvas and linking up its constituent parts. This surreptitious movement is echoed by the picture's human protagonists, an understated cast of reapers and shifters of corn who deliver the crop to a rustic building and finally wander off into the middle distance, acting out the ancient drama of the harvest.

While he was still working on this epic scene, Van Gogh sent a long letter to his brother that announced the dispatch of three drawings, one of them representing *The Harvest*. Since Van Gogh's move from Paris, drawing had taken on a new role in his practical routine and a more complex significance in his creativity, summarized in the group of studies surrounding *The Harvest* itself. Two of them are large—almost two-thirds the size of the canvas—and are worked in color as well as pen and ink, while variations in their composition suggest that they were preliminary studies made in advance of the finished work. One

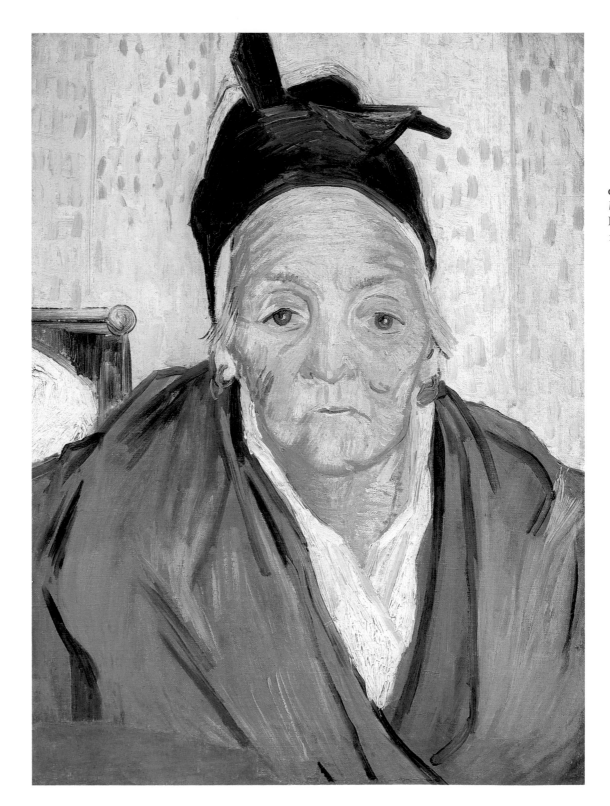

cat. 48 *An Old Woman from Arles*, February–March 1888

of these, *Harvest in Provence* (fig. 27), for example, has a lower horizon and a more oblique foreground fence, as well as a reduced emphasis on the spaciousness of the valley in comparison with the painted canvas. The remaining drawings are smaller and entirely executed in ink, reproducing the painting in its final form and evidently made as gifts for Van Gogh's intimates. All four works are marvels of concision, capturing the broad sweep of the landscape and its finely nuanced detail in crisp dottings, hatchings, and parallel strokes of the reed pen. Though working essentially in monochrome, Van Gogh had by this time evolved an extraordinary calligraphic language that came as close to the expressiveness of oil paint as any notation devised before or since, allowing him to hint at passages of impasto and the flow of the brush, even at the broad slabs of color that so characterize his current work.

Clearly satisfied with his new graphic shorthand, the artist used it regularly to communicate the qualities of recently completed pictures to his brother and to a growing circle of painter friends in Paris and beyond. In his long letter to Theo, Van Gogh mentioned six or seven such acquaintances, among them the Australian artist John Russell who was to receive a set of a dozen drawn copies of pictures (including a variant of *The Harvest*) a month or so later. Van Gogh's motives for sending these drawings were mixed, but one of their consequences was to keep his name and his latest achievements in circulation and to main-

tain his artistic intimacy with valued colleagues. Far from seeking isolation in Arles, Van Gogh was keener than ever to exchange ideas, pictures, and plans for future cooperative projects with kindred spirits like Russell, Bernard, and Gauguin, as well as to pursue new openings in the market that would enable him and his fellow artists to pay their way.

Soon after arriving in Provence, Van Gogh announced "I think there would be something to do here in portraits," observing that the local people were "much more artistic than in the North," and adding "as for portraits, I'm pretty sure they'd take the bait."[83] After several months, he urged Bernard to "Do as many portraits as you can and don't flag. We must win the public over later on by means of the portrait: in my opinion it is *the* thing of the future."[84] One of Van Gogh's own early attempts had been the painting *An Old Woman from Arles* (cat. 48), a study of the "old Arlésienne" he encountered during his first few days in the town. Choosing a format favored in his Paris portraits—that of a centrally placed figure who stares directly back at the viewer—Van Gogh responded with typical honesty to the woman's furrowed flesh and wistful countenance, her head and shoulders unceremoniously wrapped against the freezing weather. A likely inspiration for the image was Bernard's *Portrait of the Artist's Grandmother*, a work painted in 1887 and later exchanged for one of Van Gogh's own pictures. In both studies, a close-up of an elderly turbaned head allows

a glimpse of wallpaper and the corner of a bed, though Van Gogh has insisted on brighter, more optimistic tones than those of his former colleague. Analysis of *An Old Woman from Arles* has shown that the fugitive crimson-purples originally used by the artist have faded to grayish pinks, resulting in an unexpected flattening of the features. Contrasting strangely with the forceful portraits and self-portraits of the last months in Paris, the now muted tones of this canvas give little indication of the dramatic leap forward in Van Gogh's figurative art that was about to take place.

Few pictures from these months announce so forcefully the arrival of a new kind of portrait painting—"*the* thing of the future," in Van Gogh's estimation—as a canvas of June 1888, entitled *The Zouave* (cat. 49). The artist himself was almost shocked by what he had done, describing the image of the soldier as

> horribly harsh, in a blue uniform, the blue of enamel saucepans, with braids of a faded reddish-orange, and two stars on his breast, an ordinary blue, and very hard to do. That bronzed, feline head of his with the reddish cap, against a green door and the orange bricks of a wall. So it's a savage combination of incongruous tones. . . .[85]

With characteristic candor, Van Gogh set out the weapons for his assault on the modern portrait: the deep colors that are more oppressive than bright; the flesh tints seemingly glazed or overpainted to capture his sitter's "bronzed"

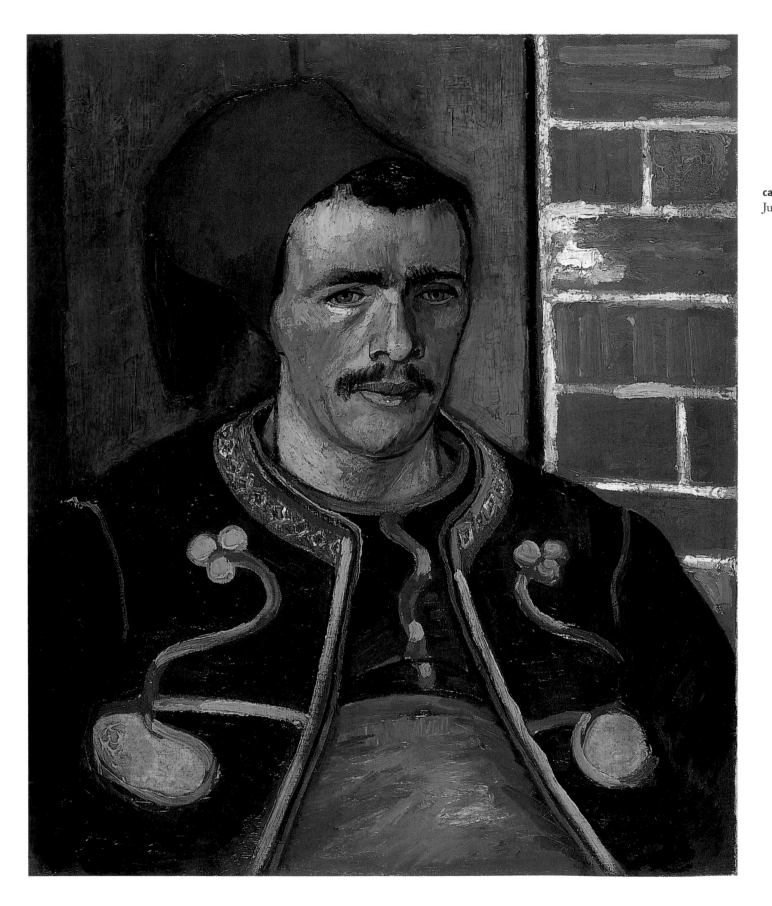

fig. 28 *Joseph Roulin, Sitting in a Cane Chair*, 1888, oil on canvas. Museum of Fine Arts, Boston

fig. 29 *The Night Café*, 1888, oil on canvas. Yale University Art Gallery, New Haven

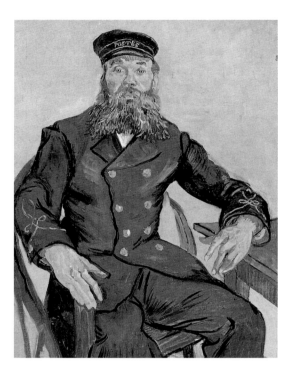

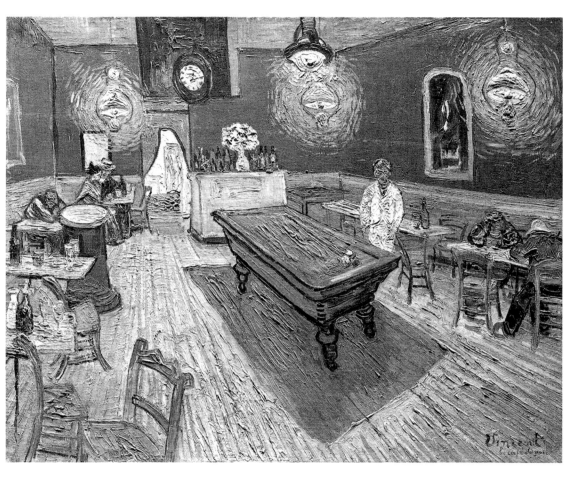

complexion; the near-childish patterning of the brickwork; and the choice of a coarsely slumped model depicted in all his vulgarity. The Zouaves were a division of French-Algerian troops stationed in Arles, notorious for their fierceness in battle and their hard-living ways. Van Gogh had befriended one of the soldiers, an individual named Milliet, making several attempts to do justice to his appearance ("a bull neck and the eye of a tiger," as he told

Theo)[86] and even trying to teach him the rudiments of drawing. The resulting portraits form part of a broader initiative to record the human types of the age and the region, from the elderly *Old Woman from Arles* to the young *Camille Roulin*, and from a uniformed functionary like Joseph Roulin (fig. 28) to the smock-wearing peasants he met in the fields.

There are echoes here of the pastorally concerned Van Gogh of Nuenen, now more

advanced in years and more deeply acquainted with his own conflicting passions and animal appetites. His letters freely acknowledge the periods of calm and bouts of "melancholy" that already shaped his life, as well as his indulgence in alcohol, excessive smoking, and occasional visits to the brothel. A painting from the late summer of 1888, *The Night Café* (fig. 29), seems part portrait, part autobiographical document, carrying the "savagery" of the

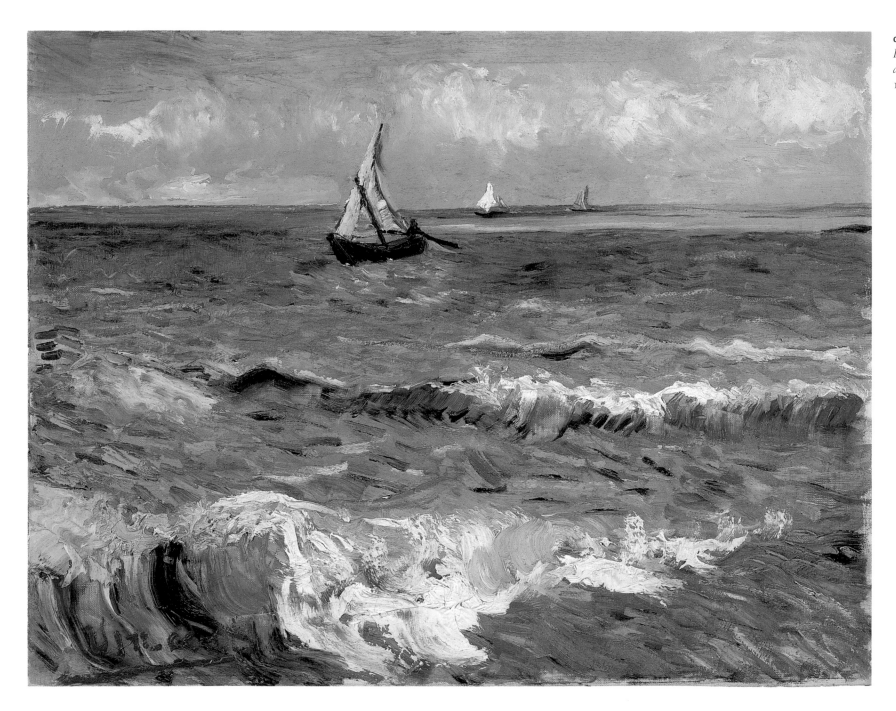

colors and forms of his studies of Milliet to a new extreme. The café in question, where "night prowlers can take refuge . . . when they have no money to pay for a lodging or are too tight to be taken in,"[87] as Van Gogh explained to his brother, was also the one where he regularly drank and ate. He described the painting—with evident satisfaction—as "one of the ugliest I have done. It is the equivalent, though different, of *The Potato Eaters*,"[88] and he went on to summarize his intention "to express the idea that the café is a place where one can ruin oneself, go mad, or commit a crime."[89]

The breadth of Van Gogh's sympathy toward his human and landscape subjects is apparent in two quite different pictures from the month *The Zouave* was painted. In the middle of June, he left Arles for a short stay at the coastal village of Les Saintes-Maries-de-la-Mer, where he became enthralled by the beauty of the sea, the elegance of the girls (who brought to mind the paintings of "Cimabue and Giotto"),[90] and the clear, starry nights. Though he stayed less than a week, the artist proceeded to draw and paint almost every aspect of his new surroundings, soon covering the three canvases he had brought with him and completing a dozen sparkling drawings in pen, ink, and watercolor. In this open country he was again reminded of Holland, of the cottages "like the ones on our heaths and peat bogs in Drenthe"[91] as he told Theo, and perhaps of the rolling waves of his first paintings of the sea, such as *Scheveningen Beach in Stormy*

Weather (cat. 1). By this date and in these surroundings, however, a picture like *The Sea at Les Saintes-Maries-de-la-Mer* (cat. 50) shows him preoccupied by other factors; "The Mediterranean has the colors of mackerel," he assured Theo, "you don't always know if it is green or violet, you can't even say it's blue, because the next moment the changing light has taken on a tinge of pink or gray."[92]

Such remarks remind us how deeply ingrained certain of the notions of impressionism were and how close Van Gogh's responses could be to those of an artist like Monet, whose name still occurs frequently in Van Gogh's correspondence. Just months before, Monet had been working on the Mediterranean coast at Cap d'Antibes and his own letters record almost identical frustrations with the shifting tones of the sea and sky. But an examination of Van Gogh's canvas shows the lengths to which the Dutchman was willing to go in his impassioned engagement with his subject, not only documenting the perceptions of the moment but aiming at a kind of ecstatic intensity, "positively piling it on, exaggerating the color,"[93] as he recalled. In *The Sea at Les Saintes-Maries-de-la-Mer*, Van Gogh has exploited his deepest blues and most aqueous greens, rhyming them with undercurrents of ocher and sienna, and "piling on" the purest of whites in the churning waves, far-off sails, and gathering cloud. Identifying the flow of his paint with the rush of water, he even pushes the color across certain areas of the canvas with

a palette knife—most noticeably, in the foreground wave—conjuring up with pigments and oils the transparency of the ocean and the opacity of the beach beneath.

If the second canvas, *Fishing Boats on the Beach at Saintes-Maries-de-la-Mer* (cat. 51), is more subdued, it also contains spectacular proofs of Van Gogh's newly perfected skills in draftsmanship, design, and the handling of paint. Immediately before he started the picture, he made a precise and elegant drawing of its principal subject (fig. 30), reporting to his brother—with amazement rather than pride—that he had finished it "in an hour. . . . I do it now without measuring, just by letting my pen go."[94] Despite the complex curvature of the boats and their clutter of masts, Van Gogh was able to fix the forms of his composition from the beginning, setting it in a more spacious context as he transferred the drawing to the final canvas. Responding perhaps to the changing weather, he built up this new image with restrained tones of gray and umber, using thin paint in the early stages and advancing to richer pastes and brighter hues as it neared completion. His accomplishment in carrying out such ambitious works prompted a number of reflections during this period of isolation, many of them concerned with his move from the capital. "I am absolutely convinced of the importance of staying in the Midi. . . . I shall set my individuality free simply by staying on here. . . . I have only been here a few months," he pointed out to Theo,

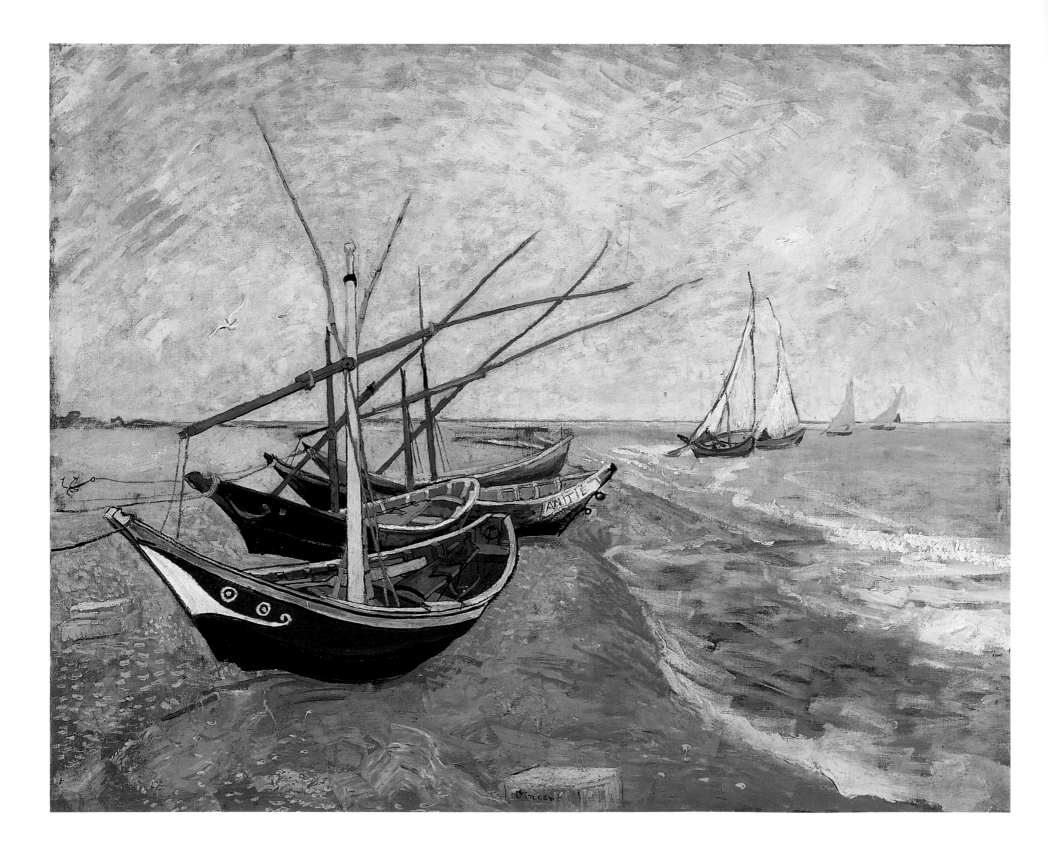

cat. 51 *Fishing Boats on the Beach at Saintes-Maries-de-la-Mer*, June 1888

fig. 30 *Fishing Boats on the Beach*, 1888, reed pen. Dr. Peter Nathan, Zurich

"but tell me this—could I, in Paris, have done the drawing of the boats *in an hour*?"[95] Van Gogh also admitted that his new life had not turned out as cheaply as he hoped, but argued stubbornly for the advantages of living in Provence, even imagining a local community of artists who would share their expenses and benefit from the healthy air and simple life.

Among the many justifications offered by Van Gogh for his move from Paris to Arles was his vision of a fraternity of painters, far away from the machinations of the city dealers and modeled in a rather ill-defined way on the traditional craft practices of Japan. Even before he had left the capital, Van Gogh envisaged that the light and color of Provence would resemble that in the Japanese woodblock prints he and his brother so keenly admired and collected; now beside the Mediterranean, he asked Theo "About this staying on in the South, even if it is more expensive, consider: we like Japanese painting, we have felt its influence, all the impressionists have that in common, then why not go to Japan, that is to say to the equivalent of Japan, the South?"[96] If his reasoning and the sources of Van Gogh's information may have been questionable, the idea still drove him to petition fellow painters to join the project and to press his brother for more funds for travel, materials, and accommodation for the proposed brotherhood. Bernard was urged to participate but declined, while Gauguin—who was in Brittany and as penniless as Van Gogh—was courted with

offers of financial support and the use of a specially prepared studio in Van Gogh's newly rented premises in the center of Arles. Distinctly in awe of Gauguin at this juncture, Van Gogh sympathized with his predicament and persuaded Theo to come to his rescue, gradually raising his own hopes for Gauguin's arrival in Provence: "If Gauguin were willing to join me, I think it would be a step forward for us. It would establish us squarely as the explorers of the South,"[97] he observed, as he put the finishing touches to the apartment. Japanese prints were pinned to the walls, the artist painted a self-portrait as a shaven-headed "worshiper of the eternal Buddha,"[98] and he began his pictures of sunflowers (fig. 31) for their shared studio, "a symphony in blue and yellow."[99]

His picture known as *The Yellow House ("The Street")* (cat. 52) shows the modest two-story building with green door and shutters that was to witness their brief cohabitation, with the rambling complex of other dwellings and commercial premises surrounding it on two sides. Now one of Van Gogh's most celebrated paintings, it is also among his least characteristic works of art at this or any other point in his career. As the years in Paris showed, Van Gogh had little interest in painting architecture or in the minute description of the urban environment. Equally, his previous studies of Provence had been characterized by a responsiveness to natural light and air, whether the fresh brightness of the fields or the grayer

tones of an overcast day. In *The Yellow House ("The Street")*, Van Gogh confronted the muddle of buildings in the Place Lamartine with something like visionary zeal, splashing the oddly assorted facades with fresh ocher, peppermint green, and sugar pink, yet mysteriously choosing to set the whole against a midnight blue sky. Almost as startling is the way these colors were applied, in flat, barely modulated planes of a single hue that transform the composition into a kind of heraldic design. Such departures from his normal practice—many of them echoed in such concurrent works as *The Bedroom* and the sunflowers series—evoke the pitch of excitement he had reached and his willingness to embrace the ideas of colleagues he soon hoped to welcome to Arles. In this dreamlike scene, color is allowed a free, decorative role of the kind that Bernard and his associates had previously urged on Van Gogh, while the confusion of night and day, and the sense of hallucinatory significance in the central building, must surely refer to the anticipated arrival of Gauguin in the town.

Inspired by his preparations, Van Gogh recounted to his brother the attempt to make "an artists' house," describing "a real scheme of decoration" with one room dominated by "white walls with a decoration of great yellow sunflowers," another by "the red tiles of the floor," and yet another by a view of "the green of the gardens and the rising sun."[100] A comparable intoxication with color infused the canvases of these months, while the artist's letters

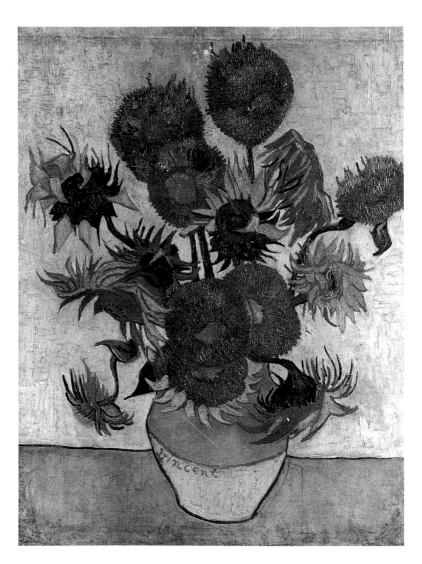

fig. 31 *Vase with Fourteen Sunflowers*, 1889, oil on canvas. Van Gogh Museum, Amsterdam (Vincent van Gogh Foundation)

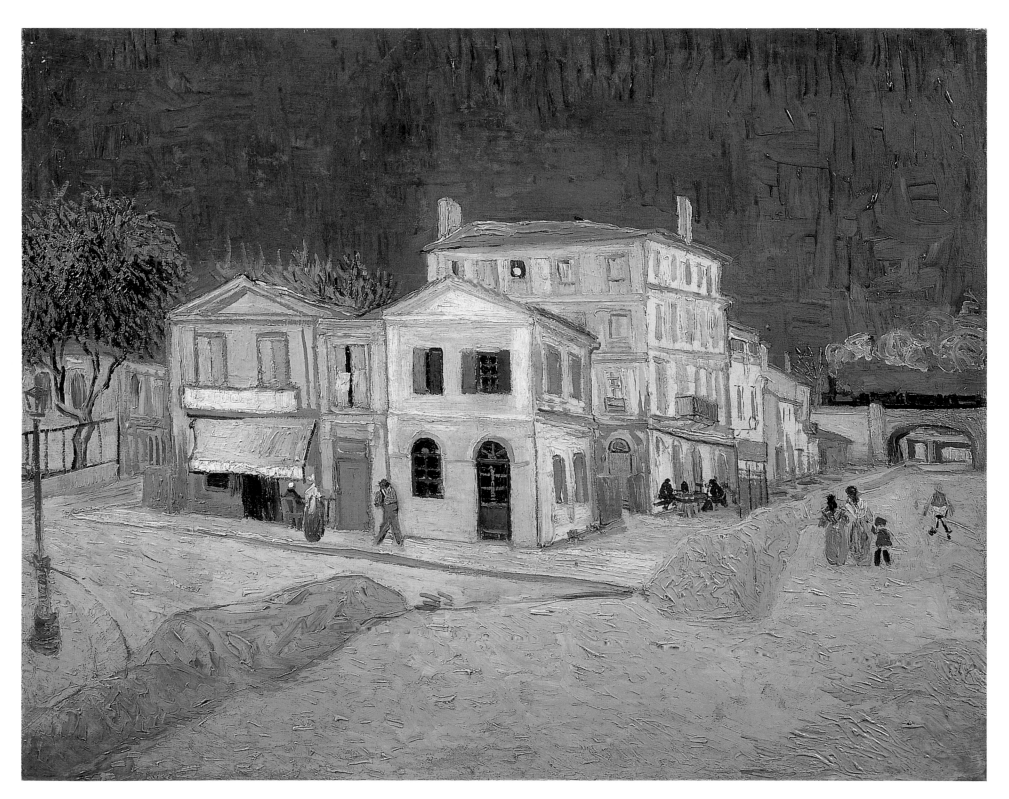

cat. 52 *The Yellow House ("The Street")*, September 1888

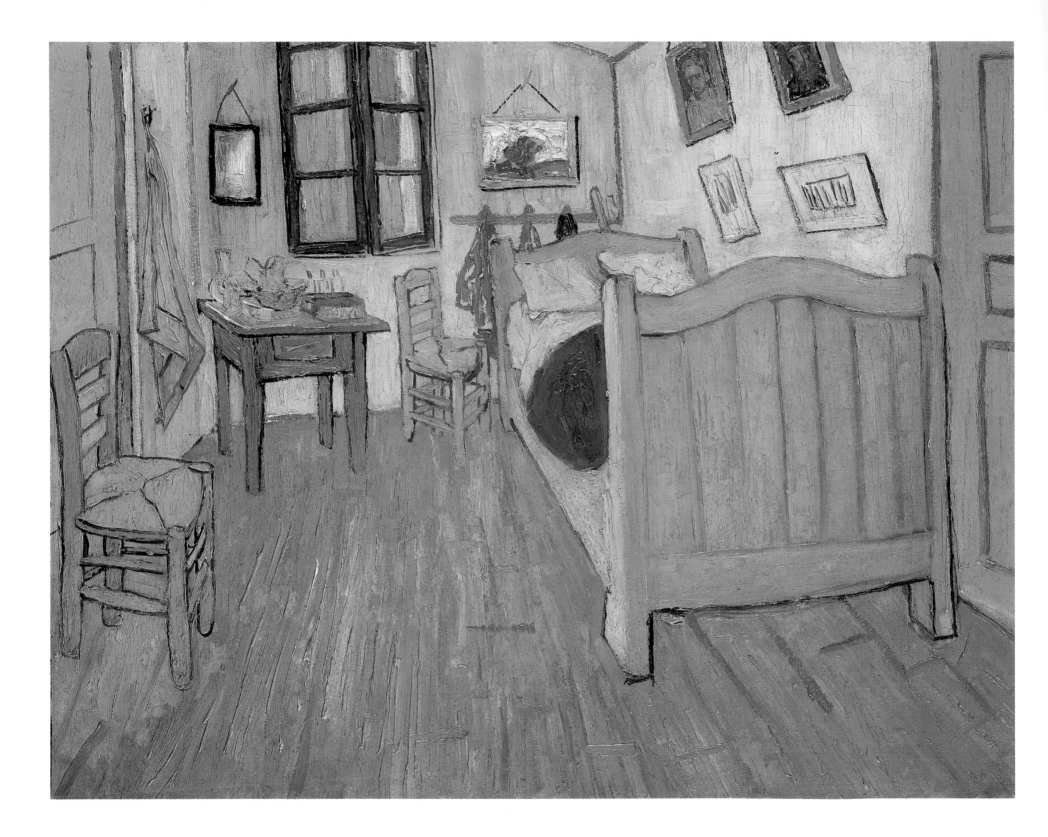

cat. 53 *The Bedroom,* October 1888

fig. 32 *Vincent's Bedroom,* 1888, sketch in letter 554. Van Gogh Museum, Amsterdam (Vincent van Gogh Foundation)

continued the same pragmatic, and sometimes contradictory, reflections on the art of the past and the future. "What I learned in Paris is leaving me and I am returning to the ideas I had in the country before I knew the impressionists," he told Theo in August: "Because instead of trying to reproduce exactly what I have before my eyes, I use color more arbitrarily, in order to express myself forcibly."[101] His picture of *The Yellow House ("The Street")* can be seen as such a statement, perhaps as a declaration of optimism or an attempt to achieve the "extreme clarity"[102] of style he admired in Japanese art. Writing about *The Bedroom* (cat. 53), a canvas specifically destined for his dec-

orative scheme, Van Gogh was even more explicit, devoting an entire paragraph to the workings of its many hued palette and bold composition (fig. 32): "here color is to do everything," he announced, adding that "the broad lines of the furniture again must express inviolable rest."[103] Van Gogh was clearly delighted with his creation, making several replicas of the work and recognizing that it brought together many of the complex preoccupations of his mature art. Characteristically, the picture is a response to a subject he knew well and cared about deeply: his private room in the "artists' house" with the furniture he had chosen—and in some cases brightly painted—

himself. Like so many of the finest studies of this period, however, it aspires to be more than a description, a simple inventory of an empty, "unbeautiful" room, as he referred to it; everything about the canvas was intended to convey something of Van Gogh himself, to bridge the gap between his own passionate experience and the lives of those around him.

After much procrastination, Gauguin arrived in Arles in late October 1888, Van Gogh reporting with some satisfaction that his guest had admired the pictures of "the sunflowers and the bedroom."[104] In their earlier correspondence Van Gogh had adopted a largely deferential attitude to Gauguin, urging him to become the "head" of the cooperative studio and insisting that his own ideas about art were "excessively run-of-the-mill compared to yours."[105] Initially maintaining this modest stance and clinging to his roots in everyday reality, Van Gogh was soon swept up in Gauguin's enthusiasm for the poetry of forms and colors, and by what Emile Schuffenecker called Gauguin's "terrible mysticism." For a while the influence was mutual, Gauguin following Van Gogh's example by painting a red and green *Café at Arles* and a number of densely colored local landscapes, and Van Gogh experimenting with subjects executed from memory and what he was later to describe as "abstractions." On several occasions the artists worked side by side—when Gauguin made a study of Van Gogh painting one of his sunflowers series, for example—bringing their contrasting

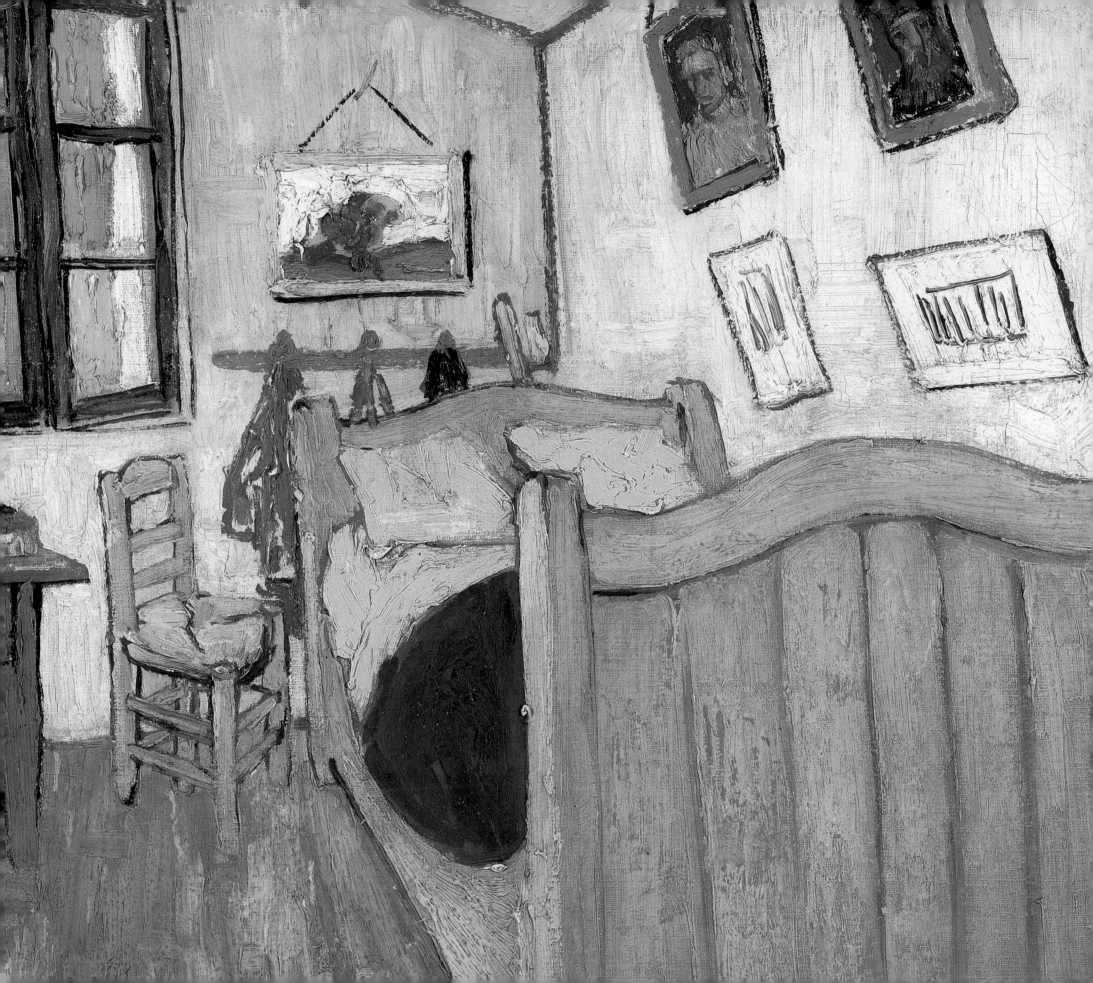

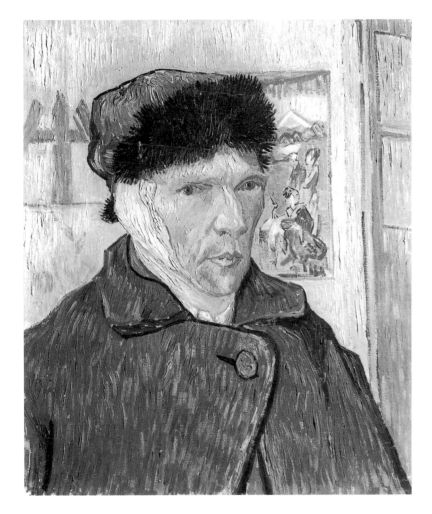

cat. 53 Detail

fig. 33 *Self-Portrait with Bandaged Ear,* 1889, oil on canvas. Courtauld Institute of Art, London

styles and divergent personalities into the closest proximity. In these circumstances, Van Gogh soon found the confidence to reassert himself and return more forcefully to his attachment to nature, leading to a number of "exceedingly electric" debates about painterly matters and a growing personal tension between the two men. It was after one of these disputes that Van Gogh threatened Gauguin with a razor and then retreated to a nearby brothel, where he damaged part of his own ear. Understandably frightened, Gauguin left Arles in haste and effectively brought to an end the dream of "the studio of the South" based in the Yellow House. Van Gogh himself was seriously weakened by the incident and spent some time in the hospital at Arles, but was soon writing long letters to family and friends, and almost joking with Theo about his recent "attack of artistic temperament."[106] Beneath his predominantly rational tone, however, Van Gogh clearly accepted that a new factor had entered his life: from now on, he would be prey to the whims of his condition and the continual threat of violent, irrational seizures.

For much of his adult career, Van Gogh made pictures that reflect with almost unbearable directness on his personal surroundings, the humblest of his possessions, and the most intense of his feelings. In a work like *The Bedroom,* the acts of living and painting appear to merge, as we step into the intimate recesses of the artist's life and find ourselves surrounded by painted furniture and objects familiar from other canvases, as well as walls hung with landscape studies and privately resonant portraits. Van Gogh's traces are everywhere, from the straw hat depicted at the head of the bed to the thickly manipulated paint itself, here applied in sensuous swathes and flourishes of color that follow the movements of hand and arm. As the pictures on his bedroom walls make clear, in the final months in Arles Van Gogh continued to work at that most direct of human encounters—the study of the face— recording the changes to his own features and the appearances of a number of close friends. Most famously, he represented himself on two occasions with his head wrapped in bandages (fig. 33), as if attempting to come to terms with his recent crisis or wishing to represent himself to the world in all his frailty. Almost as poignant are his pictures of the Roulin family, who lived near the Yellow House and offered him a virtual second home during his stay in the town. Van Gogh had already painted Joseph Roulin (fig. 28), the town postman, whom he described as "like old Tanguy in so far as he is a revolutionary,"[107] but now executed no less than ten canvases of the uniformed official and his wife Augustine. Soon a similar number of pictures of the children were added to the total and he was able to tell Theo excitedly, "I have made portraits *of a whole family.*"[108]

It is one of the paradoxes of his career that Van Gogh, for many the landscape painter *par excellence,* consistently maintained that it was

the portrait that represented his highest ambition. Portraiture, he wrote in August 1888, "is the only thing in painting that moves me to the depths, and it makes me feel closer to infinity than anything else."[109] Images of those close to him were especially valued (he had recently instigated an elaborate exchange of self-portraits with Gauguin, Bernard, and Charles Laval) and the responsibility of doing justice to his relationship with a familiar sitter weighed heavily upon him; "I don't know if I can convey the postman *as I feel him*," he wrote while working on the first picture of Roulin.[110] The more sympathetic feelings must surely lie behind the studies Van Gogh made of the Roulin's new baby, who was twice depicted with its mother soon after the birth and again in a trio of near-identical close-up portraits. Beside customary images of the young, his *Portrait of Marcelle Roulin* (cat. 54) might appear brash, even grotesque in its depiction of bulging cheeks and berrylike eyes, its thickly painted planes of marzipan green and lobster pink. But the three-dimensional vividness of the child is inescapable, as is the sense of healthy and cheerful energy (the baby was "born smiling," according to the painter),[111] which seems to overflow the canvas edges. Such pictures bring us—almost literally—face-to-face with Van Gogh's daily experience and with the battery of painterly expedients now at his disposal. In the *Portrait of Camille Roulin* (cat. 55), a study of Marcelle's elder brother, a similar closeness to the individual makes itself felt, both in the

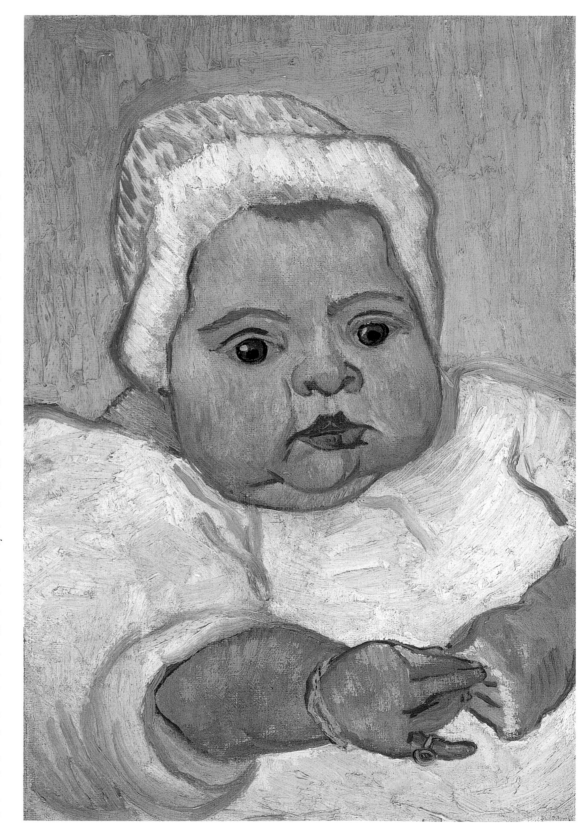

cat. 54 *Portrait of Marcelle Roulin*, December 1888

114

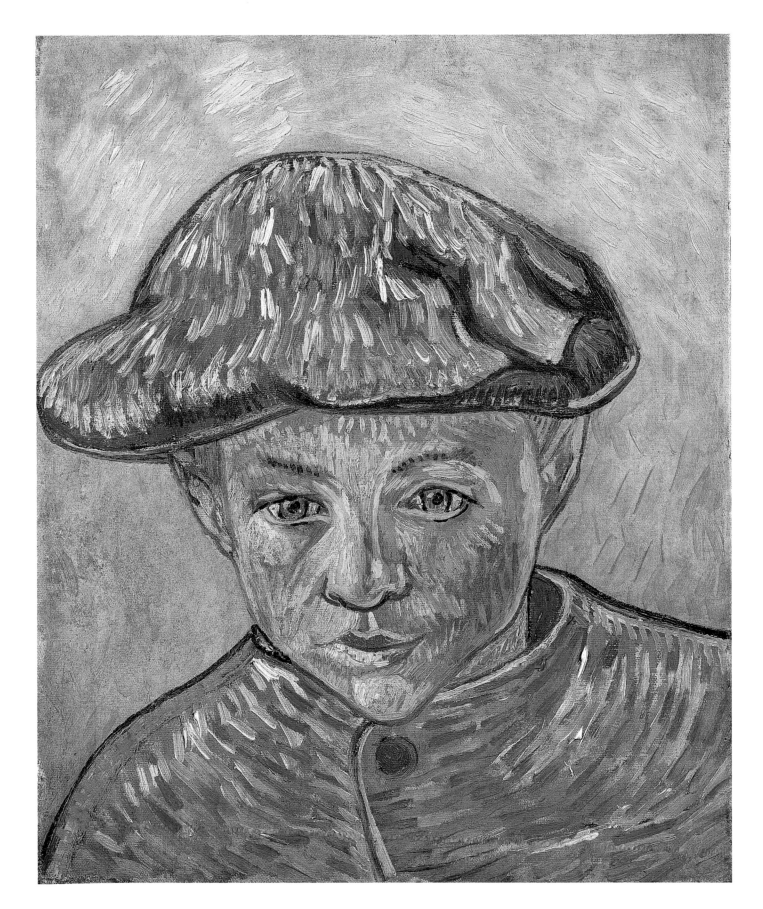

crowding of the picture rectangle and the art-less openness of the young boy's gaze. In the same way that our eyes feel free to explore his sun-bronzed complexion, so the painter's brushes seem to follow the intimate curvature of chin and nose, the sweeping texture of his jacket, and the abrupt form of his oversized cap. Not only do we see Van Gogh's model, we come close to touching it and enclosing it in our own private space.

In January 1889, as he was recovering in the hospital from the attack that had driven Gauguin from Arles, Van Gogh announced "I am going to set to work again tomorrow. I shall begin by doing one or two still lifes so as to get back into the habit of painting."[112] If *Crab on Its Back* (cat. 56) was one of these exercises, as is generally believed, we can only marvel at the clarity of his vision and the surpassing control that is apparent in every aspect of its surface. As much as in his portraits, Van Gogh has plotted the crests and concavities of the animal form, the fine junctions of its limbs, and the delicate bristlings and serrations of its body. Drawing defines the crab's structure, while resonant color and vivid brushwork evoke the potential for violence that remains in the creature's claws. Attempts have been made to link this image with Japanese wood-cuts of fish and crustaceans, but—as with Van Gogh's *The Courtesan* (cat. 37)—the image seems to defy conventional modes of repre-sentation as much as respect them. Aggres-sively volumetric, the hot-tinted crab thrashes

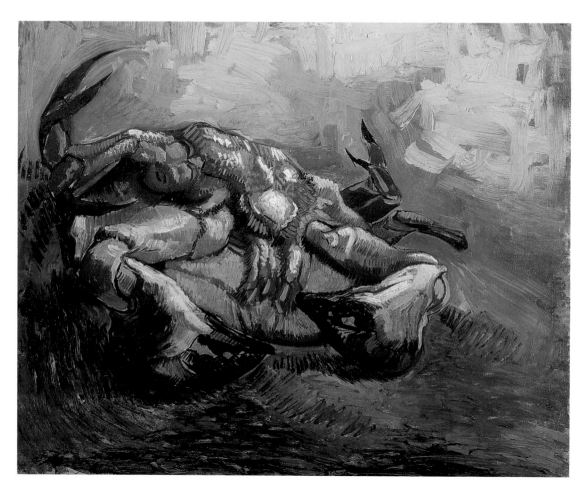

cat. 56 *Crab on Its Back*, winter 1888–1889

against a maelstrom of roughly painted greens that are far removed from any notions of graphic nicety. More persuasive is the idea that the artist identified in some way—perhaps un-consciously—with the helpless beast at a par-ticularly vulnerable moment in his life; like Van Gogh, the crab needs only patience, luck, or intense determination to become fully ac-tive again.

SAINT-RÉMY-DE-PROVENCE: 1889–1890

"I could almost believe that I have a new period of lucidity before me"

fig. 34 *Pine Tree in front of the Entrance to the Asylum*, 1889, oil on canvas. Musée d'Orsay, Paris

fig. 35 *Window of Vincent's Studio in Saint Paul's Hospital at Saint-Rémy*, 1889, black chalk and gouache. Van Gogh Museum, Amsterdam (Vincent van Gogh Foundation)

After the distressing end to his stay in Arles, Van Gogh moved with evident relief to the asylum at Saint-Rémy-de-Provence in May 1889. There he remained for almost exactly a year, insulated from the tensions as well as the stimulus of society at large and delivered from most of the day-to-day cares that had troubled him in adult life. In the asylum—more properly the mental hospital of Saint-Paul-de-Mausole, which can be seen in the background of *Pine Tree in front of the Entrance to the Asylum* (fig. 34)—Van Gogh followed a simple regime in which he was encouraged to draw and paint, his modest expenses paid by the ever-devoted Theo in Paris. Though he was initially restricted to the building, Van Gogh gradually progressed to working in the gardens and nearby countryside, rediscovering that ecstatic affinity with nature that had produced some of his finest canvases at Arles. In many ways the seclusion of the hospital suited him, allowing a new purposefulness and a profound lyricism to take hold of his art. Disarmingly open about his condition, which was eventually diagnosed as a form of epilepsy, he welcomed the sympathetic care of the staff and the opportunity to regain some of his former strength. In the supremely cogent letters that continued to flow from his pen, the painter explained that he was subject to periodic and debilitating attacks, but that for weeks and even months on end he felt himself calm and entirely lucid. Even before he left Arles, he told Theo in his usual self-deprecating manner, "As far as I can judge I am not really mad. You will see that the canvases I've done in the meantime are untroubled and no worse than the others."[113]

Faced with the relative confinement of the hospital, Van Gogh was often thrown back on his own resources as he had formerly been in winter-bound Paris, friendless Antwerp, and philistine Nuenen. His search for subject matter obliged him to improvise; temporarily distanced from the landscape, he painted views through the window or the rooms themselves (fig. 35); cut off from exhibitions, galleries, and other artists, he made replicas of his own canvases and copies of favorite paintings (cat. 59); and starved of models, he studied his own features and those of his fellow patients. One of the latter seems to have posed for *Portrait of a One-Eyed Man* (cat. 57), a typically frontal image that has much in common in compositional terms with the portraits of the Roulin family. Again the sitter's clothes, hat, and immediate background are woven into a single, flowing whole, while even his cigarette smoke

seems to billow with the same rhythms that govern his face and body. In some areas the canvas shows signs of hesitation or reworking by the artist—especially around the jacket—but the overall result is both forceful and surprisingly amiable. Neither the identity of the man nor the nature of his affliction is recorded, but Van Gogh unhesitatingly represents him from close quarters and stresses his common humanity; writing of this or a similar study, he told Theo, "I am working on a portrait of one of the patients here. It is curious that after one has been with them for some time and got used to them, one does not think of them as being mad any more."[114]

Some of the most affecting moments in Van Gogh's early months at the Saint-Rémy asylum concern his response to the outside world, as seen through the window of his room or encountered on his forays into the garden. From his bedroom and the room set aside as his studio (fig. 35), the artist established an intense relationship with certain segments of the surrounding countryside; "Through the iron-barred window I see an enclosed wheatfield, a prospect à la Van Goyen, above which I see the morning sun rising in all its glory," he wrote on 25 May. Soon this subject—with all its echoes of personal enclosure, of the landscapes of Van Goyen, and of the symbolic power of light—seized his imagination, resulting in an entire series of drawings in pen, chalk, and pencil and a family of canvases, such as *Wheatfield with a Reaper* (cat. 58). His preliminary

cat. 57 *Portrait of a One-Eyed Man*, December 1888

cat. 58 *Wheatfield with a Reaper*, July–September 1889

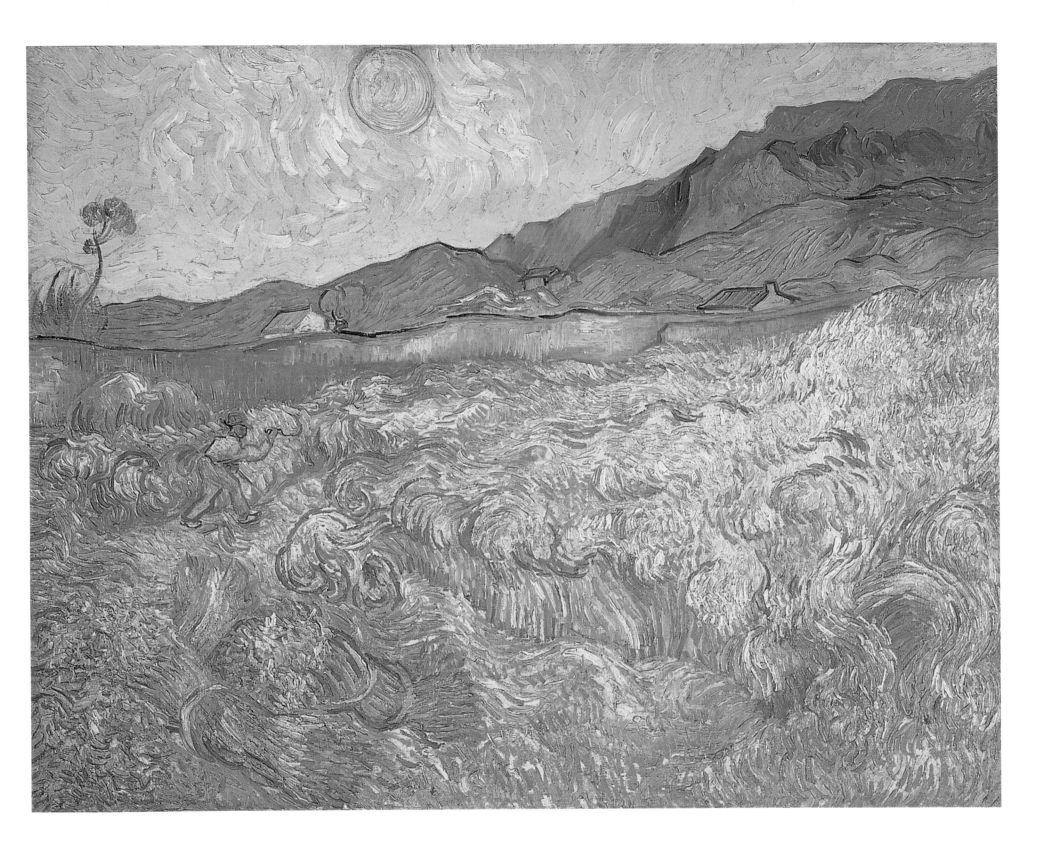

pencil sketches reveal how prosaic the scene probably was, while other studies show the artist discovering subtle new angles and variations in design, emphasizing the distant hills and varying the roles of trees, buildings, and changing crops. Simple though these compositions are, seen as a whole they amount to a virtual summation of Van Gogh's artistic creed. Each representation is different from the others in a way that is irreconcilable with topographical fact, yet all are persuasive as products of his encounter with nature and of his broader human concerns. Unusually, around the time he painted *Wheatfield with a Reaper*, Van Gogh allowed himself to reflect on the subject as a projection of larger forces and to interpret the figure of the reaper in highly specific terms: "I see in him the image of death, in the sense that humanity might be the wheat he is reaping. . . . But there's nothing sad in this death, it goes its way in broad daylight with a sun flooding everywhere with a light of pure gold."[115]

Van Gogh's identification with the reaper theme becomes even more poignant when linked—as he certainly expected it to be—with his artistic hero of former years, Millet. Pictures by Millet were once more to haunt his stay at Saint-Rémy, whether in new studies of men digging, sowing, or cutting corn, or in more than twenty painted copies or transcriptions of Millet's celebrated rural scenes, such as *The Sower* (fig. 36). Intensely personal though they are, the making of such copies at

this stage in Van Gogh's career can still disconcert his admirers, who may see them as an act of retrenchment or as evidence of a failure of nerve. The artist's need for reassurance at a time of crisis might offer a partial explanation for these works, but Van Gogh rarely discriminated between past and present—or attached himself to models of continuous innovation—in the way that some of his successors tend to expect. In *Wheatfield with a Reaper*, for example, we are unashamedly taken back to the beginning of his career in this combination of history and elemental landscape, the whole then transposed to sun-blasted Provence. For Van Gogh, the move to the South had always been linked with tradition, not only with his Japanese forebears but with other artists—such as Delacroix, Monticelli, and Cézanne—who had preceded him there. He wrote eloquently of the "stronger sun" of the region that helped him appreciate their work: "because one feels that one could not understand Delacroix's pictures from the point of view of execution and technique without knowing it."[116] At Saint-Rémy, he turned again to Delacroix, whose work was also represented in his collection of prints, one of the latter becoming the subject of a painted transcription after another sudden attack: "this last time during my illness an unfortunate accident happened to me—that lithograph of Delacroix's *Pietà*, along with some other sheets, fell into some oil paint and was ruined. I was very distressed—then in the meantime I

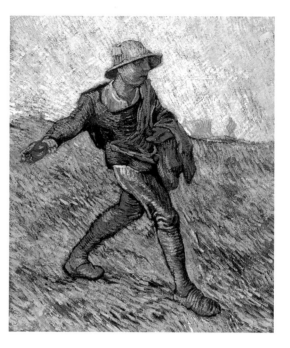

have been busy painting it, and you will see it some day."[117]

While he was working on his *Pietà* (cat. 59) Van Gogh told Theo that the wife of a hospital attendant had said "she did not believe I was ill—and indeed, you would say the same thing yourself now if you could see me working, my brain so clear and my fingers so sure that I have drawn that *Pietà* by Delacroix without taking a single measurement."[118] Van Gogh's canvas is indeed a tour-de-force of dexterity, not just in the precision and subtlety of its draftsmanship but in the free inventiveness of the color. Working from a damaged black-and-white print—which still survives (fig. 37)—the artist has improvised a miraculous palette of deep blues, pinkish browns, and

cat. 59 *Pietà* (after Delacroix), September 1889

fig. 37 Célestin Nanteuil (after Eugène Delacroix's *Pietà*), lithograph. Van Gogh Museum, Amsterdam (Vincent van Gogh Foundation)

sepulchral greens, many of them suffused with an eerie glow of dull lemon. As in his *Portrait of a One-Eyed Man*, though here on a much more ambitious scale, these hues are woven around the principal forms and across the dominant spaces to create a unity of texture, pattern, and pictorial energy. Respectful of his predecessor's manner, Van Gogh has restrained his inclination to exuberance and followed with touching attention the modeling of Christ's torso and the precise disposition of the Virgin's fingers. If he has allowed himself liberties, it is in the exaggeration of the frailty of the male body and the hint—in his red-bearded face—of Van Gogh's known appearance at this time. A little defensive about these transcriptions,

the artist suggested that they were the equivalent of one composer playing the music of another, a familiar theme to which the performer has added his own personal interpretation. He was also quick to point out that despite some unexpected moments of consolation from "religious thoughts" during his recent illness, such pictures did not represent an abandonment of his commitment to everyday subjects and to the simplest modes of communication. Repeating a sentiment that echoes through his career, he said simply of his *Pietà*, "I hope it has feeling."[119]

The same theme recurs in a different form in a ferocious passage from one of Van Gogh's letters to Bernard, written from Saint-Rémy in November 1889. Bernard had sent him some photographs of his recent paintings, illustrating a move toward more imaginative compositions and specifically to such biblical themes as the *Adoration of the Magi* and *Christ Carrying His Cross*. Van Gogh was shocked by this retrogressive development, calling his friend's pictures "appalling" and "affected" and reminding him that Millet, who knew his Bible thoroughly, "never, or hardly ever, painted biblical pictures."[120] Asserting himself with unusual vehemence, Van Gogh urged Bernard to make up for his errors "by painting your garden just as it is" and pointing out that he himself had "been slaving away on nature the whole year, hardly thinking of impressionism or of this, that and the other."[121] "If I am capable of spiritual ecstasy, I adore Truth," he

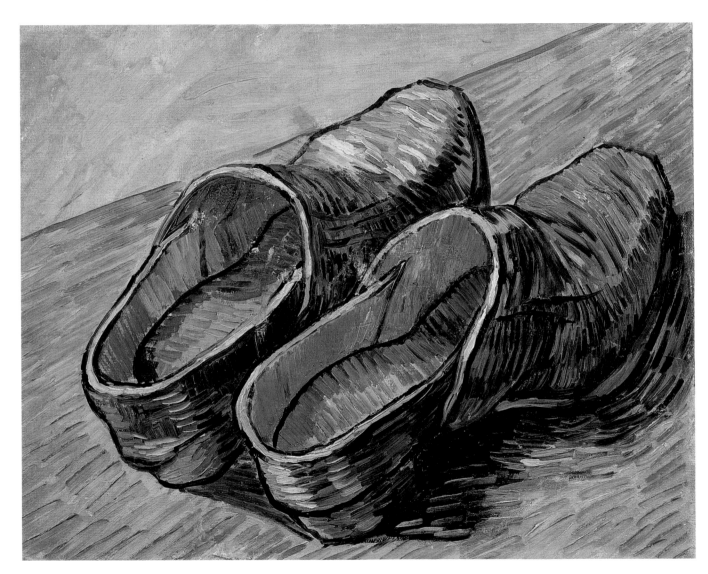

cat. 60 *A Pair of Leather Clogs*, 1889

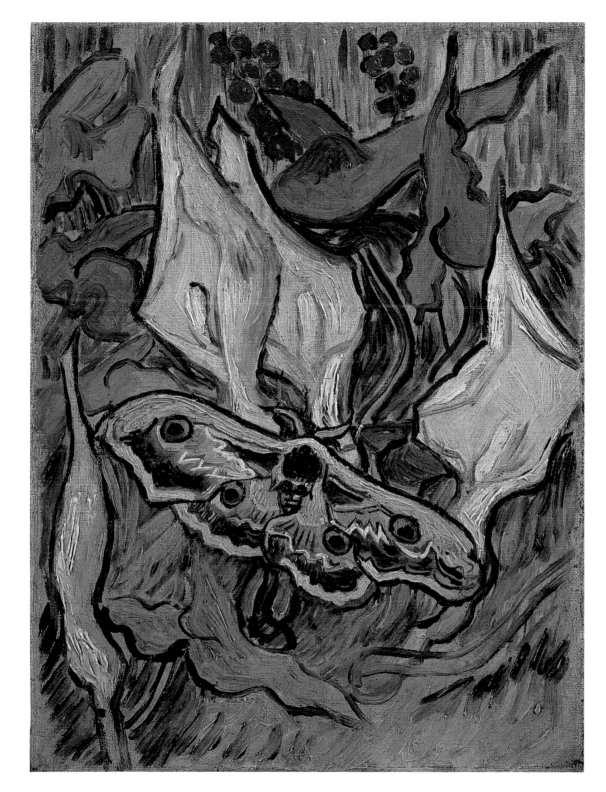

cat. 61 *Emperor Moth*, May 1889

told his correspondent, proceeding to describe a number of canvases of olive groves, gardens, and "the sun rising over a field of wheat" he was currently engaged in.[122] Distinct though it is from these pastoral subjects, he might equally have cited *A Pair of Leather Clogs* (cat. 60), a small masterpiece of truthful observation that carries the processes of painting into near-ecstatic regions. Everything that can be said about the complex volumes of these shoes—with their scuffed edges, worn bulges, and cavernous interiors—seems to be contained in a few hundred brushstrokes, with hardly a hesitation or a mark out of place. Van Gogh's command of his craft was now so complete that it could appear effortless, with such exquisitely judged details as the meeting of the table edge with the contour of one of the clogs almost taken for granted. The briefest comparison with an early work like *A Pair of Shoes* (cat. 18), however, shows both the continuities of his art and the sophistication of his late manner, here revealed at its most self-effacing.

On more than one occasion, Van Gogh acknowledged that the painting of still lifes helped to calm his nerves. As he became bolder in his forays into the open air, studies of insects, flowers, and the trunks of trees were added to this repertoire, often with the same curious fusion of literalness and transcendence that marks out *A Pair of Leather Clogs*. In *Emperor Moth* (cat. 61), a description of the intricacies of the moth's wings and body is testimony to the artist's awe in front of nature,

123

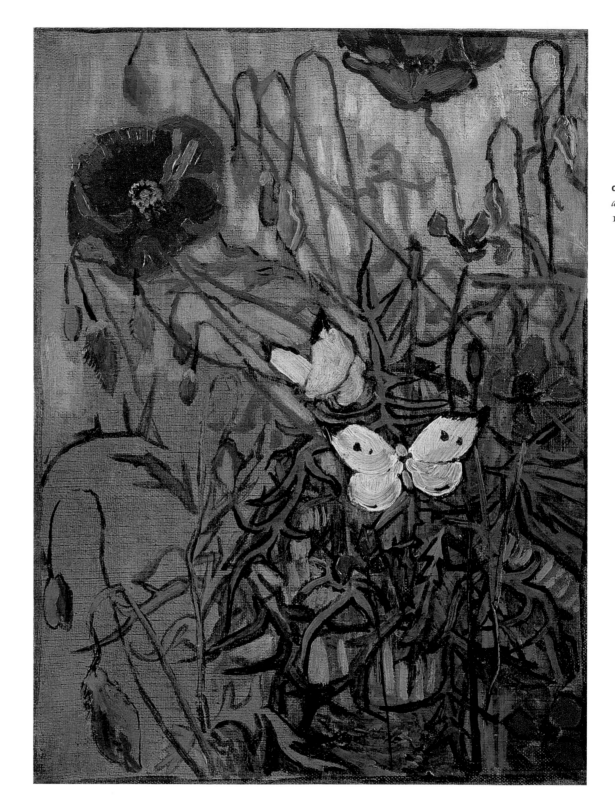

cat. 62 *Butterflies and Poppies*, May 1890

while the firm scaffolding of painted dark blue lines asserts his controlling vision. This is not a fragile, fleeting presence, but an awesome entity in its own right, "a very big, rather rare night moth, called the death's head,"[123] as Van Gogh believed it to be, before confessing to his brother that he had to kill the moth in order to paint it. Once again, a memory of a Japanese print of a similar subject may lie behind this uneasy image, just as a similar source may have prompted another glimpse of insect life at Saint-Rémy, *Butterflies and Poppies* (cat. 62). In this barely finished canvas, the artist's progress from a linear statement to the beginnings of a naturalistically tinted composition can be followed with unusual clarity, leaving us to speculate on his initial attraction to such a congested corner of nature. Resisting the temptation—as Van Gogh himself almost invariably did—to see in this thicket of stems, leaves, and drooping buds a projection of his own phases of confusion, we can look to such delicately resolved areas as the poppy flowers and the yellowish-white butterflies for evidence of his improvisational skills. With just a few flicks of a paint-loaded brush, the artist has summed up the weightlessness of the principal butterfly and used the more convoluted form of its companion to suggest their imminent flight. Among the more modest-sized canvases of this period, this too represents a tiny fragment of truth.

Unlike the earlier phases of his working life, the years in Arles and Saint-Rémy are marked by the survival of a significant number of letters written to his brother by Theo van Gogh. Rarely as eloquent or as fulsome as the painter's, Theo's notes are nevertheless full of affectionate concern for his health, his general well-being, and the progress of his art, the latter continually revealed to him in parcels of paintings and drawings sent from Provence. In the spring of 1889, Theo described the apartment he had just moved into with his new wife, Johanna, where Vincent's pictures made "the rooms look so gay, and there is such an intensity of truth, of the true countryside in them."[124] A version of the *Sunflowers* was hung in the dining room and Theo reported that many of their visitors—who included artists like Camille Pissarro and Meyer de Haan, Gauguin's colleague, as well as fellow dealers like Tanguy—had admired this work greatly. In his remote hospital room, Van Gogh was obliged to follow his growing reputation through Theo's letters, hearing that pictures like his *Irises* and *Starry Night* were attracting favorable attention at the Independents exhibition and, in July, learning of an invitation to show his work with the progressive Vingtistes group in Brussels. With each package of new pictures, Theo's conviction of his brother's originality seemed to deepen. After the arrival of a consignment of canvases painted in Arles, which contained portraits of the postman Roulin and baby Marcelle, Theo assured the artist that the work was "very important: there are superb things in it. . . . Certainly there is none of the beauty which is taught officially in them, but they have something so striking and so near the truth . . . they will undoubtedly be appreciated some day."[125]

In another group of pictures welcomed rapturously by Theo was "one with underbrush and the trees overgrown with ivy. . . . those trees with their dense foliage full of freshness and bathed in sunlight are marvelously good," he told Vincent.[126] This work formed part of an extended series of painterly reflections on olive, cypress, pine, and other kinds of tree in the vicinity of the asylum, made between the spring and autumn of 1889, which in some senses took the place of the portraits Van Gogh still longed to produce. Just as he had recorded the human types of the Midi at Arles and some of the other residents at Saint-Rémy, so he now chose to paint the personalities of the new landscape; "olive trees are very characteristic," he informed the less well-traveled Theo, "They are old silver, sometimes with more blue in them, sometimes greenish, bronzed, fading white above a soil which is yellow, pink, violet-tinted or orange, to dull ocher,"[127] *Olive Grove* (cat. 63) is a superb evocation of this shifting spectrum of tones, hinting at the gnarled and timeless individuality of the separate trees and their conspiratorial unity of texture and foliage. Compared to the lone cypresses that famously emerged from this same preoccupation, these olive trees are ground hugging and wistful, inhabiting shadowy regions of indeterminate form and color that the artist has handled with consummate ease. Close-valued

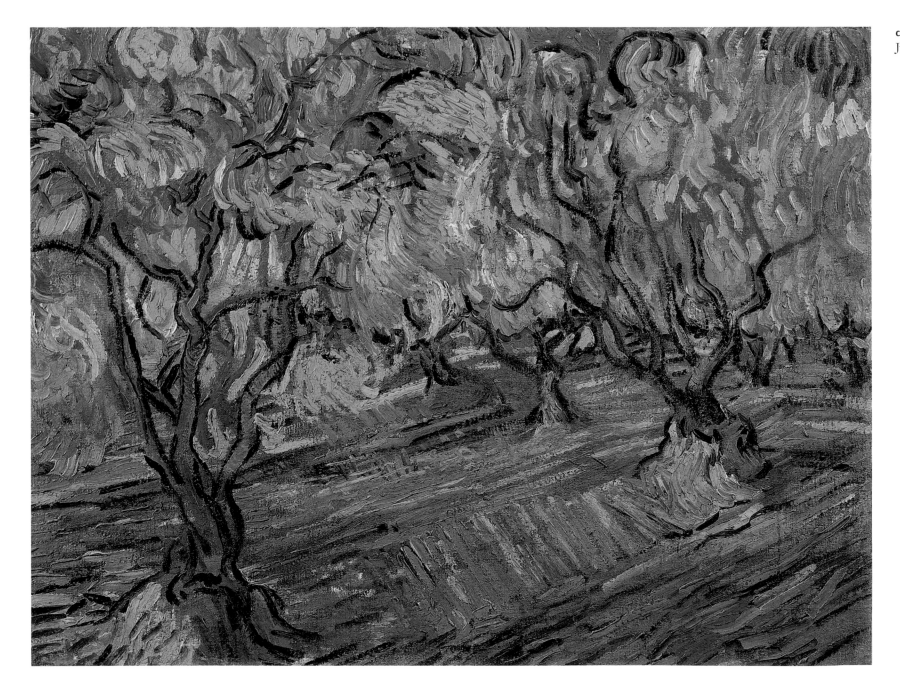

cat. 63 *Olive Grove,*
June–July 1889

fig. 38 *Trees with Ivy*, 1889, pencil, reed pen, and brown ink. Van Gogh Museum, Amsterdam (Vincent van Gogh Foundation)

hues of blue, green, and earth brown lie side by side, the direction of the brushstrokes modeling space and evoking the restless animation of the olive grove itself. This is a tour-de-force of painterliness, partly improvised in the still-wet color of the canvas surface but principally derived from several years of "hand-to-hand struggle with nature," as Van Gogh called it in a letter to Bernard.[128]

If olive groves stood in some way for the identity of Provence, the unidentified "trees overgrown with ivy" admired by Theo appear to have had a more universal significance in the mind of the painter. Speaking of an earlier version of this subject, closely related to his drawing *Trees with Ivy* (fig. 38), Van Gogh claimed that it "represents the eternal nests of greenery for young lovers,"[129] perhaps in coy reference to his recently married brother. Certainly the large composition entitled *Undergrowth* (cat. 65) has an all-enveloping sensuousness, its shadows and dense foliage relieved of their ominousness by artfully placed patches of sunlight and understated structure. Beneath the multitude of brushstrokes, a diagonal progression of tree trunks advances from bottom left to top right, marshaling the incipient disorder of the forest and secluding the viewer from the brash open spaces beyond. A wealth of color in its deep blues and greens is also reassuring, with hints of lavender, ocher, and pinkish-gray enlivening the cooler tones and implicitly reflecting the late summer light. When Van Gogh had tackled similarly amorphous forest subjects in Paris just two years previously (cats. 33 and 34), on a significantly less grand scale, he had felt the need of his drawing frame and a vestigial system of perspective. Now he dealt triumphantly with an even more demanding scene, picking his way through tangled weeds and around twisted branches, relying on the rhythms of his brush as much as the space-defining conventions of the past. As in *Olive Grove*, it is the precise weight and orientation of each stroke of paint, and the eddies of sympathetic marks flowing together and against the dominant line of trees, that bring articulation to this wonderfully resolved work.

It can still come as a surprise to discover the deliberation with which Van Gogh—the reckless, unstable creator of legend—set about painting his major images. Habitually dismissing his smaller works as "studies," he would often labor at several variants of a theme—frequently based on one or more drawings, such as *Trees with Ivy*—before arriving at the definitive "picture." *Undergrowth* is a case in point, existing in a total of three versions with similar titles, among which the smaller canvas of the same name (cat. 64) is clearly Van Gogh's first exploration of the motif. Here the arrangement of tree trunks is still largely haphazard, while the harmony between the dank penumbra and the scatterings of light has begun to anticipate the larger composition. Everything about this study suggests haste or excitement, as if the artist wished to record a chance encounter with an effect of daylight before it changed beyond recall. Seizing an unprimed, brown-tinted linen canvas, Van Gogh has rapidly noted down the dominant hues in front of him and the shapes of branches and shadows, introducing streaks of complementary color as an answering counterpoint. His strokes are broad and coarse, partly in response to the unmediated canvas surface and partly as a kind of shorthand that could be expanded into the richer poetry of the enlarged scene. Time has been harsher on the first attempt, the darkness of the unprepared canvas increasingly asserting itself and the brightness of some of Van Gogh's colors becoming measurably more

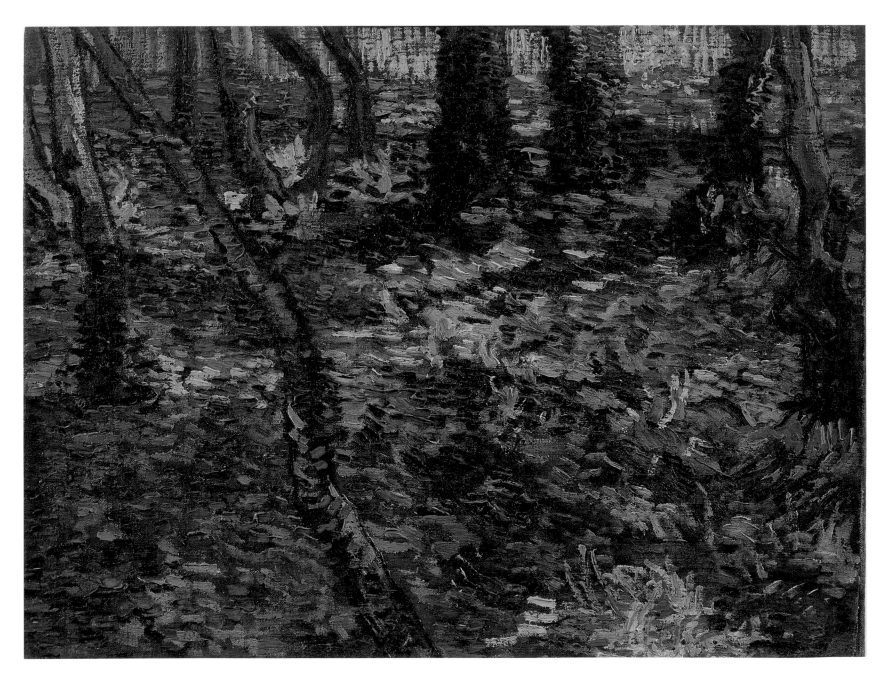

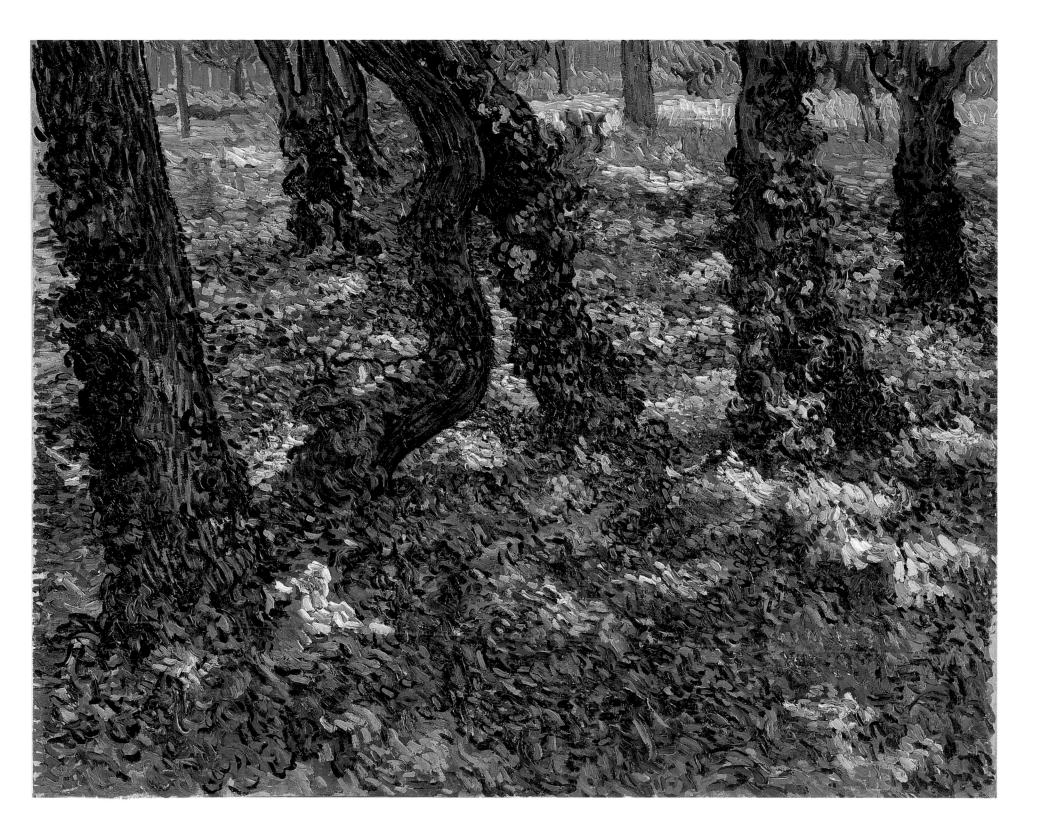

muted. Some of its vitality survives, however, in this mysterious, flickering preamble to one of the finest creations of the Saint-Rémy sojourn. When the large canvas was hung in the Independents show in March 1890, Johanna van Gogh told the painter that she "sat there for a whole fifteen minutes enjoying the delicious coolness and freshness of the *Undergrowth*—it's as though I knew this spot."[130]

It can be deduced from the brothers' letters that Vincent finished the *Undergrowth* series shortly before an epileptic seizure in mid-July 1889. During his attacks, the artist would behave wildly and engage in such activities as eating soil or paint, forgetting everything about the incident as soon as the storm was past. He was disarmingly open about his condition, reflecting on other painters from the past who had lost their reason and speaking with characteristic generosity about his fellow inmates: "though there are some who howl or rave continuously, there is much real friendship here among us," he reassured Theo soon after his arrival.[131] For much of the time at Saint-Rémy, however, Van Gogh enjoyed long spells of serenity between his bouts of illness and was soon trusted to come and go as he pleased. "I am working from morning till night," he wrote in September, "my strength is returning from day to day," then adding, "I could almost believe that I have a new period of lucidity before me."[132] As in the past, his letters to Theo dealt at length with practical matters, with the need to send paints and canvases, and with his

views on the Dutch, French, and English artists they both admired. Van Gogh's reading was as important to him as ever and he thanked his brother for sending a volume of Shakespeare's plays with the words, "what touches me, as in some novelists of our day, is that the voices of these people, which in Shakespeare's case reach us from a distance of several centuries, do not seem unfamiliar to us."[133] The need for sympathetic company preyed on him more and more, revealing itself in nostalgia for Paris and even for family life in Holland, and in expressions of warm affection for Theo and Jo, the latter now addressed as "sister." By the autumn, Van Gogh had fixed his mind on a return to the North, where Theo had begun to make inquiries for the appropriate care and accommodation of his vulnerable, difficult, but much-loved brother.

One of the brightest moments in Van Gogh's last months at the Saint-Rémy hospital was the announcement from Paris that Jo had given birth to a baby boy, who was to be christened Vincent in honor of his uncle. By chance, the event coincided with another happy omen, that of the publication of an enthusiastic article on Van Gogh's work by the young critic Albert Aurier. The artist's letters move with surprising ease between the two subjects, a note to his mother mentioning his recent critical success as well as a painting planned for the baby; "I started right away to make a picture for him, to hang in their bedroom, big branches of white almond blossom against a

cat. 66 *Almond Blossom*, February 1890

fig. 39 Utagawa Kunisada, *Portrait of a Woman*, woodblock print. Van Gogh Museum, Amsterdam (Vincent van Gogh Foundation)

blue sky."[134] As radical as any of the work made at Saint-Rémy, *Almond Blossom* (cat. 66) was also painted immediately before one of his attacks; "My work was going well," he informed his brother, "the last canvas of branches in blossom—you will see that it is perhaps the best, the most patiently worked thing I had done, painted with calm and with a greater firmness of touch. And the next day, down like a brute."[135] Poised between lucidity and desperation, this lacework of light and color is kept aloft by the confidence Van Gogh had acquired in the previous two or three years

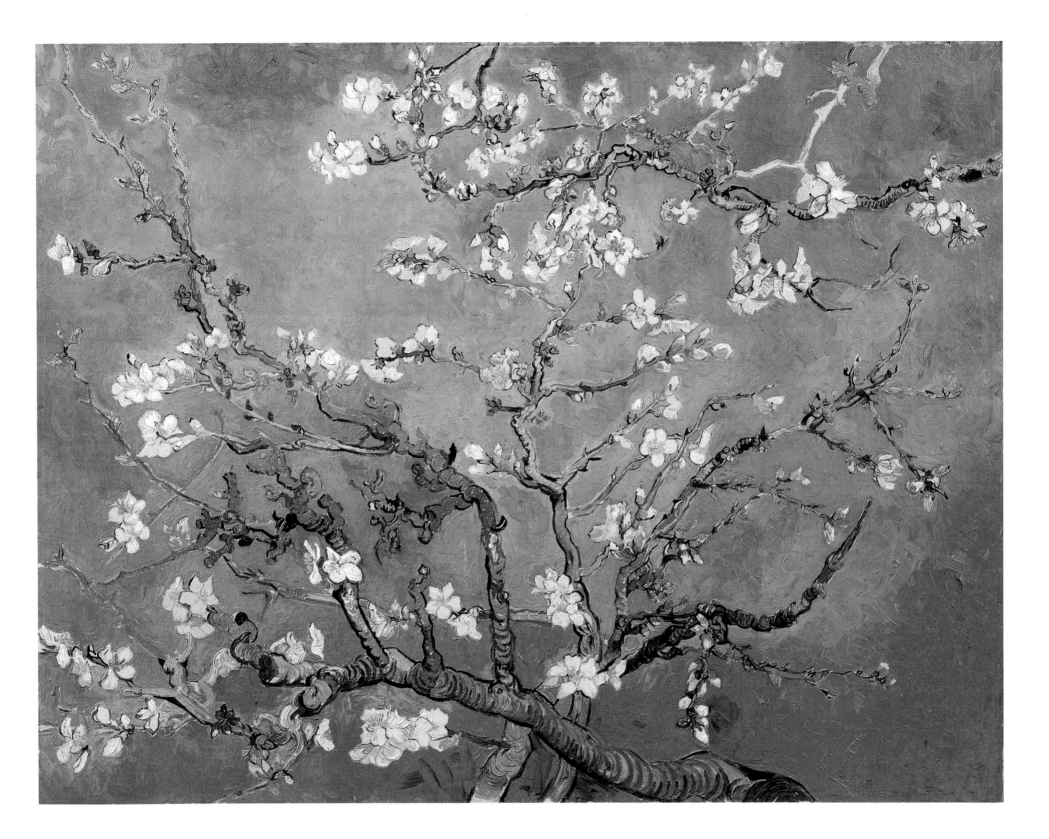

and the sheer technical finesse now at his command. At the back of his mind may well have been a blossom study from a Japanese print, such as the work by Kunisada acquired at some point by the two brothers for their collection (fig. 39). In the "firmness of touch" of *Almond Blossom*, we see the culmination of years of intensive, questioning draftsmanship; and in the openness and buoyancy of the design, we sense the optimism that the artist—despite his insurmountable condition—could magnificently, magically translate into paint.

AUVERS-SUR-OISE: 1890

"I did not have to go out of my way to try to express sadness and extreme loneliness"

Van Gogh traveled north in May 1890 in much the same positive spirit that had marked his journey to Provence two years earlier, if now chastened by his experiences and wary of his physical condition. Optimistic by temperament, he had convinced himself that his cycle of attacks was "mostly a disease of the South" exacerbated by "the other patients' society" in the asylum,[136] and he now looked forward to its amelioration in a relatively normal life at Auvers, just north of Paris. First he stayed in the city for a few days and met both his nephew Vincent and his sister-in-law Jo, who later remembered his "sturdy, broad-shouldered" figure and smiling, resolute appearance on this occasion. Paradoxically, it was Vincent who now began to worry about the health of Theo and his family, writing letters from Auvers to assure them of his own tranquillity and urging them to eat more and take the country air. Theo had been periodically unwell for several years, while the strains of working for those "skinflints Boussod and Valadon"[137] and bringing up a child in the metropolis continued to take their toll. Money was still scarce, but Theo's support and affection for his brother seemed to deepen with each passing month, boosted by a new rapport between Jo and the painter,

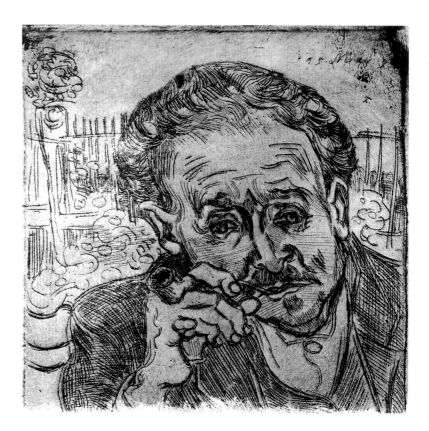

fig. 40 *Portrait of Dr. Gachet with Pipe*, 1890, etching. Van Gogh Museum, Amsterdam (Vincent van Gogh Foundation)

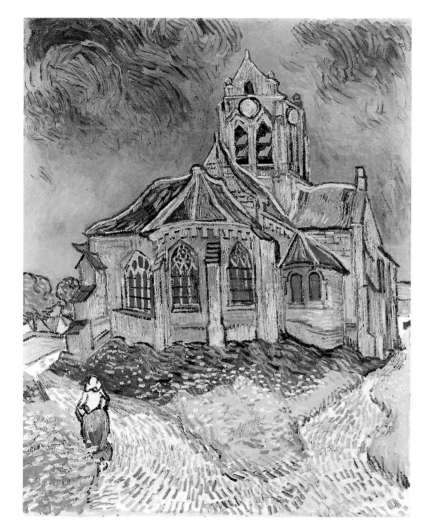

fig. 41 *The Church at Auvers*, 1890, oil on canvas. Musée d'Orsay, Paris

and by a growing tide of admiration for Van Gogh's paintings in the capital and the world beyond.

The village of Auvers-sur-Oise had two principal attractions for Van Gogh. As a rural site on the river Seine, it had been painted by Corot, Guillaumin, Pissarro, and Cézanne, and still retained much of its unspoiled charm; "it is profoundly beautiful, it is the real country, characteristic and picturesque," the artist wrote in his first note to Theo and Jo.[138] More specifically, it was the home of Dr. Paul Gachet, a homeopathic specialist with an interest in neurosis who was an amateur artist and a friend of Pissarro. With Pissarro's help Theo had arranged an introduction to Gachet, who soon discovered an affinity with both Van Gogh and his art, despite—or perhaps because of—his own nervous disposition; "he certainly seems to me as ill and distraught as you or me," Van Gogh told Theo, but insisted "we are great friends already."[139] As so often, Van Gogh used his painting to reach out to unfamiliar surroundings and acquaintances, making portraits of Dr. Gachet and his daughters, and an etching that encapsulated the qualities of his new friend (fig. 40). Gachet responded by welcoming Van Gogh into his home, encouraging him to put illness out of his thoughts and occupy himself completely with his painting, a therapy which appeared to pay dividends. In late May and throughout the month of June, more than thirty energetic canvases of cottages and the local landscape appeared, with

as many drawings of children, village characters, and farmyard animals. If some of the more darkly monumental of these works, such as *The Church at Auvers* (fig. 41), can be seen as expressions of the "melancholy" he still reported, they have also impressed successive generations as the work of an artist at the very height of his powers.

Daubigny's Garden (cat. 67), by contrast, is a composition of unusual serenity, its square format and silvery tones evocative of seclusion and the richness of domestic grasses, shrubs, and flowers. Even the brushwork is orderly when compared to many of the Saint-Rémy studies, following a pattern of vertical strokes over much of the surface and becoming denser only in the foreground rose bed. So mellow is the scene that its intense private significance for Van Gogh himself is easily overlooked. Soon after he settled in Auvers, he discovered that the widow of Charles Daubigny—one of the principal landscapists of his generation and a revered predecessor of the impressionists—still lived in the village and immediately planned a picture of the site. A hasty but incisive sketchbook drawing (fig. 42) fixed its principal elements and three substantial paintings soon followed, the latest two being horizontal canvases in a friezelike format. Though the larger variants are less reposeful, each is a distinct tour-de-force in the handling of color, playing off gray-greens, yellow-greens, and greens speckled with ocher, lilac, and scarlet against the flatter grays and blues of the sky

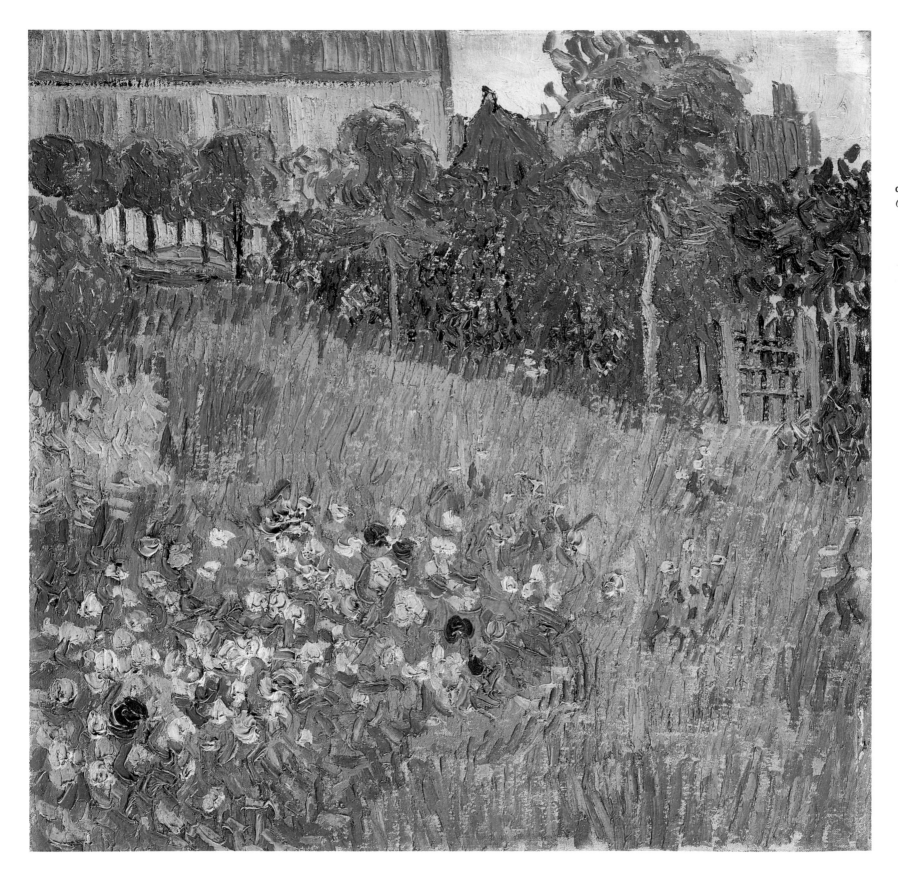

cat. **67** *Daubigny's Garden,* June 1890

fig. 42 *Daubigny's Garden*, 1890, pencil, in sketchbook 7, page 61. Van Gogh Museum, Amsterdam (Vincent van Gogh Foundation)

and the geometry of half-concealed buildings. In *Daubigny's Garden*, Van Gogh opted for one of the most muted, respectful palettes of his career, perhaps in honor of his historic subject or as an expression of the occasional calm—"almost too much calmness"—he described in a letter to his mother and Wil.[140]

By his own account, the act of painting could itself be reassuring even when Van Gogh was at his most troubled. When he was at Saint-Rémy the artist had gained confidence by drawing insects and flowers, reflecting on their intricate structures and translating them into such idiosyncratic canvases as *Emperor Moth* (cat. 61) and *Butterflies and Poppies* (cat. 62). Writing from Auvers to Gauguin, with whom he had slowly reestablished contact, Van Gogh told him about a new pictorial project he was tackling and included several thumbnail sketches of his composition:

> I am trying to do some studies of wheat like this, but I cannot draw it—nothing but ears of wheat with green-blue stalks, long leaves like ribbons of green shot with pink, ears that are just turning yellow, edged with the pale pink of the dusty bloom—a pink bindweed at the bottom twisted round the stem.[141]

The work in question, *Ears of Wheat* (cat. 68), is among the most unexpected of his late career, tapestry-like in its evenly distributed textures and less focused on a single element than even the exceptional *Almond Blossom* (cat. 66)

135

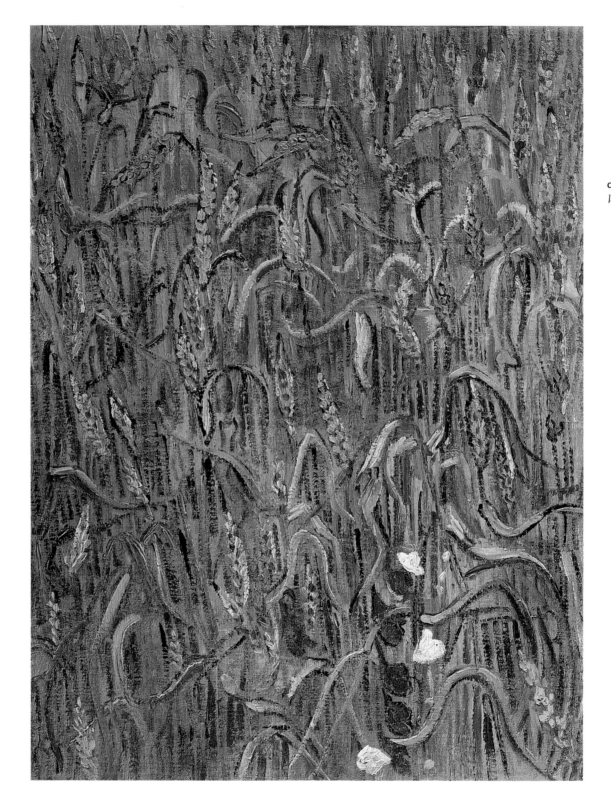

cat. 68 *Ears of Wheat*, June 1890

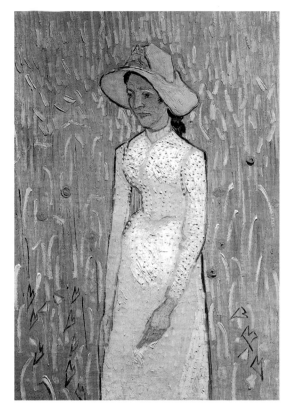

painted earlier in the year. Before we see it as the product of his distracted mind, however, we must take into account Van Gogh the practical artist. Continuing his letter to Gauguin, he explains his plan "to paint some portraits against a very vivid yet tranquil background . . . which by its vibration will make you think of the gentle rustle of the ears swaying in the breeze."[142] *Ears of Wheat*, it seems, was both a trial study for a picture like *Girl Standing in the Wheat* (fig. 43) and a curiously independent work in its own right.

During the summer of 1890, the painter made the short trip into Paris to see his brother's family and was in turn visited by them in his country retreat. While their cordiality continued, there were difficulties of many kinds over these months, brought to a head in late June by reports of the baby's illness and a concerned, almost agonized letter from his painter uncle. Torn between the wish to see the child and his parents, and the belief that his presence would increase their troubles, Van Gogh held back, knowing "that I should be even more powerless than you in the present state of anxiety."[143] A sense of powerlessness and an awareness of his dependence on others seemed to haunt his time at Auvers, leading to moods of deep distress that still alternated with periods of extreme elation. Attempting to persuade Jo to move with her child into the country, Van Gogh reminded her that "nature is very, very beautiful here" and hoped that the arrival in Paris of some of his paintings— "three more big canvases"—would communicate "what I cannot say in words, the health and restorative forces that I see in the country."[144] The pictures in question were part of the series of eight landscape panoramas that included *Daubigny's Garden*, which Van Gogh believed to be both "restorative" and suggestive of his deeper anxiety; of one group he wrote "they are vast fields of wheat under troubled skies, and I did not have to go out of my way to try to express sadness and extreme loneliness."[145] Even the format of these celebrated

works is torn between extremes: on the one hand, their friezelike proportions were a gesture toward precursors like Pierre Puvis de Chavannes and Daubigny, the latter a pioneer of the sweeping pastoral view and the melancholy sunset; on the other, their generous scale allowed Van Gogh to explore his painterly energies with unbridled originality, almost abandoning his orchestrated bars and blocks of paint in favor of the impassioned gesture.

Van Gogh's written description of *Landscape at Twilight* (cat. 69), one of this frieze sequence, gives little indication of its intensity: "an evening effect—two pear trees quite black against a yellowing sky, with some wheat, and in the violet background the chateau surrounded by somber greenery."[146] In reality, the tonal drama of this painting has few equals outside the urban nocturnes of the Arles period, such as *The Night Café*, or the earlier *Potato Eaters*. Using the deepest of midnight blues as well as the black mentioned in his letter, Van Gogh covered almost half his canvas with shadowy forms, as much like echoing voids as foliage and fields. The grimness might be overwhelming, were it not for answering areas of light and color that offer a precise balance of lemons, pale greens, and streaks of pink in sky and foreground. Even more subtly, the dark and bright portions of the composition are contrived to flow into and around each other, the pear tree at the left, for example, standing out against a luminous sky while the path below it blazes through unlit farmland,

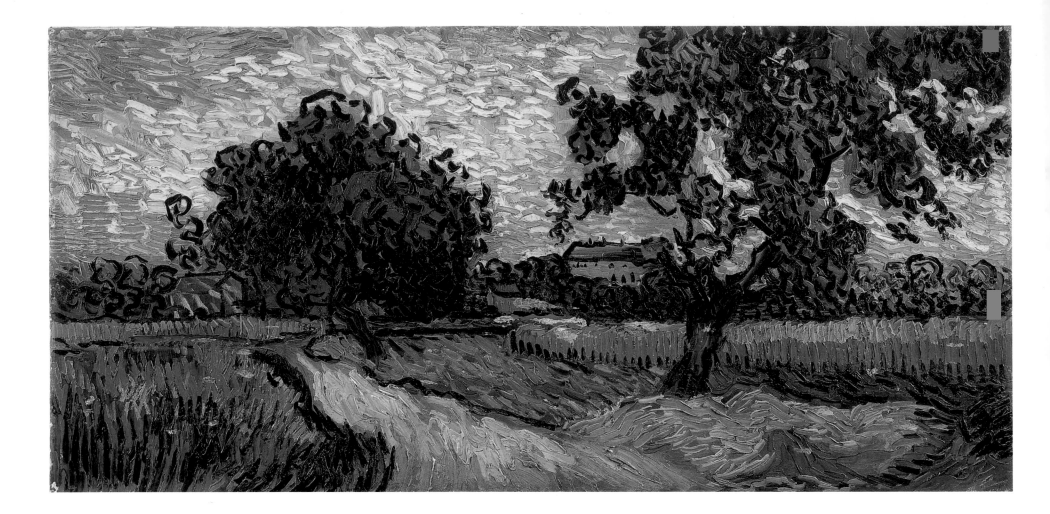

and the right-hand tree mingling its opaque leaves with bars of sunlight. This counterpoint of elemental forms is based on a more refined interweaving of pictorial devices than might first be apparent. Beneath the sumptuous strokes of color—as freely improvised as anything in Van Gogh's Provençal pictures—a pondered structure of broadly laid down underpainting can be glimpsed, along with evidence of adjustment to contours and the last-minute revision of hues. A case in point is the road or path, where the original pinkish-gray surface was later brushed over with almond green and whose uncertain margins were emphatically redefined with the same strokes of Prussian blue that fixed the outlines of the pear trees.

Similar modifications to the paint surface at the horizon and in the upper areas of the sky reveal the exceptional fluidity of the picture-making process in certain of these last canvases. Color has been piled on color, perception on perception, until the picture seems barely able to sustain the weight of its sensory burden.

Faced with the deeply entrenched tradition that *Wheatfield with Crows* (cat. 70) was the last picture Van Gogh painted, attempts by modern scholars to suggest otherwise have made little headway in the popular imagination. But this equally stark, if less intricately composed, canvas was certainly produced in the final weeks of the artist's life and was probably one of the "vast fields of wheat under trou-

bled skies" referred to in his letter of early July. As in *Landscape at Twilight*, its immediate subject is the open country around Auvers—the "real country, characteristic and picturesque"—that had moved him so powerfully from the first and continued to stir memories of great paintings admired in galleries and childhood experiences carried with him from Holland. Here again the spirit of Daubigny presides over the scene, in a distantly recalled horizontal composition of crows over a sheepfield, along with the thunderous skies of Georges Michel and the harvest imagery of Millet. Like Van Gogh's twilight view, *Wheatfield with Crows* was completed in a continuous burst of creative energy, its thick impasto revealing swathes

cat. 69 *Landscape at Twilight*, June 1890

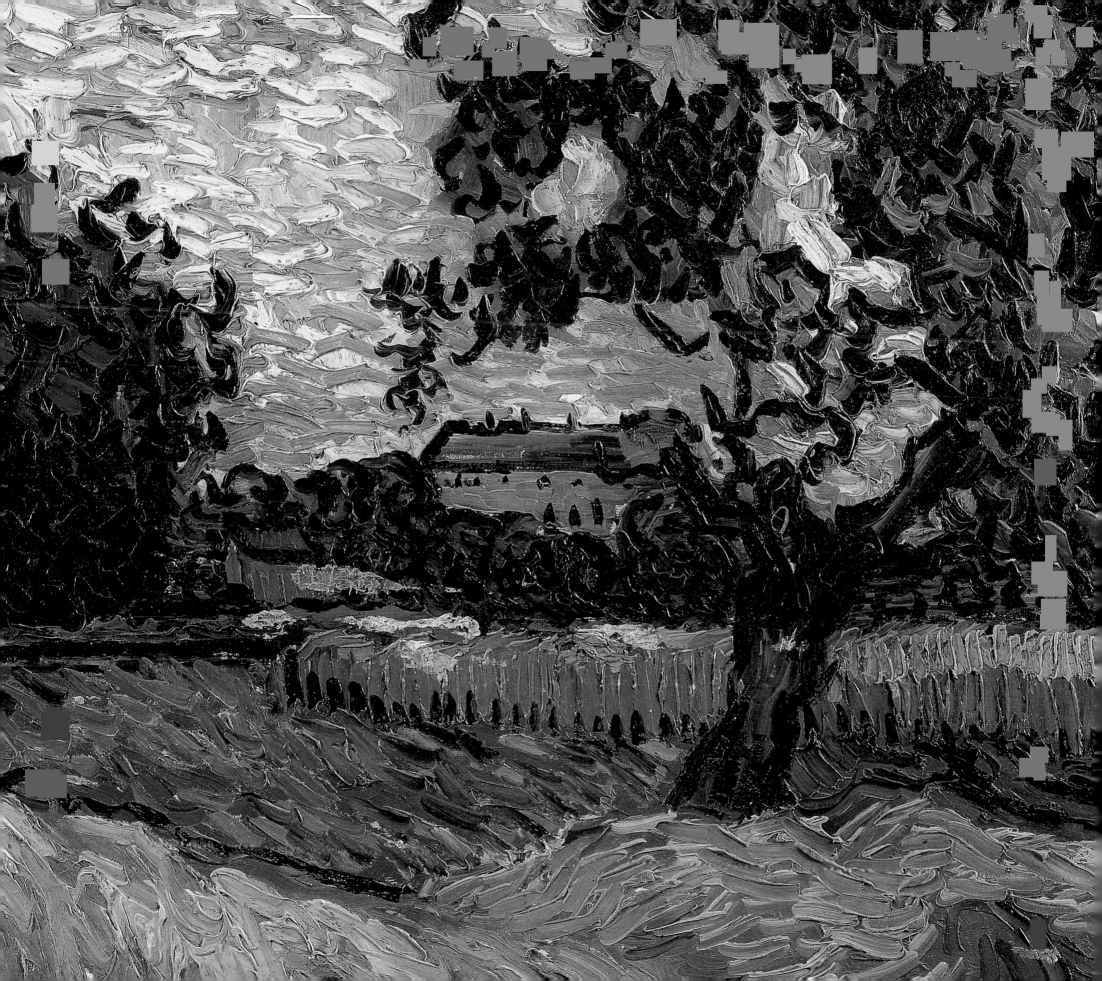

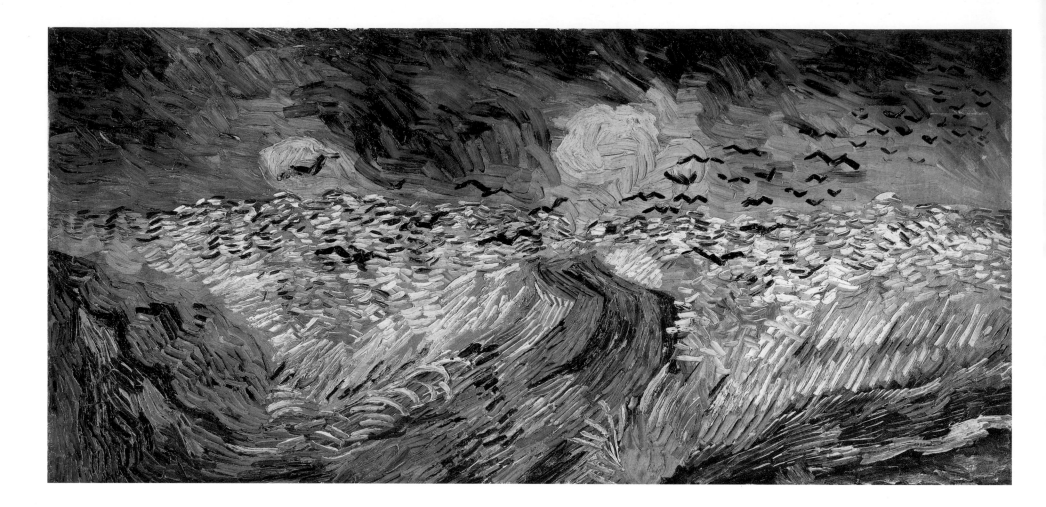

of free invention and the fusion of still-wet brushstrokes on the densely colored surface. Here a different spatial architecture gives shape and direction to the vista, with a rolling, turbulent momentum running through the sky and a stark pattern of paths or tracks articulating the mass of the wheatfield. In place of trees silhouetted against the sunset, a line of black angular birds heightens the luminosity of the cloudscape and intensifies the gold beneath, linking heaven and earth in a nervous staccato of wingbeats.

Van Gogh himself offered no clues to the private meaning of this picture—if indeed it had one—other than the "sadness" and "extreme loneliness" he felt was unavoidable in his vision of Auvers and its countryside. Seen

dispassionately, *Wheatfield with Crows* shares the ocher and cobalt palette—and even its division into heraldic bands of color—with *The Yellow House ("The Street")*, and might similarly be seen as a celebration of the love for "art and life" professed by the painter in one of his final letters to Theo and Jo.[147] Despite our best efforts, however, it is perhaps impossible to detach this mesmerizing work from our knowledge of Van Gogh's state of mind or from the events that preceded and followed its completion. To some extent, the artist seemed to encourage the broader poetic analogy, telling his brother after returning from a visit to Paris, "I still felt very sad and continued to feel the storm which threatens you weighing on me too. . . . my life is also threatened at the

very root and my steps are also wavering."[148] Though he had yet to experience an attack since leaving Arles, the likelihood of further seizures and his belief that he was a burden on those around him seem finally to have proved unbearable. In the last letter he wrote, he attempted a summing up of his affection and respect for his brother, while confusedly imagining talks they would still have and their plans for the future. Of his own work he writes with characteristic lucidity, "I am risking my life for it and my reason has half-foundered because of it," only to return to the aspiration that had driven him forward from his earliest days; referring to the lot of the painter, he confided in Theo, "The truth is, we can only make our pictures speak."[149]

cat. 70 *Wheatfield with Crows*, July 1890

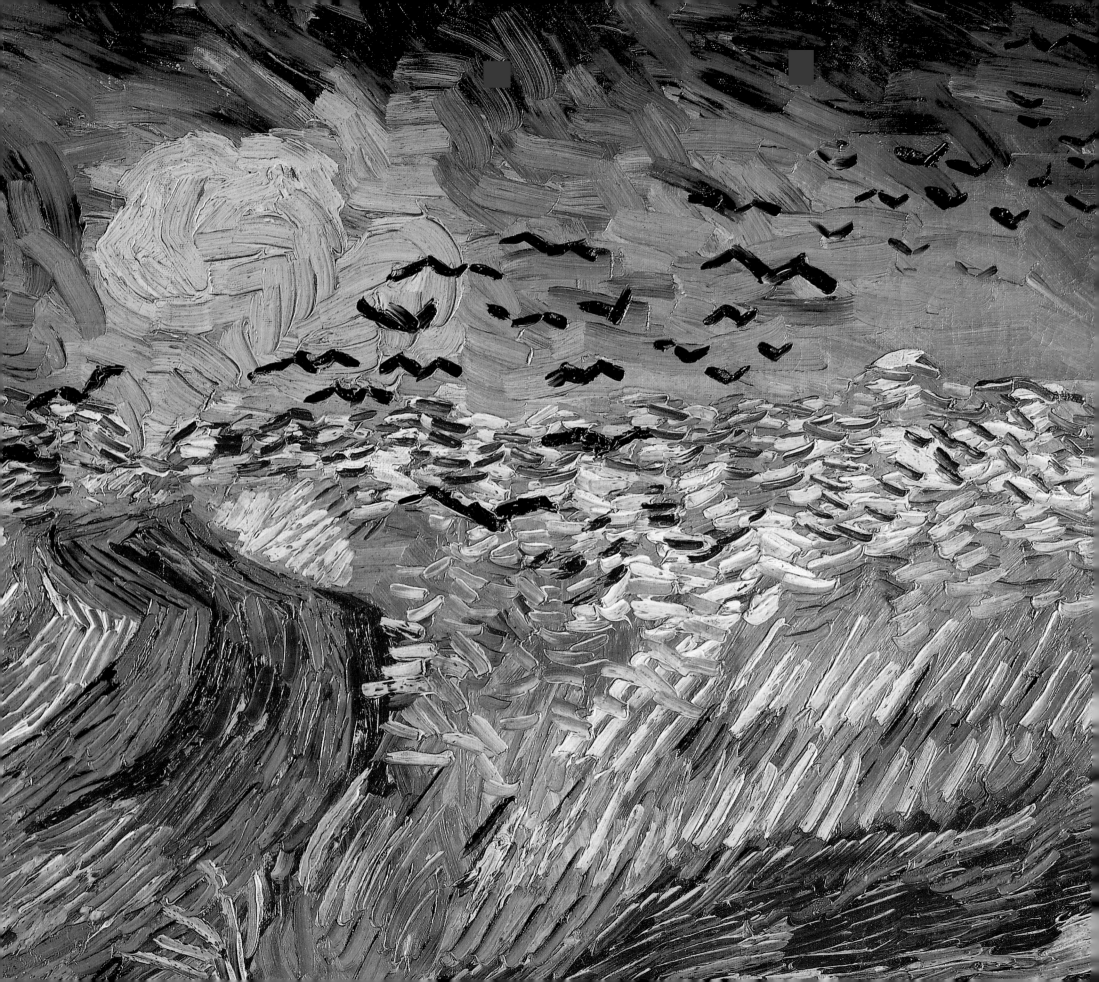

Notes

Citations are from the *Complete Letters of Vincent van Gogh* (London, 1958; reprint ed. 1991).

1. Letter 218, p. 416.
2. Letter 237, pp. 467–468.
3. Letter 198, p. 368.
4. Letter 186, p. 336.
5. Letter 228, p. 448.
6. Letter R2, pp. 307–308.
7. Letter 340, p. 210.
8. Letter R21, p. 353.
9. Letter R43, p. 401.
10. Letter R7, p. 320.
11. Letter R13, p. 329.
12. Letter R43, p. 398.
13. Letter 299, p. 77.
14. Letter R43, p. 398.
15. Letter R43, p. 401.
16. Letter B7, p. 492.
17. Letter 227, pp. 442–443.
18. Letter 378, p. 308.
19. Letter 384, p. 325.
20. Letter 404, p. 368.
21. Letter 251, p. 505.
22. Letter 404, p. 371.
23. Letter 404, p. 371.
24. Letter 404, p. 369.
25. Letter 402, p. 367.
26. Letter 405, p. 372.
27. Letter 404, p. 369.
28. Letter 404, p. 369.
29. Letter 404, p. 370.
30. Letter 401, p. 364.
31. Letter 404, p. 370.
32. Letter 399, p. 359.
33. Letter 401, p. 364.
34. Letter 399, p. 359.
35. Letter 401, p. 364.
36. Letter R51, p. 410.
37. Letter 424, p. 414.
38. Letter 405, p. 372.
39. Letter 450, p. 1.
40. Letter 439, p. 456.
41. Letter R57, p. 418.
42. Letter 439, p. 454.
43. Letter 438, p. 455.
44. Letter 446, p. 476.
45. Letter 444, p. 474.
46. Letter 449, p. 479.
47. Letter 449, p. 485.
48. Letter 452, p. 493.
49. Letter 443, p. 471.
50. Letter 460, p. 517.
51. Letter 459a, p. 513.
52. Letter 459a, p. 513.
53. Letter B1, p. 476.
54. Letter 459a, p. 515.
55. Letter W1, p. 428.
56. Letter W1, p. 426.
57. Letter W1, p. 427.
58. Letter B1, p. 474.
59. Letter W4, p. 433.
60. Letter 459a, p. 513.
61. Letter 461, p. 523.
62. Letter 527, p. 20.
63. Letter 404, p. 369.
64. Letter 497, p. 359.
65. Letter B7, p. 494.
66. Letter 528, p. 21.
67. Letter W4, p. 437.
68. Letter 463, p. 525.
69. Letter L464, p. 527.
70. Letter 466, p. 529.
71. Letter 472, p. 537.
72. Letter 473, pp. 538, 540.
73. Letter 474, p. 541.
74. Letter 475, p. 543.
75. Letter B3, p. 478.
76. Letter 477, p. 545.
77. Letter 477, p. 545.
78. Letter B2, p. 476.
79. Letter 497, p. 583.
80. Letter B9, pp. 498–499.
81. Letter 497, p. 583.
82. Letter 497, p. 583.
83. Letter 481, p. 556.
84. Letter B19, p. 516.
85. Letter 501, p. 591.
86. Letter 501, p. 591.
87. Letter 518, p. 2.
88. Letter 533, p. 28.
89. Letter 534, p. 3.
90. Letter B6, p. 490.
91. Letter 499, p. 588.
92. Letter 499, p. 588.
93. Letter 500, p. 589.
94. Letter 500, p. 590.
95. Letter 500, pp. 589–590.
96. Letter 500, p. 589.
97. Letter 497, p. 583.
98. Letter 545, p. 66.
99. Letter 526, p. 19.
100. Letter 534, p. 30.

101. Letter 520, p. 6.

102. Letter 542, p. 55.

103. Letter 554, p. 86.

104. Letter 558, p. 95.

105. Cited in R. de Leeuw 1996, 414.

106. Letter 569, p. 426.

107. Letter 520, p. 7.

108. Letter 560, p. 101.

109. Letter 531, p. 25.

110. Letter 520, p. 7.

111. Letter 599, p. 191.

112. Letter 569, pp. 113–114.

113. Letter 580, pp. 141–142.

114. Letter 612, p. 226.

115. Letter 604, p. 202.

116. Letter 605, p. 208.

117. Letter 605, p. 208.

118. Letter 605, p. 209.

119. Letter 605, p. 208.

120. Letter B21, p. 524.

121. Letter B21, p. 522.

122. Letter B21, p. 524.

123. Letter 592, p. 174.

124. Letter T4, p. 537.

125. Letter T9, pp. 542–543.

126. Letter 711, pp. 545–546.

127. Letter 608, p. 220.

128. Letter B21, p. 521.

129. Letter 592, p. 172.

130. Letter T30, p. 567.

131. Letter 592, p. 174.

132. Letter 604, p. 202.

133. Letter 597, p. 187.

134. Letter 627, p. 258.

135. Letter 628, p. 260.

136. Letter 640a, p. 281.

137. Letter T39, p. 576.

138. Letter 635, p. 273.

139. Letter 638, p. 276.

140. Letter 650, p. 296.

141. Letter 643, p. 287.

142. Letter 643, p. 287.

143. Letter 646, p. 289.

144. Letter 649, p. 295.

145. Letter 649, p. 295.

146. Letter 645, p. 288.

147. Letter 646, p. 293.

148. Letter 649, p. 295.

149. Letter 652, p. 298.

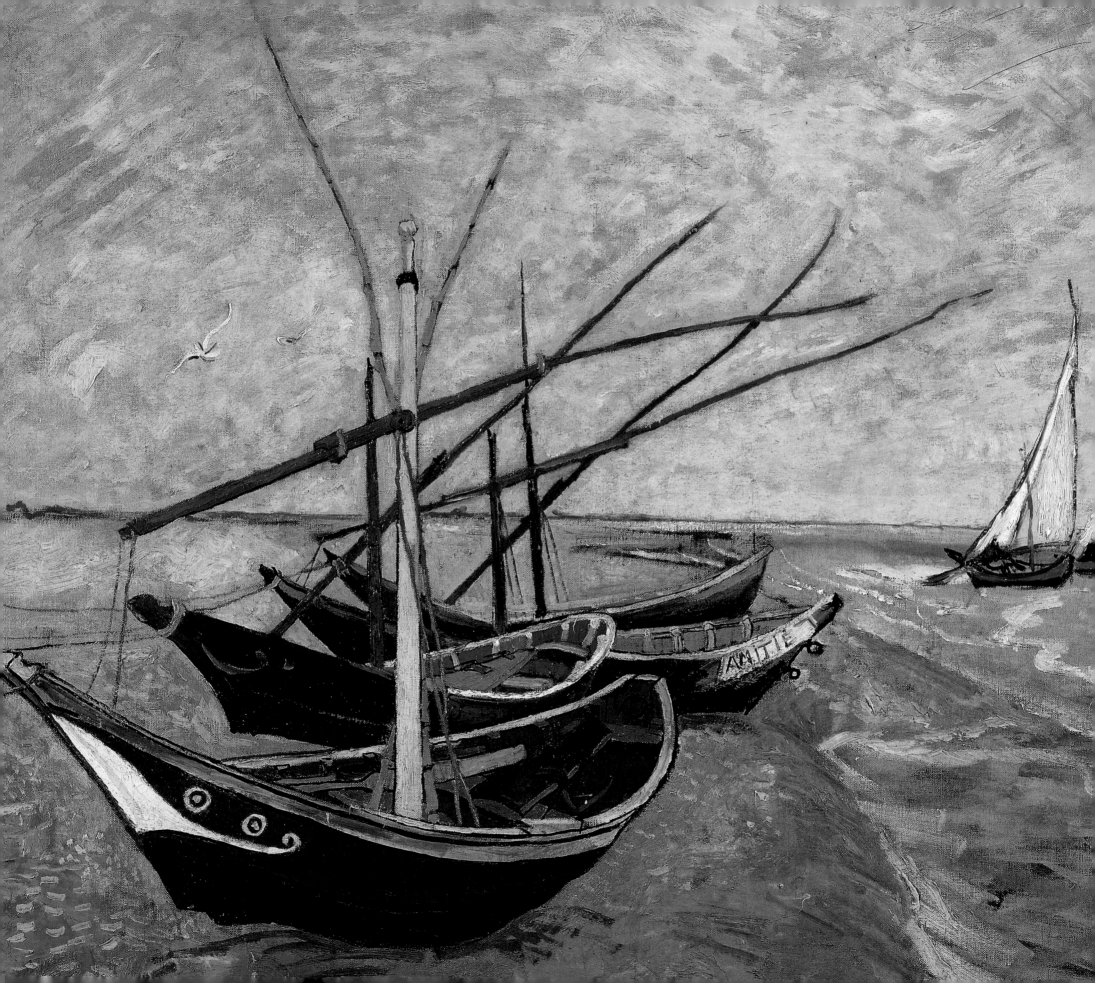

The Life of Vincent van Gogh

Sjraar van Heugten

Vincent van Gogh was born on 30 March 1853 in Zundert, a village in the southern province of North Brabant. He was the eldest son of the Reverend Theodorus van Gogh (1822–1885) and Anna Cornelia Carbentus (1819–1907), whose other children were Vincent's sisters Elisabeth (Lies), Anna, and Wil, and his brothers Theo and Cor. Little is known about Vincent's early years other than that he was a quiet child with no obvious artistic talent. He himself would later look back on his happy childhood with great pleasure.

Van Gogh received a fragmentary education: one year at the village school in Zundert, two years at a boarding school in Zevenbergen, and eighteen months at a high school in Tilburg. At sixteen he began working at the Hague gallery of the French art dealers Goupil et Cie., in which his uncle Vincent was a partner. His brother Theo, who was born on 1 May 1857, later worked for the same firm. In 1873 Goupil's transferred Vincent to London, and two years later they moved him to Paris, where he lost all ambition to become an art dealer. Instead, he immersed himself in religion, threw out his modern, worldly books, and became "daffy with piety," in the words of his sister Elisabeth. He took little interest in his work, and was dismissed from his job at the beginning of 1876.

Van Gogh then took a post as an assistant teacher in England, but, disappointed by the lack of prospects, returned to Holland at the end of the year. He now decided to follow in his father's footsteps and become a clergyman. Although disturbed by his fanaticism and odd behavior, his parents agreed to pay for the private lessons he would need to gain admission to the university. This proved to be another false start. Van Gogh abandoned the lessons, and after brief training as an evangelist went to the Borinage coal-mining region in the south of Belgium. His ministry among the miners led him to identify deeply with the workers and their families. In 1879, however, his appointment was not renewed, and his parents despaired, regarding him as a social misfit. In an unguarded moment his father even spoke of committing him to a mental asylum.

FUTURE AS AN ARTIST

Vincent, too, was at his wits' end, and after a long period of solitary soul-searching in the Borinage he decided to follow Theo's advice and become an artist. His earlier desire to help his fellowman as an evangelist gradually developed into an urge, as he later wrote, to leave mankind "some memento in the form of drawings or paintings—not made to please any particular movement, but to express a sincere human feeling."

His parents could not go along with this latest change of course, and the financial responsibility for Vincent passed to his brother Theo, who was now working in the Paris gallery of Boussod, Valadon et Cie., the successors to Goupil's. It was because of Theo's loyal support that Van Gogh later came to regard his oeuvre as the fruits of his brother's efforts on his behalf. A lengthy correspondence between the two brothers (which began in August 1872) would continue until the last days of Vincent's life.

UNSUSPECTED TALENTS

When Van Gogh decided to become an artist, no one, not even he himself, suspected that he had extraordinary gifts. His evolution from an inept but impassioned novice into a truly original master was remarkably rapid. He eventually proved to have an exceptional feel for bold, harmonious color effects, and an infallible instinct for choosing simple but memorable compositions.

In order to prepare for his new career Van Gogh went to Brussels to study at the academy, but left after only nine months. There he got to know Anthon van Rappard, who was to be his most important artist friend during his Dutch period.

In April 1881, Van Gogh went to live with his parents in Etten in North Brabant, where he set himself the task of learning how to draw. He experimented endlessly with all sorts of drawing materials, and concentrated on mastering technical aspects of his craft like perspective, anatomy, and physiognomy. Most of his subjects were taken from peasant life.

At the end of 1881 he moved to The Hague, and there, too, he concentrated mainly on

drawing. At first he took lessons from Anton Mauve, his cousin by marriage, but the two soon fell out, partly because Mauve was scandalized by Vincent's relationship with Sien Hoornik, a pregnant prostitute who already had an illegitimate child. Van Gogh made a few paintings while in The Hague, but drawing was his main passion. In order to achieve his ambition of becoming a figure painter he drew from the live model whenever he could.

In September 1883 he decided to break off the relationship with Sien and follow in the footsteps of artists like Van Rappard and Mauve by trying his luck in the picturesque eastern province of Drenthe, which was fairly inaccessible in those days. After three months, however, a lack of both drawing materials and models forced him to leave. He decided once again to move in with his parents, who were now living in the North Brabant village of Nuenen, near Eindhoven.

NUENEN

In Nuenen, Van Gogh first began painting regularly, modeling himself chiefly on the French painter Jean-François Millet (1814–1875), who was famous throughout Europe for his scenes of the harsh life of peasants. Van Gogh set to work with an iron will, depicting the life of the villagers and humble workers. He made numerous scenes of weavers. In May 1884 he moved into rooms he had rented from the sacristan of the local Catholic church, one of which he used as his studio.

At the end of 1884 he began painting and drawing a major series of heads and work-roughened peasant hands in preparation for a large and complex figure piece that he was planning. In April 1885 this period of study came to fruition in the masterpiece of his Dutch period, *The Potato Eaters.*

In the summer of that year he made a large number of drawings of the peasants working in the fields. The supply of models dried up, however, when the local priest forbade his parishioners to pose for the vicar's son. He turned to painting landscapes instead, inspired in part by a visit to the recently opened Rijksmuseum in Amsterdam.

In 1885, feeling the need for a proper artistic training, Van Gogh enrolled at the academy in Antwerp. He found the lessons rather tedious, but was greatly impressed by the city and its museums. He fell under the spell of Rubens' palette and brushwork, and also discovered Japanese prints.

PARIS

In early 1886 Van Gogh went to live with his brother in Paris. There, at last, he was confronted with the full impact of modern art and especially with the recent work of the impressionists and postimpressionists. He discovered that the dark palette he had developed back in Holland was hopelessly out-of-date. In order to brighten it up he began painting still lifes of flowers. The search for his own idiom led him to experiment with impressionist and postimpressionist techniques and to study the prints of the Japanese masters. During his time in Paris he made friends with such artists as Paul Gauguin, Emile Bernard, Henri Toulouse-Lautrec, Paul Signac, and Georges Seurat. Within two years Van Gogh had come to terms with the latest developments and had forged his own, highly personal style.

ARLES

At the beginning of 1888, Van Gogh, now a mature artist, went south to Arles, in Provence, where he at last began to feel confident about his choice of career. He set out to make a personal contribution to modern art with his daring color combinations. He was swept away by the landscape around Arles. In the spring he painted numerous scenes of fruit trees in blossom, and in the summer the yellow wheatfields. Although he had some difficulty finding models, he did make portraits, among which were those of the Roulin family. It was typical of Van Gogh's faith in his own abilities that he decided not to try to sell any work yet but to wait until he had thirty top-class pictures with which he could announce himself to the world. He cherished the hope that a number of other artists would come and join

him in Arles, where they could all live and work together. The idea seemed to get off to a promising start when Gauguin arrived in October 1888.

Toward the end of the year, however, his optimism was rudely shattered by the first signs of his illness, a type of epilepsy that took the form of delusions and psychotic attacks. It was during one of those seizures that he cut off his left earlobe. Gauguin made a hasty departure and Van Gogh's dreams of an artist's colony disappeared.

SAINT-RÉMY

In April 1889 he went to nearby Saint-Rémy, where he entered the Saint-Paul-de-Mausole asylum as a voluntary patient. Van Gogh was unable to work when suffering from bouts of his illness. If he felt well enough, though, he went out to draw and paint in the garden or surroundings of the asylum. His use of color, which had often been so intense in Arles, became more muted, and he tried to make his brushwork more graphic. In the closing months of the year he had a success when two of his paintings were shown at the fifth exhibition of the Société des artistes indépendants.

Van Gogh also made a large number of "translations in color" of prints by some of his favorite artists, like Millet and Eugène Delacroix. He found them consoling, and they helped him keep in practice.

In January 1890 the critic Albert Aurier published an enthusiastic article about Van Gogh's work.

AUVERS-SUR-OISE

The artist left Saint-Rémy in May 1890 and went north again, this time to the rustic village of Auvers-sur-Oise, near Paris. On his way he stopped off in Paris to call on Theo, his wife Johanna, and their infant son Vincent Willem.

Although he now had a small but growing circle of admirers, Van Gogh had lost his original passion. "I feel—a failure," he wrote to his brother. "That's it as far as I'm concerned— I feel that this is the destiny that I accept, that will never change."

He nevertheless continued working hard during his two months in Auvers, producing dozens of paintings and drawings. Life, though, had become an intolerable burden. On 27 July 1890 he shot himself in the chest. He died two days later. Theo, who had stored the bulk of Vincent's work in Paris, died six months later. His widow, Johanna van Gogh-Bonger (1862–1925), returned to Holland with the collection, and dedicated herself to getting her brother-in-law the recognition he deserved. In 1914, with his fame assured, she published the correspondence between the two brothers. From that moment on Van Gogh's oeuvre became inextricably interwoven with the story of his remarkable and tragic life.

Translated from the Dutch by Michael Hoyle

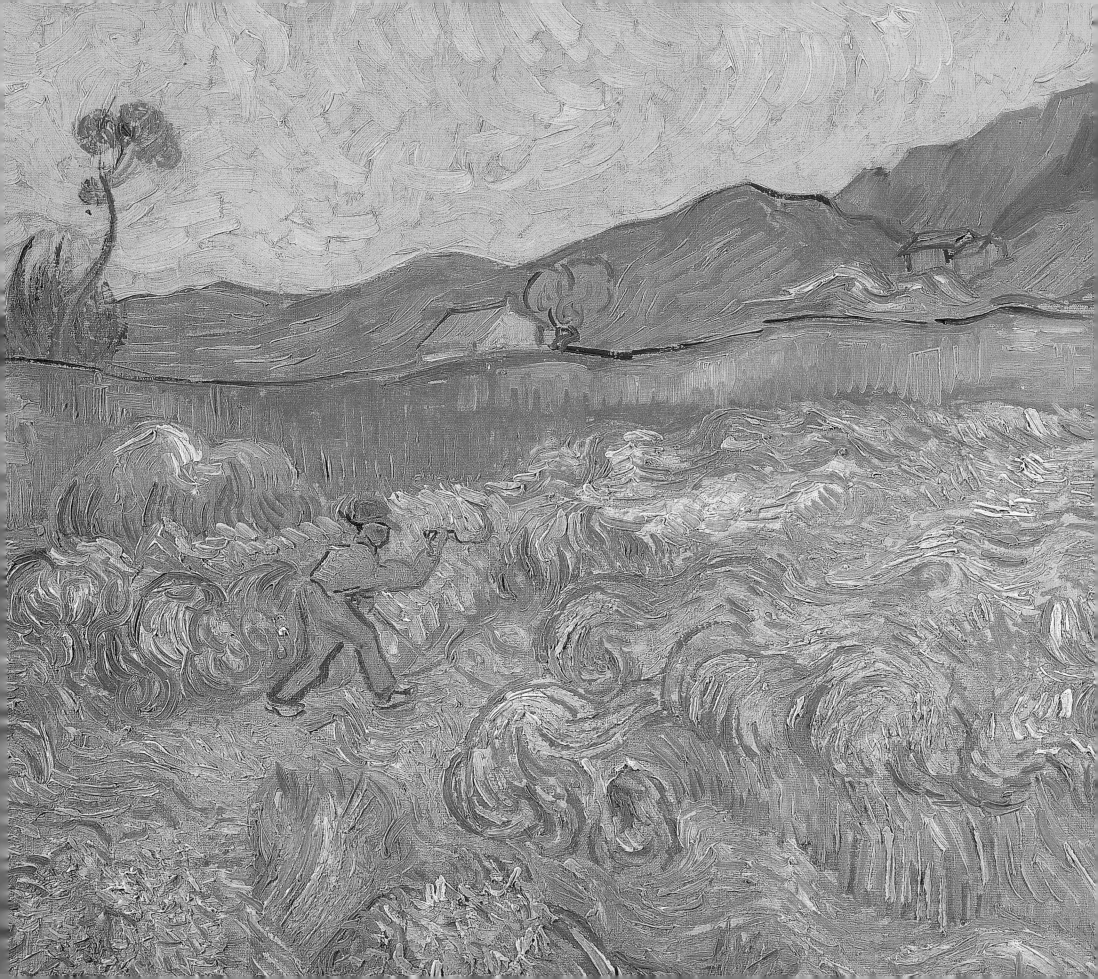

Checklist

Abbreviations

F = Faille, J.-B. de la. *The Works of Vincent van Gogh: His Paintings and Drawings.* Amsterdam, 1970

JH = Hulsker, Jan. *The New Complete Van Gogh: Paintings, Drawings, Sketches.* Amsterdam, 1996

Unless otherwise stated, all works are the property of the Vincent van Gogh Foundation on permanent loan to the Van Gogh Museum, Amsterdam

1

Scheveningen Beach in Stormy Weather
Oil on canvas
34.5 x 51 ($13\frac{9}{16}$ x $20\frac{1}{16}$)
Unsigned

The Hague, August 1882

inv. s 416 m/1990
F 4; JH 187

Van Gogh Museum, Amsterdam

2

Farmhouses near Hoogeveen
Oil on canvas
35 x 55.5 ($13\frac{3}{4}$ x $21\frac{7}{8}$)
Unsigned

Drenthe, September 1883

inv. s 53 v/1953
F 17; JH 395

3

Still Life with Earthenware and Bottles
Oil on canvas
39.5 x 56 ($15\frac{9}{16}$ x $22\frac{1}{16}$)
Unsigned

Nuenen, September–October 1885

inv. s 138 v/1962
F 53; JH 538

4

Woman Sewing
Oil on canvas
43 x 34 ($16\frac{15}{16}$ x $13\frac{3}{8}$)
Unsigned

Nuenen, March–April 1885

inv. s 7 v/1962
F 71; JH 719

5

Woman Winding Yarn
Oil on canvas
41 x 32.5 ($16\frac{1}{8}$ x $12\frac{13}{16}$)
Unsigned

Nuenen, March 1885

inv. s 73 v/1962
F 36; JH 698

6

The Potato Eaters
Oil on canvas
82 x 114 ($32\frac{5}{16}$ x $44\frac{7}{8}$)
Signed at lower left, on the upper rung of the chairback: Vincent

Nuenen, April 1885

inv. s 5 v/1962
F 82; JH 764

cat. 58 Detail

7

Head of a Woman
Oil on canvas
43 x 30 (16 $^{15}/_{16}$ x 11 $^{13}/_{16}$)
Unsigned

Nuenen, March–April 1885

inv. s 6 v/1962
F 160; JH 722

8

Head of a Man
Oil on canvas
38 x 30 (14 $^{15}/_{16}$ x 11 $^{13}/_{16}$)
Unsigned

Nuenen, December 1884–May 1885

inv. s 69 v/1962
F 164; JH 558

9

Basket with Potatoes
Oil on canvas
44.5 x 60 (17 $^{1}/_{2}$ x 23 $^{5}/_{8}$)
Unsigned

Nuenen, September 1885

inv. s 153 v/1962
F 100; JH 931

10

The Cottage
Oil on canvas
65.5 x 79 (25 $^{13}/_{16}$ x 31 $^{1}/_{8}$)
Signed at lower left: Vincent

Nuenen, May 1885

inv. s 87 v/1962
F 83; JH 777

11

The Vicarage at Nuenen
Oil on canvas
33 x 43 (13 x 16 $^{15}/_{16}$)
Unsigned

Nuenen, October–November 1885

inv. s 140 v/1962
F 182; JH 948

12

Head of an Old Man
Oil on canvas
44.5 x 33.5 (17 $^{1}/_{2}$ x 13 $^{3}/_{16}$)
Unsigned

Antwerp, December 1885

inv. s 61 v/1962
F 205; JH 971

13

Head of a Woman
Oil on canvas
35 x 24 (13 $^{3}/_{4}$ x 9 $^{7}/_{16}$)
Unsigned

Antwerp, December 1885

inv. s 59 v/1962
F 206; JH 972

14

Skull of a Skeleton with Burning Cigarette
Oil on canvas
32 x 24.5 (12 $^{5}/_{8}$ x 9 $^{5}/_{8}$)
Unsigned

Antwerp, winter 1885–1886

inv. s 83 v/1962
F 212; JH 999

15

Self-Portrait
Oil on canvas
46 x 38 (18 $^{1}/_{8}$ x 14 $^{15}/_{16}$)
Signed at upper left: Vincent

Paris, 1886

inv. s 158 v/1962
F 180; JH 1194

16

Roofs in Paris
Oil on pasteboard on multiplex
30 x 41 ($11^{13}/_{16}$ x $16^{1}/_{8}$)
Unsigned

Paris, 1886

inv. s 95 v/1962
F 231; JH 1099

17

The Hill of Montmartre with Stone Quarry
Oil on canvas
32 x 41 ($12^{5}/_{8}$ x $16^{1}/_{8}$)
Signed at lower left: Vincent

Paris, 1886

inv. s 64 v/1962
F 229; JH 1176

18

A Pair of Shoes
Oil on canvas
37.5 x 45 ($14^{3}/_{4}$ x $17^{11}/_{16}$)
Signed at upper left: Vincent

Nuenen, 1885

inv. s 11 v/1962
F 255; JH 1124

19

Flying Fox
Oil on canvas
41 x 79 ($16^{1}/_{8}$ x $31^{1}/_{8}$)
Unsigned

Nuenen, 1885

inv. s 136 v/1973
F 177A; JH 1192

20

Vase with Autumn Asters
Oil on canvas
61 x 46 (24 x $18^{1}/_{8}$)
Signed at lower left: Vincent

Paris, summer–autumn 1886

inv. s 177 v/1962
F 234; JH 1168

21

Self-Portrait with Felt Hat
Oil on pasteboard
19 x 14 ($7^{1}/_{2}$ v $5^{1}/_{2}$)
Unsigned

Paris, 1887

inv. s 156 v/1962
F 296; JH 1210

22

Self-Portrait with Straw Hat
Oil on pasteboard
19 x 14 ($7^{1}/_{2}$ x $5^{1}/_{2}$)
Unsigned

Paris, 1887

inv. s 157 v/1962
F 294; JH 1209

23

*Mother by a Cradle, Portrait of Leonie Rose
Davy-Charbuy*
Oil on canvas
61 x 45.5 (24 x $17^{15}/_{16}$)
Unsigned

Paris, 1887

inv. s 165 v/1962
F 369; JH 1206

24

Boulevard de Clichy
Oil on canvas
45.5 x 55 ($17^{15}/_{16}$ x $21^{5}/_{8}$)
Unsigned

Paris, 1887

inv. s 94 v/1962
F 292; JH 1219

25

Vegetable Gardens and the Moulin de
Blute-Fin on Montmartre
Oil on canvas
44.8 x 81 (17 $^5/_8$ x 31 $^7/_8$)
Signed at lower left: Vincent

Paris, 1887

inv. s 15 v/1962

F 346; JH 1244

26

Flowerpot with Chives
Oil on canvas
31.5 x 22 (12 $^3/_8$ x 8 $^{11}/_{16}$)
Unsigned

Paris, 1887

inv. s 183 v/1962

F 337; JH 1229

27

Still Life with Carafe and Lemons
Oil on canvas
46.5 x 38.5 (18 $^5/_{16}$ x 15 $^3/_{16}$)
Signed and dated at lower right: Vincent 87

Paris, 1887

inv. s 20 v/1962

F 340; JH 1239

28

Glass of Absinthe and a Carafe
Oil on canvas
46.5 x 33 (18 $^5/_{16}$ x 13)
Unsigned

Paris, 1887

inv. s 186 v/1962

F 339; JH 1238

29

The Seine with the Pont de la Grande Jatte
Oil on canvas
32 x 40.5 (12 $^5/_8$ x 15 $^{15}/_{16}$)
Unsigned

Paris, summer 1887

inv. s 86 v/1962

F 304; JH 1326

30

Banks of the Seine
Oil on canvas
32 x 46 (12 $^5/_8$ x 18 $^1/_8$)
Unsigned

Paris, April–June 1887

inv. s 77 v/1962

F 293; JH 1269

31

Restaurant at Asnières
Oil on canvas
18.5 x 27 (7 $^5/_{16}$ x 10 $^5/_8$)
Unsigned

Paris, summer 1887

inv. s 134 v/1962

F 321; JH 1311

32

Courting Couples in the Voyer d'Argenson
Park in Asnières
Oil on canvas
75 x 112.5 (29 $^1/_2$ x 44 $^5/_{16}$)
Unsigned

Paris, spring–summer 1887

inv. s 19 v/1962

F 314; JH 1258

33

Trees and Undergrowth
Oil on canvas
46.5 x 55.5 (18 $^5/_{16}$ x 21 $^7/_8$)
Unsigned

Paris, summer 1887

inv. s 66 v/1962

F 309A; JH 1312

34
A Park in Spring
Oil on canvas
50 x 65 (19 $^{11}/_{16}$ x 25 $^{9}/_{16}$)
Unsigned

Paris, 1887

Private collection, on loan to the
Van Gogh Museum, Amsterdam

inv. s 119 b/1993
F 362; JH 1264

35
Portrait of a Restaurant Owner,
Possibly Lucien Martin
Oil on canvas
65.5 x 54.5 (25 $^{13}/_{16}$ x 21 $^{7}/_{16}$)
Unsigned

Paris, 1887

inv. s 125 v/1962
F 289; JH 1203

36
Still Life with Books
Oil on panel
31 x 48.5 (12 $^{3}/_{16}$ x 19 $^{1}/_{8}$)
Dated at upper right: 87

Paris, 1887

inv. s 181 v/1962
F 335; JH 1226

37
The Courtesan (after Eisen)
Oil on canvas
105.5 x 60.5 (41 $^{9}/_{16}$ x 23 $^{13}/_{16}$)
Unsigned

Paris, 1887

inv. s 116 v/1962
F 373; JH 1298

38
Still Life with Quinces and Lemons
Oil on canvas
48.5 x 65 (19 $^{1}/_{8}$ x 25 $^{9}/_{16}$)
Signed, dated, and annotated by Vincent at
lower left: Vincent 87 A mon frère Theo

Paris, 1887

inv. s 23 v/1970
F 383; JH 1339

39
Self-Portrait as an Artist
Oil on canvas
65.5 x 50.5 (25 $^{13}/_{16}$ x 19 $^{7}/_{8}$)
Signed and dated at lower right: Vincent 88

Paris, winter 1887–1888

inv. s 22 v/1962
F 522; JH 1356

40
Self-Portrait
Oil on pasteboard
19 x 14 (7 $^{1}/_{2}$ x 5 $^{1}/_{2}$)
Unsigned

Paris, January–March 1887

inv. s 155 v/1962
F 267; JH 1224

41
Self-Portrait with Felt Hat
Oil on canvas
44 x 37.5 (17 $^{5}/_{16}$ x 14 $^{3}/_{4}$)
Unsigned

Paris, winter 1887–1888

inv. s 16 v/1962
F 344; JH 1353

42
Self-Portrait with Straw Hat
Oil on canvas on pasteboard
42 x 30 (16 $^{9}/_{16}$ x 11 $^{13}/_{16}$)
Unsigned

Paris, 1887

inv. s 163 v/1962
F 524; JH 1565

43

Sprig of Flowering Almond Blossom in a Glass
Oil on canvas
24 x 19 (9 $^7/_{16}$ x 7 $^1/_2$)
Signed at upper left: Vincent

Arles, February–March 1888

inv. s 184 v/1962
F 392; JH 1361

44

Almond Tree in Blossom
Oil on canvas
48.5 x 36 (19 $^1/_8$ x 14 $^3/_{16}$)
Unsigned

Arles, April 1888

inv. s 35 v/1962
F 557; JH 1397

45

Field with Flowers near Arles
Oil on canvas
54 x 65 (21 $^1/_4$ x 25 $^9/_{16}$)
Unsigned

Arles, April–May 1888

inv. s 37 v/1962
F 409; JH 1416

46

Wheatfield
Oil on canvas
54 x 65 (21 $^1/_4$ x 25 $^9/_{16}$)
Unsigned

Arles, June 1888

inv. s 146 v/1962
F 411; JH 1476

47

The Harvest
Oil on canvas
73 x 92 (28 $^3/_4$ x 36 $^1/_4$)
Signed at lower left: Vincent

Arles, June 1888

inv. s 30 v/1962
F 412; JH 1440

48

An Old Woman from Arles
Oil on canvas
58 x 42.5 (22 $^{13}/_{16}$ x 16 $^3/_4$)
Unsigned

Arles, February–March 1888

inv. s 145 v/1962
F 390; JH 1357

49

The Zouave
Oil on canvas
65 x 54 (25 $^9/_{16}$ x 21 $^1/_4$)
Unsigned

Arles, June 1888

inv. s 67 v/1962
F 423; JH 1486

50

The Sea at Les Saintes-Maries-de-la-Mer
Oil on canvas
51 x 64 (20 $^1/_{16}$ x 25 $^3/_{16}$)
Signed at lower left: Vincent

Arles, June 1888

inv. s 117 v/1962
F 415; JH 1452

51

Fishing Boats on the Beach at Saintes-Maries-de-la-Mer
Oil on canvas
65 x 81.5 (25 $^9/_{16}$ x 32 $^1/_{16}$)
Signed in the foreground, on a chest: Vincent

Arles, June 1888

inv. s 28 v/1962
F 413; JH 1460

52

The Yellow House ("The Street")
Oil on canvas
72 x 91.5 (28 $^3/_8$ x 36)
Unsigned

Arles, September 1888

inv. s 32 v/1962
F 464; JH 1589

53

The Bedroom
Oil on canvas
72 x 90 (28 $^3/_8$ x 35 $^7/_{16}$)
Unsigned

Arles, October 1888

inv. s 47 v/1962
F 482; JH 1608

54

Portrait of Marcelle Roulin
Oil on canvas
35 x 24.5 (13 $^3/_4$ x 9 $^5/_8$)
Unsigned

Arles, December 1888

inv. s 167 v/1962
F 441; JH 1641

55

Portrait of Camille Roulin
Oil on canvas
40.5 x 32.5 (15 $^{15}/_{16}$ x 12 $^{13}/_{16}$)
Unsigned

Arles, December 1888

inv. s 166 v/1962
F 538; JH 1645

56

Crab on Its Back
Oil on canvas
38 x 46.5 (14 $^{15}/_{16}$ x 18 $^5/_{16}$)
Unsigned

Arles, winter 1888–1889

inv. s 124 v/1962
F 605; JH 1663

57

Portrait of a One-Eyed Man
Oil on canvas
56 x 36.5 (22 $^1/_{16}$ x 14 $^3/_8$)
Unsigned

Arles, December 1888

inv. s 113 v/1962
F 532; JH 1650

58

Wheatfield with a Reaper
Oil on canvas
73 x 92 (28 $^3/_4$ x 36 $^1/_4$)
Unsigned

Saint-Rémy, July–September 1889

inv. s 49 v/1962
F 618; JH 1773

59

Pietà (after Delacroix)
Oil on canvas
73 x 60.5 (28 $^3/_4$ x 23 $^{13}/_{16}$)
Unsigned

Saint-Rémy, September 1889

inv. s 168 v/1962
F 630; JH 1775

60

A Pair of Leather Clogs
Oil on canvas
32.5 x 40.5 (12 $^{13}/_{16}$ x 15 $^{15}/_{16}$)
Unsigned

Saint-Rémy, 1889

inv. s 120 v/1962
F 607; JH 1364

61

Emperor Moth
Oil on canvas
33.5 x 24.5 (13 $^{3}/_{16}$ x 9 $^{5}/_{8}$)
Unsigned

Saint-Rémy, May 1889

inv. s 189 v/1962
F 610; JH 1702

62

Butterflies and Poppies
Oil on canvas
34.5 x 25.5 (13 $^{9}/_{16}$ x 10 $^{1}/_{16}$)
Unsigned

Saint-Rémy, May 1890

inv. s 188 v/1962
F 748; JH 2013

63

Olive Grove
Oil on canvas
45.5 x 59.5 (17 $^{15}/_{16}$ x 23 $^{7}/_{16}$)
Unsigned

Saint-Rémy, June–July 1889

inv. s 44 v/1962
F 709; JH 1760

64

Undergrowth
Oil on canvas
49 x 64 (19 $^{5}/_{16}$ x 25 $^{3}/_{16}$)
Unsigned

Saint-Rémy, June–July 1889

inv. s 111 v/1962
F 745; JH 1764

65

Undergrowth
Oil on canvas
73 x 92.5 (28 $^{3}/_{4}$ x 36 $^{7}/_{16}$)
Unsigned

Saint-Rémy, June–July 1889

inv. s 51 v/1962
F 746; JH 1762

66

Almond Blossom
Oil on canvas
73.5 x 92 (28 $^{15}/_{16}$ x 36 $^{1}/_{4}$)
Unsigned

Saint-Rémy, February 1890

inv. s 176 v/1962
F 671; JH 1891

67

Daubigny's Garden
Oil on canvas
50.7 x 50.7 (19 $^{15}/_{16}$ x 19 $^{15}/_{16}$)
Unsigned

Auvers, June 1890

inv. s 104 v/1962
F 765; JH 2029

68

Ears of Wheat
Oil on canvas
64.5 x 48.5 (25 $^{3}/_{8}$ x 19 $^{1}/_{8}$)
Unsigned

Auvers, June 1890

inv. s 88 v/1962
F 767; JH 2034

69

Landscape at Twilight
Oil on canvas
50 x 101 (19 $^{11}/_{16}$ x 39 $^{3}/_{4}$)
Unsigned

Auvers, June 1890

inv. s 107 v/1962
F 770; JH 2040

70
Wheatfield with Crows
Oil on canvas
50.5 x 103 (19 $^7/_8$ x 40 $^9/_{16}$)
Unsigned

Auvers, July 1890

inv. s 149 v/1962
F 779; JH 2117

Tracing of the cover of *Paris Illustré*:
The Courtesan
Pencil, pen, and ink, on tracing paper
39 x 25 (15 $^3/_8$ x 9 $^7/_8$)
Unsigned

Paris, July–September 1887

inv. d 773 v/1962

Cover of a special edition of *Paris Illustré*:
Le Japon
May 1886

Select Bibliography

CATALOGUES RAISONNÉS

Faille, Jacob-Baart de la. *The Works of Vincent van Gogh: His Paintings and Drawings*. Rev. ed. Amsterdam, 1970.

Hulsker, Jan. *The Complete Van Gogh: Paintings, Drawings, Sketches*. New York, 1980.

Hulsker, Jan. *The New Complete Van Gogh: Paintings, Drawings, Sketches*. Rev. ed. Philadelphia, 1996.

Walther, Ingo F., and Rainer Metzger. *Vincent van Gogh: Sämtliche Gemälde*. Cologne, 1994.

LETTERS

The Complete Letters of Vincent van Gogh. 2d ed. Boston, 1978.

The Letters of Vincent van Gogh. Ed. Ronald de Leeuw, trans. Arnold Pomerans. London, 1996.

GENERAL LITERATURE

Bernard, Bruce, ed. *Vincent by Himself: A Selection from His Paintings and Drawings together with Extracts from His Letters*. London, 1985.

Dorn, Roland, and Fred Leeman. *Vincent van Gogh and the Modern Movement 1890–1914*. Trans. Eileen Martin [exh. cat., Museum Folkwang and Rijksmuseum Vincent Van Gogh] (Essen and Amsterdam, 1990).

Dorn, Roland, et al. *Van Gogh und die Haager Schule* [exh. cat., Bank Austria Kunstforum] (Vienna, 1996).

Leeuw, Ronald de. *The Van Gogh Museum: Paintings and Pastels*. Zwolle, 1994.

Noll, Thomas. *Vincent van Gogh: Fischerboote am Strand von Les Saintes-Maries-de-la-Mer*. Frankfurt am Main and Leipzig, 1996.

Pickvance, Ronald. *Van Gogh in Arles* [exh. cat., The Metropolitan Museum of Art] (New York, 1984).

Pickvance, Ronald. *Van Gogh in Saint-Rémy and Auvers* [exh. cat., The Metropolitan Museum of Art] (New York, 1986).

Schneede, Uwe M., et al. *Van Gogh: Die Pariser Selbstbildnisse* [exh. cat., Hamburger Kunsthalle] (Hamburg, 1995).

Tilborgh, Louis, et al. *The Potato Eaters by Vincent van Gogh*. Zwolle, 1993.

Van Uitert, Evert, et al. *Van Gogh in Brabant: Paintings and Drawings from Etten and Nuenen* [exh. cat., Noordbrabants Museum] ('s-Hertogenbosch, 1987).

Van Uitert, Evert, Louis van Tilborg, and Sjraar van Heugten. *Vincent van Gogh: Paintings* [exh. cat., Rijksmuseum Vincent van Gogh] (Amsterdam, 1990).

Van Gogh in England: Portrait of the Artist as a Young Man. Introduction by Martin Bailey [exh. cat., Barbican Art Gallery] (London, 1992).

Welsh-Ovcharov, Bogomila, et al. *Van Gogh à Paris* [exh. cat., Musée d'Orsay] (Paris, 1988).

Van der Wolk, Johannes, Ronald Pickvance, and E. B. F. Pey. *Vincent van Gogh: Drawings* [exh. cat., Rijksmuseum Kröller-Müller] (Otterlo, 1990).

Index of Paintings in Exhibition